PORTRAIT OF A YOUNG FORGER

PORTRAIT OF A YOUNG FORGER

BY MARIAN PRETZEL

AN INCREDIBLE TRUE STORY
OF TRIUMPH OVER THE THIRD REICH

Introduction by Simon Wiesenthal

KNIGHTSBRIDGE PUBLISHING COMPANY
NEW YORK

This edition of *Portrait of a Young Forger* first published in August 1990 by Knightsbridge Publishing.

Published in 1989 by University of Queensland Press

First published in 1985 as *By My Own Authority*
Condensed edition, Reader's Digest 1987

Published in the United States by
Knightsbridge Publishing Company
255 East 49th Street
New York, New York 10017

Library of Congress Cataloging-in-Publication Data

Pretzel, M. M. (Marian M.)
 Portrait of a young forger / Marian M. Pretzel.—1st ed.
 p. cm.
 Originally published: By my own authority, 1985.
 ISBN 1-877961-60-4 : $19.95
 1. Pretzel, M. M. (Marian M.) 2. Jews—Ukraine—L'vov—Biography.
3. Holocaust, Jewish (1939–1945)—Ukraine—L'vov—Personal
narratives. 4. L'vov (Ukraine)—Biography. I. Title.
DS135,R95P697 1990
940.53'18'0947718—dc20 90-32255
[B] CIP

10 9 8 7 6 5 4 3 2 1

FIRST EDITION

This book is dedicated to my parents,
my wife, Yvonne,
and my children, Stephen and Shari

People who continued fighting found out after a while that the fight itself, the personal contest, was more important than the life they were fighting for.

Death is the sign of defeat in a struggle for survival.

Albert Camus

Contents

Introduction

Marian Pretzel is a very talented author, and as I write down these words, I become aware of other similarly talented young people who were killed by Nazi barbarity without ever having had the opportunity to use their abilities for the benefit of us all.

I must confess that in spite of my good memory, I simply cannot remember the short episode of how I helped Marian Pretzel escape from the "Ostbahn-Aus- besse" of the German Railway. I let a number of other prisoners use this route by the pigsty; I did not know their names, and none of them—except, of course, the author of this book—got in touch with me again. They probably did not survive the war.

The extent of the tragedy of the Jewish people can be shown best by citing two numbers that give us a fair picture of the crimes committed by the Nazis. In 1963 the Public Prosecutor's Office in Stuttgart, West Germany, asked me for my cooperation in the preparations for the upcoming trial about crimes committed in Lemberg. I should not only find the criminals, but also survivors who would be able to testify. After two years of conducting my research in various parts of the world, I was confronted by an almost unbelievable fact: Of the 149,000 people who had passed through the Lemberg

ghetto and the Janowska camp, no more than about 500 survived. That means an estimated 148,500 human beings—witnesses who cannot tell the world about their lives and personal fates anymore—perished.

The well-preserved remembrance of what happened is supported by each generation of Jews in order to pass on their experiences to their children and their children's children.

There are only about a dozen accounts of the Janowska concentration camp published in books; my heart bleeds when I read them, but I also feel a certain satisfaction, because after all, there are some lucky ones who survived.

—SIMON WIESENTHAL
VIENNA, 1990

Progress of World War II in Europe

March 1938	German troops enter Austria
September 1938	Czechoslovakia loses the Sudetenland to Germany
March 1939	Germany occupies the rest of Czechoslovakia
September 1939	Germany and Russia attack Poland
November 1939	Russian troops enter Finland
April–May 1940	The German army sweeps into Denmark, Norway, Belgium, Luxembourg and Holland
June 1940	The Russians invade the Baltic countries France capitulates to Germany
October 1940	Italian troops land in Greece
April 1941	Germany invades Yugoslavia and Greece
June 1941	Germany and her allies attack Russia
September 1942	German troops reach Stalingrad (Volgograd)
November 1942	The Russian army begins a counter-attack in Stalingrad
September 1943	The Allied forces land in Italy
June 1944	The Allied forces land in Normandy
January 1945	The Russians enter Warsaw
February 1945	The Red Army occupies Budapest
April 1945	Russian troops reach Berlin
May 1945	Germany surrenders to the Allies

Maps showing Europe at different stages of the war are included on pages 337–42, and a map showing Marian Pretzel's travels appears on page 343.

Prologue

25 August 1942

"Good luck, Marian!"

We had reached the suburbs of Lvov and the last of my companions touched my shoulder before turning down the street which led to his home.

I made a brief gesture of farewell and hurried on, my mind racing ahead quicker than my legs could carry me.

It was three and a half hours since we had been let out of the German forced labour farm at Wilniczka. The pieces of cardboard I had put into my dilapidated sandshoes had long since worn through. The soles of my feet were sore and bleeding from the grit of the rough roads. My skin was grimed, my clothes dirty.

I stumbled along, sweating under the hot August sun. Usually we were allowed to return to our families in Lvov each weekend, but during the last eighteen days we had been kept locked in the farm without a change of clothes or proper facilities to wash; worst of all, we were given no reason why we were not being allowed home.

"Be glad you're here," one of the Polish workers had said. The question that tormented us all was — *why*? What was happening in Lvov, where we all lived, that could be worse than being kept in the farm?

It was August 1942, the third year of the war. The Germans had forced the Russians out of this part of Poland fourteen months ago.

Rumours were rife that a particularly vicious *aktion* had begun, and that though Jews employed by the Germans were being left alone, the rest of the Jewish population was being rounded up and sent, according to age and condition, either to a concentration camp or to the trains for Belzec where the huge crematoria were nearing completion. We were no strangers to *aktions*, but for one to last as long as this. . . It seemed a lifetime before the order to let us go home was given.

The sixteen men who had trudged with me had, one by one, left the group and made for their homes. I lived farthest away, so I would be the last to find out what had happened. The others were all married with young children and it was impossible not to realise that their worries were greater than mine. I was not married. I was just twenty years old.

Please God let my parents and my sister Giza be safe, I had prayed over and over in my head during the nightmare walk. Now my mind was filled with one desperate plea that in the next few minutes I would find things as they always were when I came home at the weekends; that my mother would welcome me with a kiss and an all-embracing hug before turning aside to wipe her tears; that my father would give me his special handshake and the look of love and approval which was charged with so much meaning. I wanted to be able to sit down to the special meal they had saved all week to prepare for me, with my mother sitting close by to watch me enjoy the only decent food I had had since last time I was home. . .

Now I was in streets where I had played as a child; now in Zielona Street. Only two more corners to turn and I

would see the house. Why did I feel so cold when the sun was so hot?

As I turned into Kochanowski Street I limped faster. I passed the blank-faced houses which told me nothing — 33, 35, 37, and there it was: number 45.

My heart lurched and my legs almost gave way under me. Three floors up, above the balcony of our flat, reared the glossy green foliage of some exotic pot-plants. We didn't have such plants; my mother, struggling to scrape together enough money for food, could not possibly afford them. I drew in my breath in a gasp of fear. I do not know how long I stood there staring, until, mindless of the pain of my sore and bleeding feet, I gave a despairing cry and began to run towards the house.

Part One

Lvov

1

Kochanowski Street, Lvov; here I was born, and, until the Germans came in 1941, it was both home and playground. The voices of my companions, the sounds of everyday life and the fragrance of its leafy chestnut trees are still alive in my memory. Recollections of childhood come back in a series of vivid vignettes.

I remember the ornate wrought-iron gate and the fountain in the garden of number 43, the house where I was born. I remember the party we had there to celebrate my parents' tenth wedding anniversary and the old French cognac which had been brought all the way from Paris so that we could drink a toast to them. I remember how the guests patted me on the head and told Mother I was a lovely little boy. I remember how my cousin Henek, my sister Giza and I watched from a window when after dinner they all danced foxtrots and tangos in the garden, to music from our new gramophone.

I remember when we moved to the flat next door, at number 45. I was five years old and used to crawl beneath the trees which grew in the grass strip at the front of the house to collect the fallen chestnuts, brown and glossy inside their soft green shells. As I grew older I climbed those tall trees.

I remember the long hours I spent watching Giza, who was three years older than me, doing her homework and the book I was given as a prize in my first year at school because I could already read and write. It was the only prize I ever won. In my second year they put me straight into third class, but from being the bright boy I became a struggler trying to keep up and made the surprising discovery that life is not always easy.

I remember the way our piano teacher, who lived next door, would pound on the wall and scream, "No! No!" when Giza or I struck a wrong note while we were doing our practice. Most of all I remember my mother and father.

Mother was the classic "Yiddishe Momma". Softly spoken, overflowing with affection, her family was her life. She adored my father and was love itself to Giza and me. Letters to her brothers and sisters in America were as stained with tears as the ones she received from them. She grew up in Kolomyja, a small town in southern Poland where there were many ultra-orthodox Jews; Yiddish was her first language until she settled in Lvov and began to speak Polish. Neither Giza nor I was encouraged to learn Yiddish; that was kept for confidential exchanges between my mother and father.

We always had a live-in maid, but there was no stopping my mother doing her own cooking. Her reward was to watch us enjoy her meals. As a very little boy I would sit on the table and watch her make apple strudel. She threw the dough on the table time after time until it was pliable enough to be rolled out and stretched, and then I had the important job seeing that she did not forget to put in the raisins, the apples, the cinnamon and the sugar. My mother's kitchen was for her the centre of the world.

Although she only attended the synagogue on high holidays, she was very religious. She lit the candles on

Fridays, kept the Sabbath, and her food was Kosher. We all respected her beliefs, but outside the house we weren't too concerned about orthodox ritual. (Father, in fact, even kept a special saucepan and plate at home for the pork sausages he enjoyed.) After my Bar Mitzvah I had to say my prayers every morning or there would be no breakfast. I said my prayers even after the German invasion; they only took five minutes and it meant so much to my mother.

Unsophisticated, with limited education, she was patient and over-protective. She was always good-tempered and composed. I can recall only one incident where she lost her temper. I happened to be the culprit. I must have been about eight or nine years old, and had learned to play the piano for nearly two years. My mother and I had an agreement whereby for each half-hour of practice I did, she would give me a small chocolate bar. For quite some time this worked successfully until one day, after receiving the chocolate, I fooled around instead of continuing my proper practice. I ignored repeated calls from my mother, and finally she could take it no longer. She stormed into the room, throwing punches at me. I fell off my stool, my head hitting the piano as I toppled to the floor. My mother ran crying into the bedroom while Giza tried to stop the bleeding. At this dramatic moment, Father walked in. He heard Mother sobbing in the next room, and saw me crying as I lay on the floor. Giza, who by that time was also crying, managed to explain what had happened. My father, after a short deliberation, sternly announced: "There will be no more piano lessons for you, Marian!" It was an irrevocable decision; he always kept his word, and I have always regretted his dictate.

When Mother developed angina she would take her drops, lie down for a few minutes and then get up and go on with her work. Nothing could stop her homemaking

and we lived in the joy of our home. If she ever thought about dying I am sure she would have wanted to die at the same time as my father; she probably got her wish. The regret of my life is that neither of my parents ever saw my wife and two children. How happy and proud they would both have been!

Father was a tall, heavy man who had been an amateur wrestler in his youth. He smoked heavily, enjoyed big meals, and always washed down his dinner with a bottle of beer. He was always the businessman. Beginning as a dealer in secondhand furniture, he soon developed an interest in antiques. With his first partner, Stanislaw Nowacki, he also built up an agency for Boessendorfer grand pianos. One of these pianos occupied pride of place in our flat. "It will be your dowry one day," Father used to say to Giza.

He was interested in soccer and exulted when "Pogon", the team he followed, won, but when it became obvious that their members were starting to indulge in anti-semitic activities, my father and his friends refused to watch them any more. Instead, they became followers of horse-racing. Not being gamblers by nature, they were satisfied with small bets.

He took me to every Grand Prix car race held in Lvov and told me all about Caraciola and his Bugatti, and Hans von Stuck and his Mercedes. He became excited when he or his partner found a particularly good antique, *objet d'art* or Persian carpet for the shop, and the way he would talk about how you could tell an original etching or lithograph from a copy was like listening to a detective story. He was a man of enthusiasm, interested in everything, especially anything that interested me, and I enjoyed every minute I spent with him.

He told me many stories about the three years he served in the Austro-Hungarian Army during the First World

War, about the many months spent in the trenches on the Russian front, and later fighting the Italians. He had numerous lucky escapes, many of them created by his foresight and initiative. As a young boy I would sit for hours, spellbound, listening to his adventures, admiring his bravery and his faith in God.

"But remember, God helps the one who helps himself. Never depend on others. Never wait for miracles. And don't be afraid to make decisions," he told me. "You'll make mistakes, but learn from them — and remember, only a fool makes the same mistake twice." He believed a man should take a hand in his own destiny; later, my own fight for survival was often sustained by the memories he had shared with me.

I particularly liked to hear his story of how he married Mother during that war. In 1918 he sent her a rail ticket so that she could join him in Vienna, where he was stationed. After her arrival, his application for short leave was denied; all leave was cancelled except on compassionate grounds. On the strength of this information he approached the army chaplain and arranged the wedding. Within a week my parents were on their honeymoon, three months earlier than planned.

When I was eleven, I decided I wanted to go to the Mechanical High School and become an engineer.

"Why?" asked my father. He had hoped that I would go to the University.

"Because in six years I will be a qualified engineer," I said.

He didn't argue. It was enough that this was something I really wanted to do. But what I *really* wanted was to finish my studies as soon as possible and go to America. My Mother's sister Annie had migrated to the USA and

her every letter pleaded with my parents to let me join her there. Brainwashed by American films, I could easily picture myself on the deck of a luxurious liner, my arms around a statuesque blonde with the moon hanging low in a star-studded sky. But at least I had enough sense to know that I needed to have a profession and to be independent before the fast cars, slim yachts and long-legged cheer-squad girls could be mine for the taking.

"You would never go, would you?" my mother pleaded.

I knew how much she hoped and prayed I would not leave her. Yet from the moment I enrolled there was no doubt in my mind that as soon as I qualified I would be on my way to America.

I did not realise what I had taken on. The six-year course was hard beyond expectations. The hours of workshop time tool-making, filing, turning, casting, welding, electroplating, anodising, combined with the hours of study of the technology of metal, physics, chemistry, mathematics, mechanical design and draughting made for a heavy schedule. At the end of four years, when we were required to have three months' practical experience, I was beginning to wonder why I had ever wanted to become a mechanic. After a short time working on diesel engines I was sent to help build a mixing machine for a chocolate factory. The sickly-sweet smell almost put me off chocolate for life, and during this time I had a real insight into how crude and hard a mechanic's life can be.

I was learning something else, too. Being born a Jew could create problems. It had never been a problem before. We lived in an area which was mostly Gentile, and where the Jewish families were liberal in their religious attitudes. I was never conscious that a Jew was so very different from a Gentile; sure enough, we had our religious instructions at school and they had theirs, but

14

apart from that there seemed to be no real distinction. Every year, my mother, orthodox as she was, would buy a Christmas tree for our Polish maid and help her to decorate it in her little room, and we always had Christmas dinner with the family of my father's first business partner and close friend, Stanislaw Nowacki, who was a strict Catholic.

I cannot remember ever being made to feel "inferior". If anyone pushed me I believed it was me, Marian Pretzel, they pushed, that it had nothing to do with my being Jewish. It never occurred to me to blame my religion for anything unpleasant or unfair which happened to me. My father and I had many Polish and Ukrainian friends as well as Jewish ones, and I appreciated being able to grow among people with different backgrounds.

Although we were aware that anti-semitism was alive elsewhere in the community, my family was virtually unaffected by it. Then, in 1937, when I was fifteen, anti-semitic outbursts started to become frequent and violent; Polish students joined with hooligans in beating up Jews on the streets, smashing windows and burning shops. Indiscriminate bashing at the Polytechnic and the University resulted in several deaths. I came alive to the fact that a Jew really was different.

There were only three Jews among the forty-two students in my year at the Mechanical High School; one dropped out after the first year, another managed to continue, buying his peace, but I always seemed to get by. This was largely due to the fact that I had the "luck" to be tall, fair and athletic. I owe a lot of that luck to Emil Krau, son of my father's best friend, and my friend for as long as I can remember. He was my idol, an extension of what I wanted to become. Although he was four years my senior, he allowed me to play soccer and other games with him and his friends in a local deadend street. And at

a time he thought appropriate, he carefully explained to me that our housemaids, who all came from the country, were able to perform duties other than floor-polishing and pot-scrubbing. They were, in fact, happy to satisfy the sexual curiosity of their employers' adolescent sons.

"But never forget the unwritten law," Emil warned me. "Don't play around with your own maid, always choose someone else's."

When I was fifteen, Emil introduced me to the Jewish scout group *"Hanoar Hazair"*, where I learned of Zionism and Doctor Herzl's dream of an independent Jewish state. I joined up, and like good scouts everywhere, learned the Morse Code, how to tie knots and the art of bush-tracking. Having developed a keenness for the group, I persuaded my mother to let me attend a mountain camp. After only four days this new adventure came to an unfortunate end. Not being an experienced scout, I gashed my foot on a rusty nail from heel to toe. The older boys carried me to bed, washed the wound and called the doctor. He stitched me up, injected me with anti-tetanus and left a supply of pain-killers. My father was phoned, and I was collected.

Although that incident marked the end of my scouting career, as soon as I recovered Emil took me along to the Jewish sporting club *"Dror"*, and from that moment, my life changed completely.

2

"Dror" in Hebrew means "freedom" or "liberty". And *Dror* was more than just a sporting club. To me it was also a social club, an educational institution and an exciting stepping-stone from adolescence to manhood. I can never think of the Club and its members without a deep feeling of humility and gratitude; so many of the people I met there had an influence on my life. It was there I learned the principles of fair play and how to be a modest winner and a gracious loser. I doubt if I would have become an artist or survived the war but for the help and advice I received from *Dror* members both then and in the difficult days to come. Now, when things were starting to get really difficult, the sporting prowess I acquired at the Club made things easier for me than they might have been.

The Club was small, but due to the excellent relationship between coaches, seniors and juniors, its standard was very high. One of our coaches, Michael Koeller, was recognised as amongst the best in Poland. Another coach, Salek Meissner, was destined to play a significant role in my future. There was a sort of brotherhood among us; a junior's problems, whatever they were, were always treated sympathetically. Once you joined *Dror* you never

needed to fear being left to fend for yourself. Gymnastics, volleyball and basketball were the main activities, followed by handball, athletics, fencing, skiing, tennis and ice-hockey. I had been skating since I was five, so ice-hockey was naturally my first enthusiasm. I remember coming home one Saturday with all my gear: padded shorts, long socks, heavy jumper, big gloves, thick felt padding on knees, shins and shoulders. I couldn't help trying my uniform and admiring myself in our full-length mirror. I might be skinny but I certainly was tall!

"Come and look at the hero of tomorrow's match," I called out to my parents.

My father took one look and burst out laughing. "There's not much of you, is there? Don't let your opponents blow on you or you'll be flat on your back!" For all his teasing his eyes were sparking with approval.

My mother was too afraid that I might get hurt to face watching me play, but the next day as I skated out onto the rink, too excited to see anything but the player in front of me, a hand reached out from the front row of spectators and patted my shoulder as I passed. There was my old man, his face alight with pleasure and pride.

"Good luck!" he said.

No boy could ever have had more encouragement from a father than I had from mine.

Later, I was invited to join the junior section of the Club, in which all the members had to take part in every one of the Club's activities. Soon sport overshadowed everything in my life. I represented my high school class in many different games and played volleyball and basketball in "B" grade competitions. Considering that the average age of the players was sixteen, we had an exceptionally good record.

Dror teams sometimes ran into difficulties because young Poles didn't enjoy seeing their teams beaten by

18

Jews, and escape to safety had to be made through the dressing-room window, but trouble came mainly from the spectators, not the competing teams. Despite, or perhaps because of, the hazards, we were always one of the first teams in the competitions.

My father, of course, was right behind me in everything I did; my mother didn't care whether I won a game or not as long as I was happy.

It was June 1939, summer holiday time; for the third year in succession we were going to the mountains to share a cottage at Skole with Willy Lipper and his family.

My father had met Willy Lipper after he had sold out his business to his partner Stanislaw Nowacki, and was recuperating from a coronary attack. They got on so well and had so many shared interests that it was natural for them to go into business together, and they made a great success of selling antiques and fine art.

Willy Lipper had a vivacious wife and three lively children, and our two families spent a lot of time together. Binka, the Lippers' eldest daughter, and my sister Giza were best friends. Imek, one year younger than I, didn't share my interest in sport. He chased girls while I chased tennis balls. I guess I was envious of the amount of success he had with his interest. Fela, the baby, I remember walking under the table. I enjoy reminding her of that today!

The summer holiday usually lasted from 14 June to the first week in September. Everything my mother thought we would need was packed into a huge wicker hamper; it took four men to carry it down the three flights of stairs from the flat to the street.

The cottage at Skole stood high in the mountains, close by the river Stryj. We spent our time exploring, bathing and fishing; there was volleyball and tennis in the park.

We only played one hour of tennis a day, for neither I nor any of my partners could afford to hire the court for a longer period. Occasionally we went to the nightclub where I could show off my newly acquired dancing skills. Our mothers, assisted by one of the maids, enjoyed the rest, gossiping together, and our fathers took it in turn to look after the shop and to spend time with us.

I remember that summer holiday of 1939 as the best we ever had as a family. It was also the last. To our loud annoyance it was cut short. My father arrived unexpectedly at the cottage in the middle of August.

"No argument, please!" he said. "Get packed. You must all come home." When my Father gave such an order you knew it was a necessary one. We packed.

Marshal Rydz-Smigly of the Polish army had called up all reserve officers and men; Hitler's strident assertion that Germany had claim on Silesia and part of Pomerania as the "corridor" between Germany and East Prussia had brought our two countries into confrontation. Over the past few weeks the German army had been massing its forces along the Polish border. Whether or not it meant war we were uncertain, but this was no time to be away from home.

I joined the cheering crowds throwing flowers to the long lines of our marching men, shouting "See you in Berlin!" I saw quite a few of my older friends swinging proudly along in their new uniforms.

For us, as for everyone else, life became feverish. The government issued a stream of instructions. Convert your cellars into bomb shelters! Store extra food! Each window-pane had to be secured with paper tapes pasted in horizontal, vertical and diagonal pattern, similar to the red stripes on the Union Jack. Within days the supplies of

tapes dried out, and people started to use any sort of paper available; the variety of colours and widths of the stripes created an interesting sight, especially on multi-storey buildings with long rows of windows. Inside, heavy curtains or blankets had to be secured every evening to block any light from penetrating outside. The cellars below our flats were large, but cold. Like everybody else, we did what we could to create some comfort, taking down odd chairs and blankets.

Before they became shelters, the cellars were used for storing wood, coal and vegetables over the winter months. They also contained a lot of junk which people didn't feel like throwing out, but didn't want to keep in their flats. Each flat had its own cellar, separated by a brick wall. There was a small chute from the outside through which the supplies were delivered.

One morning, Father went to the country and arrived back late that night on a cart full of sacks of potatoes and other vegetables and fruit. By now there were long daily queues of anxious-looking people outside every food store. We were fortunate not to have to stand for hours in front of the grocery shop; our reserve supplies were delivered personally by Emil from his father's shop.

Out on the streets we would suddenly hear the scream of air-raid sirens. Panic-stricken people ran for cover. These rehearsals were necessary, we were told. It was hard not to become nervous wrecks.

We waited uneasily.

Wherever I went, I couldn't help listening to the interminable discussions and heated arguments about the Germans and the unavoidable conflict we were facing. Groups congregated on the streets, men with very strong patriotic feelings, proudly announcing that their sons were called into the army from the Reserves. Their answer to sceptics who doubted the sincerity of the British and

French to come to Poland's help was: "We don't need anybody's help. We are strong enough to take care of the Germans without England or France. Didn't you hear Marshal Rydz-Smigly's last speech?"

On the other hand, just as vocal were the doom-merchants prophesying the destruction of the whole civilised world as we knew it. It was much more encouraging to listen to my friends, who professed to have "inside information". They knew, for instance, that the Polish airforce had the latest and undisputedly the best fighter planes ever built, and that the American tanks, brought to Poland only a few weeks before, were much superior to the German. At home, the radio was never switched off; at news times we gathered around full of hope and expectation.

In all the extraordinary confusion, life still went on. I was seventeen and had matriculated from the Mechanical High School. But I knew now that I didn't want to be an engineer. Unfortunately, I didn't know what I wanted to do instead. My teacher of mechanical draughting offered to employ me as his assistant, but the prospect of spending the rest of my life going to school every day, no matter in what capacity, didn't appeal to me at all.

I spent hours discussing the problem with my friend Milek Sigal, who couldn't decide what to do about his future either. He had just graduated from the Humanistic High School.

Milek was a year older than me, shorter and more solidly built, with bright red hair and more freckles than I have ever seen on a human face. We played in the same team in *Dror*, and as sportsmen we could have done with his being as fiery as he appeared, but there was nothing aggressive about Milek; he was placid and easy-going, looking for a laugh rather than an argument. For him, life was one continuous joke. He saw the funny side of every

situation and his loud, hearty laugh was well known and easily recognised by his friends.

Friends since we both joined *Dror*, Milek and I now became inseparable. We had the same sorts of problems and were discovering together a new enthusiasm: art. We looked through my father's collection of sketches and books with growing excitement, and when we came across a hoard of drawings, sketches and watercolours by the well-known artist Wojciech Kossak and his brothers and sisters, we spent hours studying their different styles and making our own copies of their work. These long quiet hours enabled us to find out where our own strengths lay. I was good at layout and lettering, while Milek, with his wicked eye and sense of humour, excelled at caricatures, cartoons and illustrations. We made all the posters and showcards for social functions at *Dror*, but still neither of us had the faintest idea of how we could make a career.

My father, ever-helpful, but not aware of my change of heart, arranged an interview for me with the director of a precision instruments factory. I only went to please Father. I didn't like the job and I didn't like the man. I stalled when he said, "Yes, I would do", saying I would let him know in three days.

We were all saved from embarrassment. The day after that interview the German army crossed the border into Poland.

On Friday 1 September we were awakened at five o'clock in the morning by a continuous dull banging, not loud enough for us to be certain what it could mean. We sat around the dining-table drinking cup after cup of coffee, listening tensely for each new thud.

They're bombing the airport at Sknilow,'' my father at last.

It was hard to take in. *War* had begun. I knew about war from all the movies I had seen, but this was something different. Curiously, it seemed less real than the things that happened on the screen.

"At least France and Britain are on our side," Father said trying to comfort my mother. "They'll help us to make short work of that fellow Hitler, you'll see." Privately, however, he expressed to me his doubts whether the actions of these two allies would have any influence on Hitler's ambitions of conquest.

Two days later, true to their agreement, France and England declared war against Germany and her fascist ally, Italy. But our other mighty neighbour, Russia, had already signed a non-aggression pact with Hitler. What would that mean to us, caught like the meat in a sandwich?

That night, bewildered and worried, I joined my parents and neighbours outside our block of flats. It was a warm, calm evening. Everybody seemed to know somebody who *knew* something. I put my arm around my mother as the voices grew louder and the arguments and discussions more fierce. Then above all those voices we heard in the distance a more impassioned sound that grew louder and nearer, and suddenly a jostling body of men, women and children rounded the corner into our street and poured down the middle of the road. I could hear their individual cries: "*Vive la France!*" "Long live England!" "Down with the Germans!" between the ragged singing of the Polish national anthem, *Jeszcze Polska nie zginela*, and one dramatic *Marseillaise*. The solid mass of people overflowed the nature strips and footpaths, filling the road like a swollen river.

I recognised one of my friends among the marchers and caught at his arm.

"What's going on?"

His eyes were shining, his face alight with patriotic enthusiasm.

"What a night!" he shouted. "We've been to the French and British consulates to show our gratitude! The French consul came out and we sang that French thing to him, then we went down to Batorego Street, but nobody knew the English national anthem so we shouted 'Long live England!' and sang our Polish 'A hundred years!' outside the British consulate until they came out and acknowledged us. 'We'll show the bloody Nazis we mean business!' we told them. Then we went to that German school, the *Evangelische Schulle* — there must have been about two thousand of us — and we smashed the front door and every single window. We'd have pulled the place apart if the police hadn't stopped us. What a night!" He wrenched away from me and rejoined the great crowd of shouting, gesticulating people. Our family stood close together and watched them go, then silently we went back and climbed the stairs to the flat.

From then on we lived by the radio and its ominous bulletins.

Many took heart as we heard on the wireless how our brave soldiers were punishing the Germans. But my father was sceptical. He had little confidence in the ability of the Polish army to stem the German advance.

"Who do they think they're kidding with such talk?" he asked, switching off the wireless. "If you read between the lines of everything we're told, it's quite clear that our defences are practically non-existent." He shook his head gloomily. "Compared to the Germans we have toys, not arms. Polish pride lies in our cavalry. What good is cavalry against tanks and guns? The Wehrmacht will reach Lvov in a matter of days." He no longer tried to comfort Mother with false hope.

Brave our Polish soldiers certainly were, facing the

advancing Germans with drawn swords and sabres in the face of mechanised artillery, but they were being rolled steadily eastward to the Russian border: the Germans were spreading across Poland with the speed and strength of a tidal wave.

"When they get here our Ukrainians will welcome them," Giza said fearfully. "We shall be living in a Nazi Ukraine."

"Our population is divided more or less evenly between Poles, Ukrainians and Jews," Father said. "The Nazis and Ukrainians would gang up against us, for sure."

"But what about the loyal Poles?" Mother protested. "Surely some of the Poles would want to help us. We have many Polish friends —"

As we shrugged helplessly in reply, she resorted to her religious feelings. "We must pray to God and have faith in Him," she told us.

Incredulously we learned that most of our planes had been destroyed on the ground in the first hours of the fighting. Five days later the German Panzer division were five hundred kilometres over the border and into the suburbs of Warsaw. On 12 September, over the crackle of the static, came the news that the remnant of our army was fighting desperately on the outskirts of Lvov to prevent the enemy entering the city. In the flat in Kochanowski Street we moved round as though in a dream.

Then the Stuka planes came, sweeping down unchallenged to lay their bombs across the city: we heard the crash of falling buildings and the loud wailing of ambulance sirens. It was terrifying. But the most frightening thing of all was to realise that Lvov would soon be occupied by the Germans. We knew all about their savage persecution of our race, the violence of their anti-Jewish pogroms. We weren't indulging in groundless fears. The long days dragged by — we hardly spoke. Our movements

were slow, as if we had resigned ourselves to the inevitable, but were trying to delay it happening.

I watched my parents growing old.

I could not sit still, but it was unwise to go out, so I took a stool onto the balcony. The sun was pouring down; the street below seemed unnaturally quiet after the bombings. I could hear the occasional tinkle of a tram bell drifting over from Zielona Street. Incredibly, the ordinary life of the city was still going on. But what was going to happen to us next day, next week, next year? The Germans would surely take the city, and as Jews we must expect vandalism and physical maltreatment. How could we live under such conditions? Yet what alternative did we have? What hope was there of fighting back?

I looked back into the room. My parents sat close together, my mother's hand resting on my father's arm. There were half-empty cups of coffee in front of them, Giza was talking quietly to Hania, our little maid, who was weeping.

I tried to engrave the scene on my memory.

Nearly a week of nerve-racking days went by. At last we thought the artillery fire was becoming less frequent. There was still no sign of the Germans. On 18 September, my father ventured out in search of news. When we heard his returning steps on the stairs we rushed to meet him.

"It's incredible," he said, sitting down heavily and reaching for my mother's hand. "The Germans aren't coming!"

It was hard not to cry out with relief. But he obviously had more to tell us.

"They say the Russians have crossed the border and are on their way here. Germany and Russia are dividing Poland between them."

They had done so three times before — were they really doing it again?

"Do you think it's true?" I asked.

"I certainly hope so. Anything would be better than the Nazis."

"But the *Russians* . . ." I said.

The Russians' single-minded pursuit of government by the people instead of by the ruling classes had shown a singular lack of compassion. They might be as bad as the Germans.

"Never confuse a people with their government," my father said now. "There are 220 million people in Russia — one hundred national groups, twenty-five different languages. The 'Russians' are just an ethnic group representing half the population, although most of the seats of power are in their hands. You can't generalise, my boy. Can't you imagine the differences that exist in background and culture among those millions?"

"Why bother? I *know* about their pogroms against Jews! The European Russians and the Ukrainians have been anti-semitic for generations."

My father spread his hands and silenced my outburst.

"Believe me; anything would be better than the Nazis."

For division of Poland, 1939, see map 1, p. 337.

3

The incredible happened. The Germans did not come to Lvov.

Weak with relief we hungrily gathered every scrap of news we could. They had stopped their advance. They were retreating to the west bank of the river San about sixty kilometres from Lvov. Groups of neighbours gathered in the street to share both news and rumours. Although our army was broken up, things were not as bad as they might have been. Many of our men were hiding in forests; they still had their arms and were forming partisan groups. The Polish Government had fled to Rumania, taking the national gold reserves with them. Large numbers of soldiers had followed them. The news passed from mouth to mouth. People who did not know each other talked together like friends. The question that could not be answered was: what would happen next?

On 22 September, the Red Army entered Lvov unopposed. They reached Kochanowski Street in mid-afternoon, greeted by brilliant sunshine reflected on gold and red autumn leaves.

The first we knew of their arrival was the sudden blaring of loud-speakers from cars touring the streets.

"Stay indoors! Keep all windows closed! Stay indoors!"

The gigantic tanks began to roll through the streets of our city. Gathered together in the kitchen, all doors and windows firmly closed, we strained our ears to hear what was going on outside. We thought we heard sporadic rifle-fire some distance away. As the day wore on it became less and less frequent. We listened to the silence.

A long day dragged by. Exhausted but relieved, we went to bed. When I woke up in the morning my first steps were towards the balcony. I could see on the street below two Russian tanks and groups of people surrounding Russian soldiers. I rushed downstairs.

As I came out into the street the sunlight hit me. Blinking, I saw a Russian officer lolling against the tank. He seemed to be engaged in an animated conversation with a group of women. Ukrainian, both spoken and written, was a compulsory subject in our schools so there was little difficulty of communication. I edged nearer to the group. The conversation had clearly been going on for some time and the atmosphere was easy — so easy that a well-dressed young girl had no hestitation in being pert.

"You've told us about all the things you have in your shops," she said, "but can Russian women buy silk stockings?"

I held my breath as he looked down on her.

"No," he said. His grin was sheepish but had a boyish humour. "But we can come in steel tanks and get them here. That's a better way!"

On 28 September, Molotov, the Russian Foreign Minister, and Ribbentrop, the German Foreign Minister, shook hands, embraced, toasted each other in Russian vodka, and signed the Moscow Pact which divided Poland between them. War had made bedfellows of two countries whose avowed intention had once been to destroy each

other. So much for principles and ideology!

But we had neither the time nor the inclination to consider ethics. We had to adjust to the fact that we, the Poles, a nation of free people, were now under Russian domination — and that was foreign to our character.

The first great surprise was to find how trouble-free it was. The edict went out that all sports clubs should be disbanded. *Dror* may no longer have had an official existence, but the Club members still met and organised games between themselves. Slowly and cautiously the normal life of the city resumed. And after all the drama, Milek and I found ourselves in the same position we had been before our country was taken over. We were still young men without a career in view.

Then Poldek Hecker, one of our heroes from the senior *Dror* team and undoubtedly the most intellectual member of the Club, asked us: "Why don't you both try for admission to the Art Institute?"

Milek and I looked at each other in sudden excitement. For Jews in Poland, art, along with medicine and veterinary science, had been in the *numero nullus* category — no Jew was permitted to join the discipline as a student. It was not so bad with architecture and law, where *numero clausus* applied: this allowed two per cent of students to be Jewish, provided they were segregated and sat on the left-hand side at the back of the lecture hall. Since there were 120,000 Jews in Lvov, one-third of the population, this was one of the most restrictive pieces of Polish legislation.

"The Russians have changed all that," Poldek said. "Surely you knew! The Soviet government has put a stop to anti-semitism. The persecution of any minority group is a punishable offence now."

Milek acted at once. He applied for admission, took the entrance examination and was immediately accepted. I hesitated.

My father, still trying to do his best for me, was negotiating an apprenticeship for me with a firm of Viennese refugees as window-dresser and designer. He knew how much the grace and style of their work appealed to me. When I found they were asking two thousand US dollars (they were not interested in roubles) for three years' tuition, I refused point-blank, although my parents were willing to pay. There was no way in which I could allow them to make such a sacrifice for me. My refusal was selfish rather than noble. Be dependent on my parents for the next three years for food, clothes and pocket-money? It was unthinkable.

By now the Russians had been in Lvov for three months.

"There are still vacancies at the Institute," Milek told me.

"Take the entrance examination," my father said.

"Take it!" Giza urged.

I knew my mother would be pleased with whatever decision I made.

All my life now centred on getting through that examination. Milek had told me what a fabulous time he was having at the Institute, how he enjoyed the work — and the girls!

The examination was in four disciplines: drawing, painting, composition and modelling. Drawing and painting tests took twenty hours each, composition and modelling four. I had no anxiety about drawing and composition, but I had never made clay models and had hardly bothered with watercolours. Milek decided to give me a crash course. Out in the park I was instructed how to paint with watercolours, Seurat-style. Pointillist painting, composed as it is of dots of colour, has no hard edges and is best viewed from a distance. He drummed into me salient instructions.

"Paint with authority." — "Use lots of different colours." — "Leave plenty of highlights."

He made a list of "do's" and "don'ts" and folded the paper concertina-style, so that I could take it into the examination room and consult it unobtrusively. At every break during the four days of examination he or one of his friends would sneak in, inspect what I had done, hiss advice and disappear.

Only seven hours into the twenty we were given for watercolour, I was following his instructions and feeling very pleased with myself, when Milek appeared, took one look at what I had done, and began to moan. "Stop it at once, you've already started to ruin it," he muttered, and was gone before he could be spotted.

I put my brush down. There were still thirteen hours to go. What should I do?

"I don't think I can improve on this," I told the supervisor.

He inspected my work thoughtfully. "You started well. I thought this was going to be outstanding, but you certainly got lost along the way. Have another sheet of paper and try a different treatment, there's plenty of time left."

Time there might be, but I had used up all the painting technique I knew. I spent the rest of the session drawing the still-life.

But what a coach Milek proved to be! When the results came out I had the second highest mark in drawing and painting, and top mark in composition. I was in!

Milek had not exaggerated about the charm of life at the Art Institute. Our time was divided between art, sport and girls. We played for the volleyball and basketball teams, arranging practice to avoid lectures on Marxist philosophy and socialism, which we found decidedly boring. In our spare time we lay around studying art books and discussing the work of artists past and present, and

our own predilections. The first year was given to all areas of the fine arts so that both students and teachers could evaluate where leanings and abilities lay. The girls we were friendly with preferred painting, textile or interior design. Milek and I, with Poldek and Artus, two students with whom we had struck up a friendship, had our sights set on careers in commercial art.

After the first half-year, students with above average marks became eligible for a government scholarship which paid out a weekly sum equivalent to the basic wage. Now I was able to do what I wanted and be paid for it! Every day brought something new to be learned or to be enjoyed. The country might be under Russian domination but I was having the time of my life.

The Institute had a great mixture of students that first year. There were many refugees: Germans who had been running away from the Nazis since 1933, Austrians who had crossed to Poland when Hitler took over their country, and, of course, Jews from both eastern and western Poland. Many idealistic Polish students came from other parts of the country to this newly created "workers' paradise". Lvov was a haven for refugees; by the end of 1939, 150,000 had been absorbed.

The older students at the Institute, nearly all of whom had stopped shaving, as a sign of mourning for Poland, were mostly shocked and unhappy to find such an influx of Jews, but there was nothing they could do about it.

We enjoyed the benefit of the Russians' enlightened attitude. Although the Dean and his deputies were Russian, most of the former professorial staff had been retained. And there were new lecturers for new subjects: "The History of the Communist Party" and "The Marxist Theory of Materialism", but in spite of repeated warnings, their lectures were never well attended.

Drawings and paintings which varied in treatment,

subject matter and size were the main practical subjects in our first year. We would work for a week or more on a pencil or charcoal drawing, then spend a few days on quick sketches in pencil or pen-and-ink.

One day, part-way through a life study of a young man in shorts and singlet holding a mallet in his hands, we were told to get out a fresh sheet of paper as the model was sick and was being replaced. A young woman wearing a long fur coat came into the room, went to the podium and slipped off her coat. She was naked. It was the first time we had faced a nude model. Most of us young men found something wrong with our drawing-boards, papers or pencils. Everything had to be rearranged, drawing pins replaced, pencils resharpened. Glances at the model were quick and covert. The girl students giggled behind their hands. I was embarrassed. It did not seem right to look at her. I was just seventeen and my mother had done everything possible to protect me from all fleshly evil. I was relieved to find that, once I had started to draw, I could look at her just as I would at a bronze or marble statue. Subsequently, when we had nude models to draw or paint, I found that as long as the model was motionless, there was no excitement, but during the breaks, when she put on a dressing-gown, had a cigarette and talked to us, the knowledge that she was naked underneath her gown was pleasantly disturbing.

An exciting and multi-dimensional period of my life began. I can only describe it as a time lived on several levels. There was the Institute and the enjoyment of being an artist, there was plenty of sport and last but not least there were girls.

I first discovered girls at *Dror*. There was a special friend called Rita, a promising gymnast and a fabulous dancer. She was my steady partner at all parties and balls organised by the Club. It was a sad day for both of us when her parents

decided to leave Lvov soon after the Russian occupation. Now, at the Institute, where the female students were in the majority, neither my friends nor I had reasons to complain about lack of companionship from the opposite sex. We had a close circle of friends and invariably we would go in a group. There were many parties, picnics, and the ever popular "five o'clock tea", held at nearly every nightclub on Saturday afternoons.

Life might be fun for me but it was a different story for my parents. Soon after the Russians took over Lvov, they nationalised all the large factories and businesses, denouncing the owners as capitalists or anti-revolutionaries and deporting them with their families to Siberia or Asian Russia. Old grudges and jealousies within the community surfaced and many managers, shopkeepers, and even public servants were denounced as anti-revolutionaries who exploited and persecuted the poor oppressed working-class. Almost every night, month after month, we heard trucks driving along the streets below. As long as they kept on driving, we knew we were safe; but sometimes they stopped and then we began to worry. My mother packed four cases with our clothes and put them next to our beds. Fortunately for us, nobody had a vivid enough imagination to accuse my father of being a capitalist, an anti-Communist or anti anything else. The only thing that happened was that our shop was taken away from us and my father and Willie Lipper were kept on as salesmen in their own business. We thought it a small price to pay for our continuing freedom. Gradually this deportation of capitalists stopped and life became more normal. (By a bizarre twist of fate the great majority of those who were deported survived, while the "lucky" ones who were left in their own homes perished in the Holocaust.)

People find it hard to believe when I tell them that as

a young Jewish student in a country overrun by the Russians, I enjoyed life. Yet the year 1940-41 was full of enjoyment. We often found it hard to believe too.

Since *Dror* was officially disbanded we joined a Russian club *Spartak*, but it was not the same as *Dror* and we soon resigned. But there was no shortage of sport. There were pressures to join the Communist Party or the *Komsomol*, the Communist Youth organisation, but there were no repercussions when we declined.

We soon learned how much the Russians enjoyed celebrating. With the Institute fully under their control, they seized on any reason to hold a ball or dance. We went to them all — and the celebrations often lasted until dawn. I remember with pleasure how the gaieties would spill over into the nearby park, where, if one was lucky, a young couple could find privacy.

Three or four times a year the Institute put on a revue. Milek, Artus, Poldek and I, mad on jazz, formed a vocal group with Poldek on the mandolin and the rest of us strumming chords on toy guitars strung like ukuleles. A Russian ballet teacher from the opera and ballet school spotted Milek and me and we were soon having tap-dancing lessons so that we could add to our repertoire. As the "Four Tigers" (with "Hold that tiger!" as our signature tune), we had a great deal of fun performing at the revues and every dance and party going.

There was not only the social life. The Russians opened an artists' club and made it available to the students. We were able to use the library and attend screenings of special movies. But the best thing about this club was the opportunity it gave us to earn money. Poster-sized portraits of the Communist leaders were always in demand and we did our best to keep that demand supplied. It was a fairly simple operation. We were given linen stretched over a frame and placed on it the drawing

of our chosen subject (the Russians naturally supplied us with a photograph of our man). The drawings had a perforated outline and we used to rub graphite powder into them so that the shape of the face was transferred to the linen. The painting of the face was then done in monochrome sepia, using the photographs as a guide to the modelling of the facial expression. After doing the same face a few times I found I could do it in two hours without having to think about it. Kalinin, with his silver beard and little eyes, was my man.

I worked hard right through the year, determined to get marks high enough to qualify me for a scholarship to take care of my pocket money. I got them. What was more, I was recommended for the graphics faculty. Now I could really go ahead with my plans to become a commercial artist.

My second year at the Institute began with all the promise of pleasure we had known in the first year. We would go out on day-long expeditions to a park or some pleasantly rural spot to do watercolour landscapes. We always took a picnic lunch. It did not take us long to realise that our paintings did not have to be finished out-of-doors! Or that you could start a painting, disappear with a girl for a couple of hours and then come back and add a few more strokes. I used to disappear with Krystyna.

She was a vivacious green-eyed brunette, a year older than me, and very talented. She was half-Ukrainian and half-Polish, which didn't make things easy for her, particularly now that Poland no longer existed and the dream of an independent Ukraine had gone up in smoke. But Krystyna never lost her sense of humour, which showed at its best in the delightful illustrations she made for children's books. She only lived a block away from our flat so we often finished our painting at either her place or

mine, depending on which gave us the best opportunity to be alone together.

I only saw Krystyna once after the Germans came. I can see her face now. I was out on the streets of Lvov, taking the risk, as I often did, of walking around without wearing the hated armband which told the world I was a Jew. Turning a corner, we met face to face. She was on the arm of a tall elegant German officer. She looked more beautiful than ever. Her eyes dropped to my sleeve. Turning her face so that only I could see it, she gave me a wink and a mischievous smile. Good old Krys!

Things were too good to last. The Russian grip began to tighten and discipline at the Institute became steadily enforced. It was no longer possible to skip lectures and take sport instead; students had to give full attention to their lessons, including the boring Communist lectures we had been crafty enough to avoid. Life was not as enjoyable, and there seemed little we could do about it.

There *has* to be something, I thought. Instead of going to some of the boring lectures, I went to one of the medical clinics and complained about chest pains. The following week I went back a second time, then again and again.

"We live in a third-floor flat," I said. "The stairs kill me. There is heart disease in our family —"

They got tired of seeing me. Finally they passed me on to a young Russian doctor who studied my long record of attendance at the clinic carefully and looked me up and down. I was tall and never carried any excess fat because of all the sport I played. It was easy to look thin and tired.

"You need complete rest," he said, his inspection over. He wrote busily, then handed me a note. "Take this to the government department in charge of convalescent homes."

I got there fast.

To my surprise the official who attended to my case was Polish. "Hello!" he said. "How is your father? And is Giza still as pretty?" I did not know him but he obviously knew my family.

"I suppose she is," I said and we exchanged smiles. A trace of a smile remained as he read the doctor's letter and the clinic report.

"My word," he said, "you *are* unwell!" He studied the letter even more carefully. Then he put it aside and looked me straight in the eye. "Four weeks holiday, that's what you need. How would a sanatorium on the Black Sea near Odessa suit you?"

It would, it would! But didn't he know it was April? The sea would be far too cold for swimming now.

"I think I ought to try to finish the school year," I said. "Could I go at the end of term?"

"Certainly. Why not?" He opened the drawer of the desk and brought out some pamphlets which he spread across the desk. "Choose one of the nicest ones," he suggested. I picked up the pamphlet which had a coloured photograph of what looked like an old Italian palace standing on a sun-drenched waterfront overlooking a wide sandy beach.

The Russians had converted beautiful mansions and palaces into hospitals, convalescent homes and rest and recreation centres where the sick could recuperate and workers recommended by their unions for good work could holiday. The Black Sea coast from Batumi to Odessa, with its warm climate, vineyards and orchards was one of the most beautiful spots in the world. Students from all over Russian hoarded every rouble they could in the hope they could holiday there in a private room. Now I was offered four weeks there entirely free!

"I'll make the necessary arrangements for you to go at the end of August," my official said, and shook my hand.

We were both perfectly aware of the game I was playing.

"Thank you very much," I said.

I never saw him again. When August came, I was not soaking up the sun and swimming in the Black Sea. Instead, sweating, dirt-encrusted, sick at heart, I was shovelling rubble under the eyes of German guards. On my sleeve was a white band showing the blue Star of David.

For plan of Lvov, see map 2, p. 338.

4

Few people who were in Lvov that day will ever forget 22 June 1941. The night before we went to bed feeling relatively safe. We woke to find that everything had changed.

I came up from sleep reluctantly; the room was still dark. The flat was quiet, but outside, distant, unfamiliar, yet suddenly frighteningly familiar, there was *noise*. In a second I was wide awake. I knew what it was. Aircraft engines, flying high; the rapid chatter of anti-aircraft guns. I leapt from my bed and went on to our balcony. My parents were already there.

The first rays of the sun were sneaking up from behind distant buildings and pencilling the deep blue sky. Memory turned the clock back two years: the same early hour, the same sounds. As we stood, faces turned towards sky, hardly breathing, we heard the dull thud of an explosion, followed seconds later by another explosion. Giza, half-asleep, joined us. I turned to my father incredulously; shock was mixed with a great upsurge of anger. Silently he nodded his head to my unspoken question.

Yes, we were at war again.

At nine o'clock the news came through on the wireless that the German barbarians (yesterday they had been

good friends!) had made a shock attack across a wide front and were pouring over the border into Russia in strength. The *blitzkrieg* tactics which had proved so successful in Europe were now being turned against yesterday's ally.

I was *furious*. What appalling timing! The treachery was bad enough, but the timing! I sat hunched over the wireless nursing my bad temper. After eighteen months of uninterrupted fun and successful, satisfying study, here I was at the term's end, about to take a holiday with friends before going off for four whole weeks of recuperation in that lovely sanatorium by the Black Sea — and now this! What a rotten piece of luck!

Midday found us down in the cellar as Stukas dive-bombed the city and the sirens wailed. It was the beginning of a miserable time. There were four to seven air-raids every day; we were up and down from the cellar all the time. We all found being cooped up indoors unpleasant and frustrating. As soon as the all-clear sounded we were out on the streets again. Thankfully there was no heavy damage in our immediate neighbourhood. When I went out to look around, I found the familiar snake-like ribbons of arguing, aggressive people queuing outside food shops.

One day after a raid, I was walking out from the cellar with my parents when we were stopped by a Russian officer and two civilians in suits and ties. The light in the entrance hall was dim, and we could not see their faces clearly.

"Marian Pretzel," one of the civilians said. I recognised him at once. He was one of the students in the sculpture faculty.

"Hello!" I greeted him. I did not know him well, just well enough to know that he was active in student political organisations.

"We would like to have a few words with you," he said. The Russian officer said nothing, but for me it was enough that he was there. My mother and father drew together and it hurt me to see how apprehensive they had become.

"It's all right," I told them lightly, though I felt far from easy. "Just go back to the flat. I'll join you in a minute or two."

"Well?" I said, turning towards the men.

"Read this," the student said, handing me a large sheet of paper. If I could not see his face clearly, I certainly could not read the typewritten sheet!

"What's it about?"

"All students at the Institute are being evacuated to Russia," he said harshly. "Be down at the Institute at nine tomorrow morning with your clothes and this form. We are going by truck — the railways have been damaged."

"But —" I said, gesturing towards the stairs to the flat behind me. For a moment or two it was as though my mind ceased to function. . . . Behind him I could see a broken windowpane in our front door. I had never noticed it before. Now I saw with ice-sharp clarity the spot where initial impact had been made on the glass and the intricate beauty of the patterns radiating from it. The patterns filled my mind. Somewhere a voice was talking about duty and obligation to the Soviet Union — about protecting the Socialist system, fighting the Fascists, the persecution of the Jews. I tried to drag my attention away from the broken glass, to listen, but a chill was running through me.

"Nine o'clock tomorrow," the student said.

The Russian shook my hand, apologising for being in a hurry. The student shook my hand. The other civilian, who had not said a word shook my hand as well and I was left holding the sheet of paper which had been served on me.

I stood in a daze. To go to Russia, to leave my parents,

at a time like this? The idea was too big to take in. What would it mean to me if I went? What would it mean to my parents if I left them? Baffled and helpless, I stood holding the paper in my hand.

After a minute or so I took a deep breath, pushed the paper into my pocket and turned to go up to the flat.

My parents were standing at the bottom of the staircase. They had heard every word. They looked as stunned as I felt. My poor mother was leaning against the newel post, her panic-stricken eyes searching for reassurance in my father's face. I put my arm around her shoulders and guided her slowly up the stairs to the flat.

As we had done so often before we sat down at the table. The silence was painful.

"What are you going to do?" my father asked at last.

"I don't know." Never, in all my life, had such trite words been so true.

I knew what life was like in the German-occupied areas of our country; how young Jewish men and girls were being forced to work long hours on a starvation diet in slave-labour camps, and how those too sick to work were shot out of hand. The newsreels had left us in no doubt as to what we could expect.

My father read my mind. "Even if the rumours exaggerate, life under the Nazis is going to be very hard," he said.

It was not only that. What of the future?

"How long do you think it will take the Allies to defeat them?" I said. "Supposing they ever could?"

How did one dare to think that such a thing could be possible? The Germans had taken over Europe, from Norway right down to Greece and Crete. As we sat here Rommel was running circles round the British in North Africa.

"It will take years to overcome them," I said "and all

the time they will be killing Jews. How many of us will be left?''

My mother got up from the table. "I shall make coffee.''

"But what do *you* think?''

She looked from one to the other of us. "I understand little of these things,'' she said. She touched my shoulder as she passed. "It's your life, Marian, you must decide.''

When she came back with the coffee we were no further forward.

"You would have to give them reasons not to go,'' my father said.

I had the best reasons in the world. I could not leave my parents. It was *impossible* for me to leave them. How could I face the weeks, months and years of mental torture knowing that I had left them to face unimaginable difficulties, possibly death, while I went free? If I left now it would be almost as though I were condemning them to death.

"It is all a gamble,'' my mother said, "but if you think you have a better chance to live through the war on the Russian front than to stay here to face the Nazis . . .'' She could not finish the sentence and my kiss stopped her lips from trying to form the words.

"I stay with you,'' I said. I had to go out on the balcony so that she could not see the tears running down my face.

My father came out to join me. He put his arm round my shoulders. "Thank you, you know how much you mean to her . . . and to me.''

He led me back into the room where Mother was sitting with her head in her hands. She lifted her wet face. "At least we'll be together. Whatever happens will happen to all of us.''

It was one of the most traumatic experiences of my life.

Forty-three years have passed but I have never regretted my decision to stay with them.

Three days later we celebrated my birthday. Mother baked a cake and prepared a special lunch. There was only one guest, Emil. The air-raid alerts were too frequent for most of my friends to dare to be away from home, but at least Milek rang to wish me a happy birthday. Giza and Mother were clearing the dishes after lunch, while my father had his afternoon nap.

Emil and I were sitting on the balcony when the quiet of the Saturday afternoon was ripped by the scream of the air-raid sirens. Emil immediately rushed away, clattering down the stairs to his own parents. I went to the kitchen and told Giza to take Mother to the shelter, then I woke my father.

Just as I was heading down the stairs, there was a piercing, whistling noise followed by a tremendous bang overhead. The rush of air threw me against the wall, I lost my balance but got up quickly and kept running downstairs to the shelter. Seconds later, a shower of bricks and debris fell around me. Something hit me on the arm but I ignored it; all I could worry about was getting downstairs as quickly as possible. Before I reached the ground floor I caught up with my mother and Giza. Bricks and pieces of timber were still falling amid clouds of dust. By the time we entered the shelter it was peaceful again, except for the sound of distant planes and guns. Then my father walked in. He was obviously shaken up; even in the dim light I could see how pale he looked. He shrugged his shoulders and said:

"Oh well, we might not have a roof over our heads any more, but at least the walls and ceilings are still there." Even in this serious situation, he could not resist a joke,

with his inimitably dry sense of humour.

Later we found out what had happened. A high-explosive bomb had hit the top of our roof, demolishing it, then landed in the square about two hundred metres away, *without exploding*.

My life has been a long chain of fortuitous events; this was the first of the links. I have never ceased to marvel at the incredible luck I have had and the coincidences, almost beyond comprehension, which have contributed towards it.

It soon became clear that the German attack had taken the Russians by surprise and that they were abandoning Lvov. They got out amid signs of panic and total lack of organisation. Trucks thundered over the cobbles carrying local Communists and their sympathisers as well as Jews who could not face the Germans. Emil was among them. Ukrainian extremists fired down on the Russian convoys from the roofs. I watched the convoys pass, truck after truck, filled with young people, some of whom I knew, and grim-faced Russian soldiers. The stench of petrol and the revving of impatient engines on that desperate day are hard to forget.

On Monday 30 June 1941, the Germans entered Lvov. They came in arrogantly; they did not sneak in, peering around corners with machine-guns at the ready as the Russians had. The unthinkable, which had occupied our minds for so long, had happened at last.

The moment the German army marched into Lvov, thousands of young, as well as not so young Ukrainian nationalists and opportunists put on a blue-and-yellow armband with a *"Trizub"*, their national emblem. They formed "Militia" and, being given a free hand by the Germans, started looting Jewish shops and homes, and bashing Jews wherever they could find them. They abused the authority they had been given, and became drunk with power.

There were 120,000 Ukrainians in Lvov. Deeply religious, extremely nationalistic, they knew how to hate; their history had taught them little else.

The history of the Ukraine goes back to the ninth century, when the state of Kiev was formed. From then until our own time it was the bone over which Polish and Russian armies fought. In 1917, towards the end of the First World War, an independent government was set up, with Kiev as its capital. Four years later, the Soviet rulers restored their control. Then, as has been the lot of the Jews down the centuries, particularly during times of stress, our people became the scapegoat. The pogroms conducted by the Ukrainians razed Jewish homes to the ground and the slaughter of women and children swelled the great wave of Jewish immigrants to the USA at the end of the nineteenth century and the early years of the twentieth. Now the Germans were promising a Ukrainian independent republic under their protection. It might or might not come into being, but it paid the Ukrainians to assist the Germans — just in case, and, since German hatred of the Jews was well known, what else could we expect but harsh treatment from any Ukrainian we might be unfortunate enough to encounter.

We stayed indoors and wondered when the first blow would fall. We did not have long to wait.

Early on Wednesday morning, while the night was still black, we were awakened by a pounding at the flat door.

"Open up! Open up!" The shouts which accompanied the pounding were angry.

I stumbled from my bed to the living-room. My parents and Giza were already there, fear written all over their faces. It seemed the door must break down any minute.

"It's all right," my father told us. "Stay where you are."

We watched him walk slowly towards the door. With

his hand on the knob he turned. "There is nothing to worry about."

A Ukrainian militiaman and two young aides pushed their way past my father and with peremptory gestures drove us into the dining-room.

"Passports!" the Ukrainian demanded.

We were too dazed to do other than stare at him.

"Hurry up!" one of the aides shouted. "Get your passports!" Father was first to make a move. Mother, Giza and I huddled together. My mother, fast asleep only a moment ago, was now wide awake. Her eyes dark with panic, she placed herself between Giza and me and the Ukrainians. We crowded in close, holding on to each other, watching every move. Giza and Mother were terribly conscious they were barefoot and wearing only night-clothes.

"Get your passports," Father said quietly to Giza and me as he went to the bedroom to get his and Mother's document.

We handed them over. The Ukrainian studied my parents' passport carefully, then consulted a piece of paper he drew from his pocket.

"Stanislaw Pretzel?"

"Yes."

"And this is your family?"

"Yes."

"Does anyone else live here?"

"No."

Our interrogator jerked his head towards one of the aides. We heard him going into each of the rooms and moving things about. The Ukrainian checked each passport photograph, staring at it then at each one of us in turn. The aide came back into the room, spread his hands and shook his head.

"Wait outside," the Ukrainian told his assistants.

When the aides had gone he put our passports back on the table. His eyes never left my father's face. He leaned forward and said softly. "Go to bed. Don't worry. You'll be all right."

We could only stare at him, bewildered and speechless. Then he was gone. We heard his feet clattering down the stairs.

Giza gave a small cry and burst into tears. Weak with relief, we embraced each other. The minutes since we had been awakened from sleep seemed as long as a lifetime. I had never admired my father more; his calmness and fortitude had enabled us to hold together.

Now noises of which I had been but half-aware claimed our attention. Trembling from tension we stumbled over to the windows and looked down into the street. It was still fairly dark but the rays of the rising sun made golden silhouettes of the buildings. There were army trucks on both sides of the road and people were milling about everywhere. The sound of running feet, screams, the barking of harsh orders by Ukrainian police came up to us. We saw the lifted long truncheons and hovering figures being forced towards the army trucks. We watched as the trucks were filled and heard the motors start one by one. Then the convoy slowly moved off. The only sign of this first tragic *aktion* were groups of women crying: mothers, daughters, sisters and wives of the men taken away. We could hear them calling out desperate questions. "Why? Where are they taking them?" There was no answer. Finally, with their arms around each other, they silently returned to their homes. Soon there was only an empty street with the sun shining down, clear, golden and serene above the roof-tops. A new day began. For many Jews in Lvov, it was their last.

We had been miraculously lucky. That morning the Ukrainian militia took over six thousand Jews from our

part of the city; they were sent to two different prisons and ordered to bury the bodies of thousands of anti-Communist Ukrainians the Russians had murdered before they withdrew. Afterwards they were tortured and finally killed. Six men from our building were among them.

How was it we were spared?

We learned that Stefan Horniak, a greengrocer who had his shop opposite our flat, had used his influence in the revolutionary Ukrainian community to see that no harm came to our family. In fact, he had waited outside our home to make sure of it. My father had always helped him with his taxation and legal problems. When my father attempted to thank him, he smilingly brushed the thanks aside. "Just repaying my debts," he said.

For diagram of 1941 German offensive, see map 3, p. 339.

52

5

We were very aware that the German Army had occupied our city. Every fence, every wall, even telegraph poles and lamp-posts became official notice-boards. Each day new regulations were announced. The red-and-black posters displaying the German eagle and swastika were plastered all over the streets. *"Achtung!"* the bold letters declared. We read it everywhere. Each poster carried in small letters the final demand. *"Heil Hitler!"*

All men and women with German blood were invited to register as *"Volksdeutche"*. It was amazing how quickly great numbers of Poles, and even Ukrainians discovered that they had German ancestors and so were eligible to be regarded as ethnic Germans, and receive food cards entitling them to better rations — particularly white bread. They could also claim preferential treatment when applying for jobs, and were able to take over Jewish properties and flats. Some of them could not even say "yes" or "no" in German, but that did not worry the authorities. They knew that once the white bread was accepted the recipient could be called into the German Army or used in any other way to aid the Nazi war effort. The stupid and the greedy had not realised that.

Loyal Poles looked upon the *Volksdeutche* as traitors. Except for my mother, we were all forced to work for the Germans. Father became a cleaner at the army barracks, I was given labouring jobs, and Giza had to do hospital work.

By design as well as a lot of luck, Milek and I managed to work together. We became bricklayers' assistants for a building contractor who was repairing army barracks. We cleared debris, mixed cement and lime, unloaded truckloads of bricks, assisted three bricklayers so that they were never short of anything they required for the job, and cleared up when the work was finished. It was hard going and the food provided was poor, but the Polish bricklayers were sympathetic and helpful, often getting extra food and cigarettes for us from the canteen. Occasionally a German soldier would call us over and give us some bread or offer us a cigarette or two. It amazed us to find how deep our gratitude could be for a few spoonfuls of soup and a few puffs of cigarette smoke. Milek and I shared everything. Things we were able to buy, things we were given, things we stole. We relied on each other completely.

Our next job was with a landscape gardening firm which had been commissioned by the local authority to make a park in the centre of the city. Bombed buildings had been demolished and we had to level the ground, spread tons of topsoil and prepare the area for lawns and footpaths and the planting of trees and shrubs. The twenty or so young men who had been working there for a few weeks were able to give us valuable advice. They told us which of the foremen had to be watched, which one could be bribed and provide an easier job, and how to escape digging by being sent to another part of the city with a message. We now had to provide our own food, and we were delighted to find that we could get a good stew with

plenty of meat, potatoes and bread at a small restaurant which had been set up in a private house nearby. We went there at least three times a week, looking forward to the treat all morning and wishing we could afford the luxury every day.

One Sunday I was raving about this stew to a group of friends when one of them burst out laughing. "You like horsemeat, then?" he said. We never went to the restaurant again. Looking back, it was a foolish decision to have made, but the year was 1942 and we had not yet undergone the experiences which were to harden both our feelings and our tastes.

One day while Milek and I were working with shovels and wheelbarrows close to a footpath, a smartly dressed man without an armband suddenly stopped as he passed us and called me over. It was Salek Meissner, our basketball coach from *Dror*! He was as Jewish as we were, yet here he was, wearing good clothes, looking well-fed and with a confident, almost cocky manner. We were as amazed by his appearance as he was sorry to see the state we were in. We exchanged greetings and hopes that before long we would meet again under happier circumstances. When Milek saw who it was he joined us; we both stood and watched with envy as Meissner walked away.

Three days later he was back.

"Come to my flat after work, I want to talk to you," he said. "Here is my address." He gave Milek a slip of paper and was gone before anyone else noticed him.

All day we were excited and puzzled. How was he getting away with things? What did he want with us? We could not get to his flat quickly enough.

He let us in and led us to a large, pleasant room where a round table was loaded with dishes of ham, cheese,

salamis, bread rolls — and bottles. We had not seen so much food for months.

"Have a vodka," he said, pouring us a drink. "Help yourselves. Don't be shy. This is German food. I have not paid for it!"

We didn't need telling twice. It was marvellous to be able to stuff ourselves with such delicious luxuries.

"You didn't just ask us here to feed us, did you?" I asked when at last we were sitting comfortable and replete and more at peace with the world than we had been for a very long time.

"No," he said. "I have something in mind for you two. Now, listen carefully. I deal on the black market. I have documents that show that I am a *Volksdeutche*, and my friend Otto and I travel on German trains and use German hotels. We buy things in one country, then take them across the border to sell them. Always different goods and different places. Otto's mother-tongue is German; his papers make him a *Reichsdeutche*. You remember Otto Feuereisen from Bielsko?"

I nodded. Although the name was familiar, I had never met Otto. I knew that he was an excellent all-round sportsman, one of the best water-polo players in pre-war Poland.

"We need many German travelling documents and many different identification papers so that we can move around freely. That's where you come in. You are both good artists, you studied at the Art Institute. It shouldn't be difficult for you to.do some forging. We will supply the documents; all you have to do is to find a way to put a stamp on them. That's all."

Milek gave me an incredulous look. I shrugged my shoulders as though to say, "The man is nuts!"

Salek picked me up instantly. "Don't tell me it's impossible. Otto told me that already, but I think you can

do it. I have confidence in your ability and intelligence. I am sure that between you, you could do it!'' He produced a typewritten, stamped document and laid it on the table before us. "Take a good look at the stamp."

It was round, with a thick circle surrounding a stylised German eagle. The word *Dienststelle* was at the top of the stamp and *Feldpostnummer 1017* appeared at the bottom. The lettering was in the old German style.

"But this is dangerous," Milek said.

Salek looked at him with a cheeky smile on his face as he answered: "Certainly not more dangerous than what you two are doing now, and much more fun." This simple answer had much more profound significance than I realised at the time. It was to come back to me time and again.

"Here are six more papers," Meissner went on. All they need is the stamp to authorise them. I'll leave them with you. I have to go away tomorrow, but I'll be back in about ten days. By then I am sure you will have solved the problem."

You did not argue with Salek Meissner. He was like a rugby front-row player, bulldozing everything which stood in his path.

"Now let's have another drink, and then I want to hear what has happened to your families and to other friends we knew at *Dror*."

Back on the street I burst out laughing.

"That suggestion wasn't funny," Milek said bleakly.

"It wasn't a suggestion. It was a challenge."

"And you are laughing because you have the solution already?"

"I am one step ahead," I said. "I am thinking of all the other things we can do when we solve the problem. Just

think of all the food cards we could get!" I deliberately used the word "when" instead of "if". It always pays to think positively.

We thought and talked of nothing else for the next three days. On Saturday after work Milek came to my place so that we could work on the project over the weekend. When he arrived he proudly produced an old rubber stamp and pad and a half-full bottle of stamp ink.

"Look what I found!" he said. "Do you think they'll be any use?"

The oblong stamp read: *Max Sigal. Tailor. Kazimierzowska 24. Telefon: 18284.*

"Father will never miss them. Wasn't it luck?"

I could see little resemblance to the German eagle surrounded by Gothic lettering but there was no need to hurt his feelings. "They're sure to come in handy," I said.

It was obvious that my parents would wonder why we were closeted together for so long. I did not want to tell them what we were doing, as I thought it might only increase their anxieties. So I told them that Salek had asked us to design a sales brochure, and made sketches and lists of suggestions which I left around for them to see.

We did not know where to start. We had never really looked at the stamps on documents, although we had seen plenty over the years. It is like the dollar note: as long as it looks familiar nobody takes any real notice of it; you just put it in a wallet or your pocket without giving it a second glance. Now we became aware of how many different sizes, shapes and designs stamps could have; how many colours they came in, how they might look clear, illegible or smudged. Above all, we realised that in general, provided a document had an official looking stamp, it would be accepted. Few people would know what the stamp should look like anyway.

But for a forger it is a tremendous challenge to try to

make a copy as perfectly as possible, even though he knows that most probably nobody will check it, or compare it with the original.

We were not just trying to find a way to make one stamp, we had to find a simple, easy method which would enable us to make a number of them in quick succession. After much thought we worked out a possible technique. The stamp had to be an imprint not unlike an etching, a print rather than a drawing. First I would trace the original stamp, using fine tracing paper and soft pencil, and transfer the tracing to either linoleum, card or paper; then, using a fine pen — the type used by cartographers — rubber-stamp ink and a compass to ensure perfection in inking the circle, I would ink in the tracing as accurately as possible. The drawing would then be used as if it were a stamp and pressed on the document while the ink was still damp.

Experimenting with Milek's rubber stamp, pad and ink, we found that we could make three reasonably good impressions from one pressure of the stamp on the inked pad and two more that were pale and not sharp enough. We had often seen genuine stamps that looked much the same. It seemed that stamp ink would be ideal for our purpose.

We had great hopes of linoleum as it was easy to obtain, had a smooth, non-absorbent surface and could be washed and used again. But after experimenting there was only one conclusion — forget it! Linoleum proved too hard and thick to make the impressions, and unless the tracing was done in pure white it was difficult to see it.

The heavy tracing-paper used by draughtsmen and architects was soft and light in colour and weight, though the absorbency was not as good as we would have liked.

I pressed the drawing I had made on to a piece of paper.

"I think this might be it!" I said with satisfaction.

I pressed it twice more. Milek picked the paper up and studied it. I looked at him, anticipating a smile of approval. It did not come. Instead he slowly shook his head. "No, Marian, it's no bloody good!"

I could have hit him, but he was right. After making the first impression the paper stretched, the round stamp starting to become oval and the straight lines curved. Each impression made the distortion more pronounced. That was no good; we had to find something thicker.

Magazine covers were a possibility, but the paper varied in quality and it was impossible to tell if it would be suitable just by looking at it; we had to do it the hard way by fully testing each cover. We tried out every single one we could get our hands on; none of them were of any real use. By now, solving the problem had become an obsession. We ran out of paper and cardboard, everything we thought possible proved otherwise.

Dejected, I began to draw idly on the back of an old photograph.

"Milek!" I said in sudden excitement. "Look here!"

The ink sat smoothly. The bromide paper was firm without being too thick. I transferred the tracing, inked in the drawing, then, with hearts in mouths, we pressed the drawing against a sheet of paper. We thought we had our solution at last! Before getting over-excited we tried again and again. Fortunately, I had an ample supply of old snapshots; they were all perfect for our purpose.

We thumped each other on the back. There was still one drawback. The paper had a low absorbency and we had to wait a long time before the ink dried sufficiently for us to be able to make the first impression. Blotting-paper was practically unobtainable nowadays. There must be a way to reduce the amount of ink.

"Try newspaper," Milek suggested. After experimenting with different techniques we finally found that by

blotting very gently and with care, newspaper absorbed just the right amount of ink, leaving enough for us to start working at once. When the stamp was laid on the document we stroked the back of the paper lightly to make the impression. The back of a common comb proved perfect for the job.

We were all set to become forgers!

Materials were easily acquired and equipment was inconspicuous: a less sinister collection of tools would be hard to find. It took about ten minutes to complete one stamp.

"Now you can smile," said Milek with the widest grin I have ever seen.

Later in the week we made copies of the stamp Salek needed. It was a Leave Pass (*Urlaubschein*). We printed it on the typed documents he had given us. The first one was too thick and the stamp was smudged, and the last one was too pale. But the final result was most satisfactory; four good stamps on the documents.

It seemed an age before Salek came back to Lvov and we could proudly present our invention for his approval.

"Faultless!" he said. "The original looks more like a forgery than your copies!"

He gave us money, cigarettes, chocolates and delicacies we had almost forgotten existed. He could not praise us enough. But the reward which pleased us most was knowing that we had been able to find a way to do it.

I learned from Salek about all the different documents required for use as travel papers and he advised me to get in touch with Michael Koeller, our coach at *Dror*.

"He might be able to get you a Polish passport and birth certificate," Salek said. "All you'll have to do is to change the photograph on the passport and adjust the stamp."

A few weeks earlier that would have seemed an impossible task; now it presented no problem. Within a fortnight

I could produce proof that I was "Marian Smolinski", Polish, born in Tarnopol in 1921. I had aged by a year.

I put this birth certificate and passport into an envelope and gave it to Milek for safekeeping. There was always a strong possibility of my mother finding them and again, I did not want to add to my parents' concern by keeping them at home; they had endured so much in the last thirteen months.

A few days before my twentieth birthday, one unforgettable Friday afternoon in June, all the workers at the "park" where Milek and I worked were assembled and advised by the manager that our work was finished. Only four men were needed to maintain and water the area. The rest of us were given a piece of paper with an address where we were to report immediately to get details of our new jobs.

Milek was to report to the Department of Supply, while I was going to work for the Agricultural Division of Civil Administration. No amount of pleading on our part could make the manager change his mind.

"The decision has been made on a much higher level, and there is nothing I can do about it," he said. His sympathetic voice did not dissipate our bitter disappointment at being separated.

Compared to the work some of our friends were doing, ours had been a "good job", in open air and without armed guards watching and abusing us. Now, looking at this huge area that only three months ago had been demolished blocks of flats, we admired the new paths we had made and the trees and shrubs we had planted. By next spring, with the grass grown and flowers blooming, this would become a lovely place in which to stroll or sit and relax, watching little children playing. It made me sad to think that no Jewish children would be allowed to enjoy it.

On the way home I called at the Civil Administration

Office. There was a queue outside an office, or rather a cubicle with a small window. When my turn came, I handed in my piece of paper; in exchange, without a word, I was given a sheet of typewritten instructions and a crude map. Once on the street I started to read it. The more I read the greater the shock became. I was to report on Monday morning to a farm in Wilniczka, some fifteen kilometres outside Lvov, where I would stay until Saturday noon, when I would be allowed to go home, returning the following Monday at eight. According to the information, it should take about two hours to get there from the centre of the city, with another thirty minutes from my home. There were no details about the work itself. The notice ended with a warning of serious consequences if I failed to appear on Monday. It sounded like the dreaded labour camp.

My thoughts turned to my parents. They would be devastated. How was I to tell them? How could I make it sound less horrific? I slowed down, trying to work out how to break the news. Then, turning the corner into Kochanowski Street, I ran into Giza. She was distressed and crying.

"What happened? Why are you crying?"

"They're taking all our furniture, the grand piano is gone, so are the books and paintings — they are taking everything! I can't bear to watch it. I just can't bear it!"

"Where are you going?"

"To Karol."

"How are Mother and Father?"

"Mother is all right, Father is in a state of shock." She hurried away to her boyfriend, and as I went along the street I saw two trucks outside our flat. I waited until they left, then went in. Giza was right. My father was standing at the balcony door, his head resting on his chest, tears running down his face as he stared hopelessly at the floor.

My mother indicated to me that I should talk to him. All I could do was to put my hand on his arm and say: "I'm sorry, Father." What could one say to a man who has just witnessed all the tangible results of his life's work being stolen in front of his eyes, in particular the grand piano which was to be Giza's wedding present?

"It's all gone," he said. "How long did it take them? Thirty or forty minutes, that's all." My mother walked up and put her arm around both of us. "What difference does it make how long it took?" she said. "It's all gone . . . but at least we are still together, and with God's help we'll be able to get even better things one day." It sounded good, but I had my doubts whether any of us really believed it. We stood there in silence, until Mother turned towards the kitchen. "I'd better go back and finish cooking dinner. I'm trying to make something special."

I waited for a little while to see whether my father wanted to talk to me then went to my room and lay down to think. I found myself falling into a deep depression. "I have to snap out of it," I told myself and jumped up again. I showered and changed for Friday dinner.

I had to admit that it could have been worse; at least we were allowed to remain in the flat. Most of the Jewish families living in this predominantly Christian area had had their flats taken over by Ukrainians and Poles. They were given twenty-four hours to gather together what belongings they could before being forced to move into the Jewish sector of the city, which would eventually become the Ghetto. We were allowed to stay because the bomb which had hit our roof without exploding had left holes in our ceiling and the rain came in. When officials came to look at the flat, my mother always pointed out the jugs, buckets and large dishes on the floor of every room which we kept full of water. We made certain that our residence was not desirable.

Giza did not stay long at Karol's place. She came back to the flat very quietly and helped my mother to lay the table.

Just before we sat to dinner, I broke the news about my new job, playing down my own feelings of anxiety and apprehension as much as I could. Traditionally, Mother lit the candles and said a prayer. This time the prayer lasted considerably longer, frequently interrupted with gentle sobbing. There was an atmosphere of sadness around the table as we ate our dinner, each absorbed in our own thoughts.

Giza broke the silence. "So this is the last Friday dinner we'll be having together — for a little while, at least . . ."

"But I'll be coming home every Saturday, and I'll stay till Monday," I said as cheerfully as I could.

My father looked at me; "Is Milek going to work there as well?"

"No. Unfortunately he's got another job. I don't know yet what or where it is."

"That's a shame. You'll miss each other."

I shrugged. There was nothing I could say.

As soon as dinner had finished, Father got up, slowly walked to the bedroom and closed the door behind him.

"I've never seen your father like this. It's not only the loss of the furniture that breaks his heart. Giza's getting married soon, then moving in with Karol's parents — the news that you are to work in Wilniczka must be the last straw. He's not used to being in a situation where he's completely helpless. His whole world is disintegrating around him, and all he can do is watch. I am very worried about him."

Mother and Giza started to clear the table and I went out on to the balcony. The memory of that Friday night breaks my heart every time I think about it.

The following day I went to see Milek. His job was in

a large Wehrmacht warehouse, quite close to where he lived. What the actual work was he hadn't been told. We promised each other to meet every Sunday morning and try to get Artus and Poldek to join us.

By now it was no use hoping, as my parents and many other Jews had done, that bad times were just a settling-in period for the Germans and that things would gradually improve. For all that, I knew that my parents would try to persuade me against any desperate measures such as using forged papers or trying to run away. The less they knew about my activities the more easily they could sleep.

Monday morning arrived. I woke up at four-thirty and by the time I was dressed my breakfast was waiting for me and the sun was throwing an orange glow on the buildings on the opposite side of the street.

My mother made me a cloth bag to carry a change of underwear and a spare shirt. Once again gloom dominated the scene. Finally, it was time for me to go. Giza, half-asleep, came out to give me a goodbye kiss and wish me good luck. My parents followed me to the door.

"Goodbye, see you on Saturday," I said with a heavy heart.

"Goodbye! Look after yourself, my love," my mother answered.

My father walked out to the landing. "God bless you! Goodbye son!" he called after me.

I looked back and threw them a kiss. This became a traditional farewell, repeated every Monday after my weekend visits.

During my long walk to Wilniczka, depression and sadness were slowly dissolved by the bright warm sunshine, changing to anticipation and curiosity about what lay ahead. What kind of work would I do? Who would I work with? It wasn't very long before I found out.

6

The farm at Wilniczka was part of a big estate; there were
about sixty cows and two ferocious bulls, an orchard and
the produce farm, where I worked. All the crops and milk
were sent to a civil administration centre in Lvov. The
manager of the farm was German but the men in charge
of the different activities were Poles. Most of them had
worked at the farm for many years. Each had a number
of Jewish workers under his control. There were seventeen
of us, and we were all totally ignorant of every aspect of
agriculture.

I was put in charge of hundreds of tomato plants. I had
never liked tomatoes — my mother was always pleading
with me not to take them out of the salads she made; now
I was only too happy to supplement my meagre diet by
eating them, secretly and hurriedly. I had to see that the
tomato patches were kept watered and weeded and that
the stakes were strong enough for the vines. I was in
charge of the cabbages as well, but they did not require
as much attention.

Although the days were twelve hours long, the work
was not too heavy. But at nightfall, after a bowl of potato
and barley soup and a slice of bread, we were glad to lie

down on the straw-covered floor of the barn. Physical fatigue helped us to accept sleeping crammed together and to ignore the body odours which mingled with the smell of manure and cattle feed.

Gentle slopes freckled with large trees lay to the east of the farm and a high hill covered with forest to the west. I often wished the hill was on the east instead so that it would block the early morning sun which sneaked through the wide gaps in the timber walls and woke me up far too soon.

There were only four new Jewish workers besides myself. We all brought spare clothing, but we soon learned this was a waste of good shirts, underwear and socks, because the local workers used to come to the barn while we were in the fields and help themselves to whatever they wanted. The only alternative was to wear the same clothes for the whole week.

Each Saturday afternoon we were allowed to go home; we had to be back again early on Monday morning. I worked at the farm for over two months, but we were all too busy during the day and too tired at night for friendships to be formed. We walked the fifteen kilometres home each weekend in small groups; our talk was mostly of our families and our fears for the future. Curiously, I do not remember even one of my fellow workers with any clarity.

One Saturday, I was held back to load a truck with tomatoes. Stefan Krol, the middle-aged Pole in charge of the dairy, saw me as I set out for home by myself. I had never had any dealings with him, though I was familiar with his friendly smile and knew how often he would leave out fresh milk or even cheese and butter for his men. He lived on the outskirts of Lvov and usually went home each day in a cart belonging to one of the local farmers.

Today, like me, he had had to work late and had missed

his usual lift. "We might as well go together," he suggested.

We could hardly walk the distance in silence, and though conversation started slowly it was friendly. He asked me about my family and what I had been doing before the Germans came. When I told him I had been at the Art Institute, I could see that he wanted to say something but was holding back. At last he said in a quiet voice, "I like to paint, too."

At once our polite, stilted exchanges became more animated. He had no formal education but obviously knew a good deal about art. It was a long time since I had enjoyed a conversation so much and the time passed very quickly. When we reached the corner of the street where he lived he said: "Come and have a glass of lemonade and I'll show you some of my paintings."

He lived alone; his wife had died and his only daughter was married and lived in Lvov. The flat was clean, neat and austere, quite without a woman's touch. On the walls, in between his own watercolours, some framed, some tacked up with drawing-pins, were colour reproductions of religious paintings. I had never realised there were so many versions of the Madonna and Child or the Crucifixion of Christ.

Proudly Krol pointed to a large round colour print in a gilded frame. "That's Botticelli's *Madonna of the Lilies*. It was painted more than four hundred years ago." He stepped back and looked at it with great affection. "It's my favourite."

I examined his own paintings while he busied himself in the kitchen cutting bread and cheese and making the lemonade. They were surprisingly good, though his drawing needed more care; it looked as though he was casual with forms because he was anxious to start painting. His still-lifes were his best work. I stayed for over an hour, and as

I thanked him for the food and the privilege of being shown his work, he shook my hand and said with deep compassion: "It's a bloody shame what those Nazi bastards are doing to your people."

As soon as I arrived home my mother gave a big sigh of relief. "You're late today. Any trouble?"

"No trouble." I told my parents about Mr Krol and his paintings, then I gave my father his address. "You never know, he could be of help if you ever needed to get in touch with me urgently."

That Sunday was one of those wet days that drag on endlessly. It was even too wet for me to go and see Milek.

Two weeks later Giza and Karol were married. They had been going out together for the last three years. Karol was a bookkeeper; to use a derogatory expression, a typical pen-pusher. Sport had no part in his life, something I just could not understand. He was big and heavy, both physically and mentally. His mother from his early boyhood had him tied to her apron strings, and he had grown up without a trace of initiative or any sense of humour. When he came to our flat to see Giza he would completely ignore me; I was just the kid brother. But I really grew to dislike Karol when I discovered he was allowing Giza to come home alone on the tram after they had been out together, no matter how late it might be, and in spite of the fact that Jews were frequently being bashed in the streets at night. Fortunately nothing ever happened to her, but it was no thanks to Karol. I could never forgive him for this cowardly behaviour.

Giza and Karol were married in a very small ceremony with only the two sets of parents, myself and Karol's brother David present. It could not be described as a happy event, and I never really understood why it happened. I am sure my mother's tears were not tears of joy as she watched her only daughter being married.

70

Without a place of their own, Giza and Karol were crowded into the flat where Karol's family lived. His father, a small feeble man, was completely dominated by his wife, who was notorious for interfering in her children's lives.

We missed Giza.

Weeks passed. As usual, every Monday I found my breakfast waiting for me. A small packet of sandwiches and some tobacco were placed beside my plate. None of us was very talkative at that early hour. I ate quickly, then kissed Mother goodbye.

"See you both on Saturday! Thanks for the cakes, Mother. Bye, Father." As they had done so many times before, they followed me to the landing, waving to me. Halfway down the stairs I turned, threw them a kiss and was gone.

The first light spread across the sky as I started my long walk back to the farm. Needles of light drizzle were reflected from the street lamps or occasional car headlights. Before long, a gentle breeze sprang up, dispersing the clouds and allowing the rising sun to dry the wet roads. By the time I reached Wilniczka, the morning brought promise of a perfect summer day.

There was no warning that our weekly leave home would be stopped. The next Saturday, when we were not allowed to leave the farm, we started to worry. It was Wednesday the following week when Mr Krol came to find me as I worked among the tomatoes.

"Your father gave me this letter and parcel for you," he said.

The letter was brief: *Things are very bad now. Tomorrow we are going to hide out with a Ukrainian family called Greszko. Here is their address. We will leave your clothing and everything else of yours with them for safekeeping. God be with you. All our love.* They had both signed the letter.

71

Reading between the lines, I felt that they doubted whether they would ever see me again. To me there was no doubt about it. It was a goodbye letter. The parcel contained a piece of bread, salami, cheese and some tobacco and cigarette papers. I was stunned. I could not think. I sat on the ground, shaking.

"Bad news?" Krol asked.

"The worst." I looked up at him and pleaded: "I would like to be alone, Mr Krol. Thanks for bringing the letter and parcel."

For twelve days we waited hoping to hear the news that we could go home once again. Conditions in the barn became absolutely unbearable. Lice crawled from one man to another, and constant scratching resulted in sores and open wounds.

After eighteen days we were at last allowed to go home. We were a sorry looking bunch of men, but the way we looked was nothing compared to the way we felt. We had heard that a vicious *aktion* had taken place in Lvov. Three weeks ago we had families — parents, wives, children. How many would be waiting to welcome us.

As I turned into Kochanowski Street I tried to run.

I passed the blank-faced houses which told me nothing . . . 33, 35, 37 and there it was: number 45. My heart lurched and my legs almost gave way under me. Three floors up, above the balcony of our flat reared the glossy green foliage of some exotic pot-plants. We didn't have such plants; my mother, struggling to scrape together money for food, could not possibly afford them. I drew in my breath in a gasp of fear. I do not know how long I stood there staring, until, mindless of the pain of my sore and bleeding feet, I gave a despairing cry and began to run towards the house. . . .

I raced up the three flights of stairs, taking giant strides. The building was unnaturally quiet; every door I passed was closed.

The door to our flat looked so blessedly ordinary and familiar that for a moment I could have believed that nothing was wrong. Then I saw the tell-tale marks around the lock.

I knocked at the door, but there was no sound from inside. I shouted and beat against the wood with my fists to no avail.

Where were my parents?

I became aware that the door of the next-door flat was slowly edging open and caught a glimpse of the frightened faces of our Polish neighbour's young sons, Jasio and Tadek.

"Marian?" Jasio quavered.

I rushed to their door and pushed it wide open. "What happened? Where are they?"

The boy flinched and I knew at once the news was bad. I turned to his younger brother. "Tadek?"

"The Germans took them," he said miserably.

I had long known that it might happen, yet now I could not accept that it had. "But they were hiding out with the Greszkos!"

The boy shook his head. "The Greszkos got frightened and made them come back home." He looked up into my face. "I saw them get into the truck," he said. Poor kids; they were only fifteen and thirteen; they should not have had to break such news.

"They had only been back about two days," Tadek went on. "Two SS men with pistols and two Ukrainian policemen with truncheons came banging on all the doors, shouting that we had to come out and produce our papers. They came early in the morning like they always do. Your mother and father wouldn't come out. It didn't do any

good though. The SS knew they were in there. I heard one of the policemen say: 'That's where the janitor says the Jews are', and they just went in and got them. They were hiding in that wardrobe in the hall.''

"Then what?"

"They dragged them out and started pushing them down the stairs. They hit your father with a truncheon when he tried to help your mother."

"Did they . . ."

"They didn't hit her," Tadek said quickly.

"Thank God for that," I whispered.

"We watched them being loaded into the lorry from our window. There were a lot of other people in it. They took Mrs Sperber from the first floor."

"When?"

"I know," said Jasio, suddenly finding his voice. "I heard my mother say, 'We'll certainly never forget the sixteenth of August'."

I had missed them by nine days.

"There are new people in your flat." Jasio was eager to talk now. "They came the very next day with all their plants and things. They told my mother they were from the other side of town and that the superintendent gave them permission to move in. Their name is Prutski. The janitor's wife is Mrs Prutski's sister. They kept all your furniture."

What did it matter, I thought. There was little enough left. But how could people behave this way?

Suddenly I remembered my sister. "Giza," I said. "Have you seen Giza?"

"She came here on the second day of the *aktion*. She said her husband's parents had already been taken away. I think she has gone into hiding." Jasio put out his hand to draw me into the flat. "Come and sit down. I'll make you a cool drink."

74

I shook my head. "No. Thanks all the same."

I kept looking at the closed door. There was unmistakable evidence of it being broken down. I can see it even now, with those tell-tale marks, as I must have seen it on that fateful day. Even in my numbed state I was aware of a symbolic relevance in this sorrowful situation. My past was locked behind this door with tragic finality. I did not care about anything at that moment, yet I felt scared of the unknown future.

There was no point in staying longer.

The door still remained closed as I made my slow way down to the street.

I had to know about Giza.

Shuffling my sore feet over the hot pavement, I tried to hurry down the road. Before turning out of Kochanowski Street, I turned to look once more at the plants on the balcony. Even today the leaves of monstera are potent reminders of evil.

At Giza's place I faced another closed door. It was a Jewish neighbourhood and nobody wanted to talk.

"We left before she did," was all the neighbours would say. "We only dared to come back yesterday. Perhaps she will be here soon."

The reality of Giza's disappearance did not really sink in; nothing mattered any more. There had been too much tragedy to absorb in such a short period of time.

Still dazed with shock, I wandered through the streets. I tried to picture my parents and what it must have been like for them. Petrified, hiding in the wardrobe behind clothes they hoped would camouflage them. Scared to make a sound or even breathe. Most probably they were standing very close, holding each other when the SS men broke down the door. I am certain my father would have pleaded with the Germans to let my mother free. I stopped walking. My hands covered my eyes. I could not continue

torturing myself.

At that moment I became aware of an overwhelming feeling of gratitude. I felt grateful — yes, grateful for being spared the agony of actually being there and watching that excruciating scene. There is no doubt in my mind that my parents must have been relieved that Giza and I were not present on what was most probably their last day.

It was hot. I kept walking aimlessly. I could feel perspiration running down my forehead and the sides of my face. I couldn't be bothered to wipe it away. Thinking about my mother and my father was my final farewell to them.

7

When it began to grow dark I headed for Milek Sigal's house. He was the only one I could turn to now. For years we had been inseparable friends. Almost brothers. I prayed to God that nothing had happened to Milek or his family.

"Good evening, Mrs Sigal."

"Hello, Marian, how —." She gave me a quick look and stopped. "Milek!" she called urgently. "Milek, Marian is here."

Milek came out and I could see from the corner of my eye his mother gesticulating to him.

"Hi," Milek said.

"Hi."

He looked at me and he knew. With his arm round my shoulders he led me to his room. Actually it used to be the dining-room before the Sigals were forced to give up two rooms to other Jewish families.

We sat on his bed, his arm still around me. That was all a friend could do, and that was all I could take. After a few minutes he asked: "Both of them?"

I nodded.

"Giza?"

"I don't know, she's not in her flat. I — I hope she's hiding somewhere."

Mrs Sigal brought us soup and bread. "You can stay here as long as you like. We'll manage," she said softly.

"Thank you."

The closed door of our flat still haunted me. Wherever I looked I saw the marks of rifle butts on the polished wood. I could even see them in the soup bowl, merging with the onion rings floating on top.

Milek broke the unbearable silence. "What are you going to do now, go back to Wilniczka?"

"No!" The answer came out quick as a bullet. "No," I said again, more slowly as the conviction grew. "I am never going back!"

Mrs Sigal returned bringing blankets and pillow. "Do you mind a bed on the floor by Milek's bed?" She made up the bed and touched my shoulder as she left us. "Sleep well."

Milek's father poked his head into the room. "Have a good rest, Marian," he said. "We can talk tomorrow."

The anguish of the day had left me exhausted. Now, knowing I was with friends and that Milek was by my side, I burrowed into the blankets and let sleep overtake me.

The following day was Sunday.

"No work today," Milek's father said over breakfast. "We can take our time."

He was much younger than my father and was working as a tailor for the Germans. He was useful to them — for the time being. It was obvious that the recent *aktion* had him deeply worried. "Your parents?" he asked.

I told them then what had happened, toning it down so as not to distress them too much. I could see from the way Mrs Sigal looked at me that she was not deceived. She

knew how it would have been.

But I could not waste time talking. I had things to do. "I have to find the Greszkos," I said.

"Greszkos?"

"They are Ukrainians. My father sent me word they would be hiding with them. He said he was taking my clothes, documents and all our family photographs to them for safekeeping. I don't know them. All I know is that they live in Pochulanka." This was a suburb nearby.

"You can't go like that," Milek's mother said. She found me some clean clothes of Milek's and a better pair of shoes and saw me to the door. "Come back here. Stay until you find Giza and know what you want to do."

Her quiet and powerful kindness seemed the only good thing left in the world.

Milek insisted on accompanying me part of the way. "I've been thinking," he said. "What are you going to do if you don't go back to the farm?"

"I spent most of the night thinking as well. I've decided to get in touch with Salek and try to make a living forging documents. It shouldn't be too difficult to find enough clients. You know how many people are looking for Polish papers and all sorts of certificates. As soon as I have enough money, I'll get out of Lvov. There's no way I'll stay here one minute longer than is absolutely necessary. What about you?" The hope that burst on me had me taking him by the shoulders. "We could work together — like we did before! We pulled it off then — we could again! It's a risk, but why not take it?"

His eyes lit up, but then I watched his face slowly drain of enthusiasm and settle into lines of despair. His shoulders sagged. "I could take the risk for myself, but what about my parents? What would happen to them when the Germans found I had got away?"

We looked at each other bleakly. I knew just how he

felt. Unlike me, he still had parents and a younger sister. In a similar situation I had found it impossible to leave my family — why should Milek be any different?

"I couldn't, could I?" he said.

We both knew that this brief impulse towards action had died. We walked along slowly and in silence, watching our feet. The sorrow and helplessness we felt hung on us like a dead weight. As we neared the streets of Pochulanka he stopped. "Not far now. Good luck with the Greszkos, and don't forget I have your Polish papers. You'll need them."

He turned towards his home. I walked on. Here was a playground where I had played as a child. It had not changed. Here was the street my father had told me to find. I counted my way down and found the house.

A woman wearing a dressing-gown, with her hair bound up in a scarf, answered the door.

"Good morning. I am Marian Pretzel. Could I please have the things my father left with you?"

She took a quick look up and down the street. "What the hell are you talking about?" she hissed.

"My clothes and papers. Our family photographs. My father wrote to tell me he would bring them to you for safekeeping. You took in my parents during the *aktion*."

Her face became mean with anger and fear, and she tried to close the door.

"Please," I said. "At least let me speak to Mr Greszko."

"Get away from here! If you don't disappear immediately, I'll call the Gestapo; they know what to do with bastards like you! I've never heard of anybody called Pretzel."

She was obviously lying.

"My papers," I said, disbelief and disgust almost choking me. "At least let me have the photographs!"

The door slammed in my face.

I stood for a moment, clenching my fists with anger. What could I do? And anyway, what difference did any of it make? My parents had gone.

Almost witlessly I made my way "home". I do not know why I went there or what I expected to find, but the compulsion to go back to where I had last seen my people was strong.

Once again I faced the battered closed door. My mind was in turmoil. Commonsense and logic said, what was the use? This might be the home in which our family had been happy for fifteen years, but it was not home any more. My parents were not there. Giza was not there. I ought to leave the past behind, go back to Milek, search for Giza. But this was where, less than three weeks ago, my mother took me in her arms for one last hug and kiss; where my father had said, "God bless you! Goodbye, son," as I walked down the stairs. I had to see inside my home again. There was no way I could just turn my back. I knocked, the wood hard against my knuckles, and knocked again.

A middle-aged woman opened the door. I saw her eyes drop to the white armband with the Star of David on my sleeve. I could see that she had realised at once who I must be. Her face became tight and ugly. Before I could speak she unleashed a torrent of abuse. "What do you want?" she spat. "Get away! Don't think you can come here bringing trouble. I know your kind!"

"Please, my parents . . ."

"Bloody Jews! If you hadn't caused the war my son would still be alive!"

I stared at her hard face in amazement. Words were pouring out with the glibness of a well-rehearsed speech. It was almost as though she had been waiting for me, schooled to employ attack as her best line of defence. She

had our flat — she had our furniture, and nothing was going to take them away.

"Bloody Jews!" she screamed again. "You've got what you deserved! You brought it all on yourselves. Clear off! Go on — clear off!"

Her face was full of hatred. I closed my eyes against it and turned away. I would not dignify such contemptible accusations with a reply. Her harangue followed me all the way down the stairs.

Out on the pavement I took a deep breath of clean air. The street I had known all my life now looked alien; the playground held hidden terrors. I felt a desperate need for something to hang on to. Those photographs! I needed them to link me with my past, my parents, Giza and my friends. The one comforting sight was the stand of chestnut trees on the grass strip in the front of the house. I needed their protection now as much as I did when I was a kid and they used to shield me from the rain and the scorching sun. Worn out with emotion, I went to my favourite tree and sank down on the grass beneath it. I pressed the whole length of my back against the strong warm trunk, taking comfort from contact with the only thing which seemed unchanged.

It was less than twenty-four hours since the tragedy had struck. I had not yet had time to absorb it and to become accustomed to the idea that I was alone in an indecent world. I was twenty years old, without papers or possessions other than a pair of useless sandshoes, a T-shirt, an old jacket and a pair of hessian pants. I did not know whether my sister was alive or dead; I did not know where I would live or what I would do next. The protected life I had led had kept me unaware of the cruelties of which the human animal is capable; until the Germans came I had known only honest and decent people; now it seemed that self-interest, greed and fear were stronger than any

impulse towards compassion. Clearly the Nazis did not have the monopoly on cruelty.

I had no option other than to accept the Nazi cruelty. Previous *aktions* and atrocities should have prepared me for this to happen sooner or later. Over the preceding six months I had often thought about the possibility of my parents being taken away from me; I had seen it happen to too many families: the older folk taken away, leaving their children unprotected. Yet when it happened to me I found myself completely unprepared, as if taken by surprise.

A sudden thought made me cry out with pain. My mother and father had disappeared from this world as if they were never here. Except in memory, they had left behind nothing that could be cherished . . . Father's tie or cufflinks, even an old watch . . . a silk handkerchief of my mother's, a brooch . . . there was nothing. Not even a grave.

"They will never have a proper grave," the thought went through my mind, over and over.

Desperate sadness almost choked me. I longed to be able to turn the clock back to when life was full of fun and I did not have a care in the world. I wanted my parents to be happily busy at home while I played soccer in the street with my friends. I wanted Emil Krau to come running from his father's shop with ice-cream and sweets, bubbling over with some new scheme for a game he had dreamed up. I wanted —.

I wanted to stay alive!

My mother and father might not see better days, but I would! For them, as well as myself. And if only I could find Giza, I would make certain that she would see them too! As I sat beneath my tree, eyes closed, determination grew and hardened. The obsession to survive took hold. There must be an end to the present madness; of this I was convinced.

I had lost everything but my life, and that I would not lose. But how to preserve it? I made a slow and careful inventory of the qualities I possessed and how they could be instrumental in my survival. To my amazement I realised how fortunate I was in having so many attributes. I was young and healthy. I had blue eyes and blond hair, and looked more like an Aryan than a Jew, I already knew how to forge stamps, and — unfortunately — I had nothing to lose any more, no responsibilities.

I felt a warmth encasing my body. I opened my eyes and found that the sun had risen higher and the shadow of the tree lay behind me. The brightness and warmth reminded me of one of my father's favourite sayings: "One day the sun will shine on my side of the street." I sat quietly and let the idea take hold. Thoughts of my father always gave me strength. When at last I got up, I found I could walk with determination and purpose.

Tragedy lay behind me; grief remained but confusion had gone. Nothing could alter what had already happened. But my future was in front of me. My father had taught me that a man should take responsibility for his own life. I now took responsibility for my own.

Walking back to Milek's house I made what were probably the most vital decisions of my life. I came to the conclusion that I could not afford the luxury of feeling sorry for myself, and I was determined not to waste my much needed energy on a blind and counter-productive hatred.

Part Two

The Ghetto

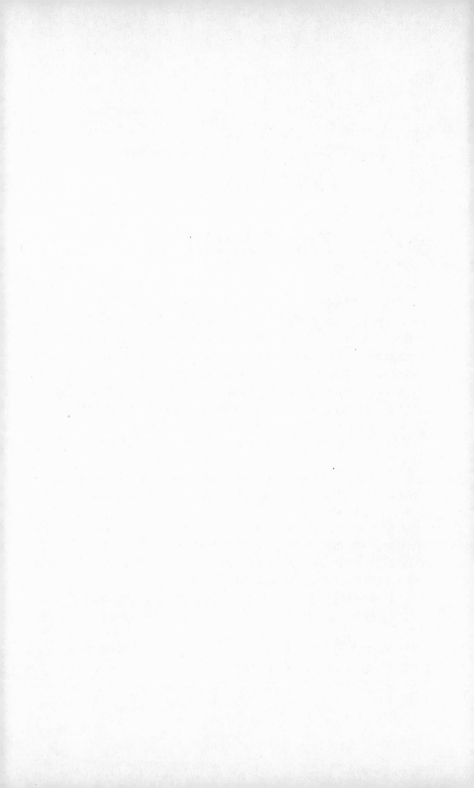

8

Six times I went to Giza's flat. Six times I came away, broken-hearted. I knew there were faces watching me from behind curtains but no one came out to speak to me. I have never spent a more miserable three days.

I went looking for Salek. I could not find him either. I was near despair when, on my third attempt, he answered my knock at the door of his flat.

"Marian! just the man I want to see!" The warmth of his greeting was almost more than I could take.

"Come in," he said quickly, aware of my distress. "What happened?" He sat me down and found me a drink. "Tell me."

I told him everything. Words poured out like a river. My story was hardly new; it was like repeating a familiar stage play; only the cast had changed — yet his interest and sympathy never flagged.

"You know I'll do whatever I can to help," he said.

I pulled myself together. "What did you want to see me about?"

He became business-like. "Otto and I need some documents. Could you do them for us?"

Of course I could.

He pushed some folded banknotes into my hand. "Here's an advance. Come back again in three days time and I'll have everything ready for you."

It was good to be with Salek. He had such an air of assurance and safety. As I left he tucked a small packet wrapped in brown paper under my arm. "I am sorry about your parents," he said, "but *you* are going to be all right. I know you are."

We shook hands and exchanged looks of deep friendship.

Going down the stairs I could not wait to open the parcel. It contained five packets of cigarettes. Real cigarettes. For weeks I had been rolling anything which would burn in newspaper and smoking that. The first deep hungry puffs of good tobacco were wonderful.

I felt heartened enough to go round to Giza's flat once again. She was not there. But at least the door of the adjacent flat opened and I saw someone beckoning to me. He kept well in the shadow.

"I am looking for my sister Giza," I said. "I don't know where she is. I believe she and her husband were hiding somewhere."

"You know Karol's a very nervous man. He'll wait until he's sure there's no further danger from the *aktion*," came the reply. "Don't worry, I'll tell Giza you called as soon as they come back."

I thanked him. It made sense. It was the least I could expect from Karol, with his timid nature. How anyone as lovely and vivacious as Giza had ever chosen him was beyond my understanding. All my dislike of him rose up anew — dislike which was mutual. It had created a situation where Giza and I had begun to see less of each other as time went on.

After two more days, I saw the curtain of the flat move slightly after I rang the bell, and to my joy Giza opened

the door. God knows what I looked like; her haggard face
shocked me. We fell into each other's arms, and, for the
first time since the horror began, I wept. At last the tears
I had stored for days could flow. They came out in a
torrent I could not stop. I did not even try.

Karol and his brother David were with her.

"Where have you been?" I said. "I've been trying to
find you for days —."

From the way Giza was looking at me I knew that my
terrible news would come as no surprise to her.

"We've been hiding with Irka. Are Mother and Father
still at the flat?" As I shook my head I heard her small
low moan. "I was afraid of it, I knew there was little hope
for them when the Greszkos made them go back to the
flat . . ."

We were sitting close together and she put her arms
around me and kissed me. Her cheeks were wet. "Mother
made me promise that I would look after you. 'He'll never
be able to look after himself,' she said. 'You know how
much he always depended on us!' "

I told Giza briefly about the way Mrs Greszko and the
woman who took over our flat had behaved. I did not
elaborate. We could not afford to look back; somehow we
had to cope with the present.

"When Karol and David came home on the first day of
the *aktion* the flat was wrecked and looted and there was
no sign of their parents, either." She stopped to wipe her
tears before continuing. "When the *aktion* continued we
went to Irka's flat. We hoped it was far enough out of
town to be safe. On the way I called to see Mother and
Father. At least I said goodbye to them."

Irka was David's Gentile girlfriend. Giza had told me
she thought David and Irka were secretly married, and I
quite understood why David would keep the news from
his family. He was even more under his Mother's thumb

than Karol, and I am sure she would rather have seen him dead than married to a non-Jewish girl.

I was vaguely aware that Karol and David were continuing to hover around. And when I finally pulled myself together to look around the flat, I saw what a dreadful mess everything was in. The floor was bare, the dining-table and chairs were gone, the wallpaper hung in rough strips. Cold air was blowing in from the kitchen.

"Have a good look round," Karol said bitterly. "Not that there's much left to see. They took everything they could carry — all our clothes, pillows, blankets. Take a look in the kitchen."

Cupboard doors had been wrenched loose and hung drunkenly; the window was smashed, there were pieces of broken pottery everywhere.

"Not a cup left, not a plate. Not a saucepan," Karol moaned.

In the bedrooms, though the mattresses were bare, the bedframes remained.

"At least you still have a roof and something to sleep on," I said.

I could not continue to impose myself on Milek's family; besides, I needed to be with Giza. Karol and David make it plain that though they were not actually up to telling me to go, they certainly hoped I would not want to stay.

"I won't be any trouble, I have my food cards and I won't ask you for any money."

Karol's mouth pulled down and he turned to his brother. "No trouble!" he said. "What good is a food card without money to buy the food?"

"I'll earn my money —."

"Black-marketeering!" David suddenly sprang to life. His voice lifted dangerously. "Don't think you can use this place to store your cigarettes or whatever —."

"I don't know anything about the black market. I'll buy my own food with my own money ... and ..." I took out the banknotes Salek had given me and offered them to Karol, "I'll pay my share of the rent. How much do you want? Take it!"

Before he could reach out his hand, Giza, who had been watching us in silence, gave a sudden angry cry and struck out, so the notes fluttered down on to the bare floor. "Pick those up and put them in your pocket!" she commanded me; her tone sounded like the Giza I used to know. "You can live here as long as you want to — and don't let me hear you say another word about paying rent!"

Poor Giza; as though things were not bad enough for her, she was now caught between two loyalties. She knew I could not impose on Milek's parents and that I had to have somewhere to stay. Since her marriage, we had drifted even further apart than the differences in our temperaments and interests had already made us. Our childhood together had been stormy. Three years older than me, she had always tried to boss me. Growing up in what was a man's world, there was no way I was going to accept *that*. The years of growing up together had been a history of teasing and tempers and jockeying for authority, with objects hurled around as freely as accusations. As we grew older we learned to accept each other better and to laugh together. We might not be close but we were family, and though the love might be stifled, it was there. The tragedy of losing our parents brought us back together.

It hurt me to see how my slim, tall, beautiful sister, with her high cheekbones, big blue eyes and long delicate fingers with almond-shaped nails, had changed. Now her nails were rough and broken, her cheeks hollow, her eyes dull, and, worst of all, her vivacious manner was quite

gone. She had begun to lose it at the start of her involvement with Karol. Now there was no trace of that high-spirited hauteur and sophistication which had made her so challenging and attractive.

Karol hated to see us together, and friction began almost at once. "Surely you are due back at the farm at Wilniczka. When are you going?" he asked.

"I'm not."

His mouth fell open. "But you have been ordered to work there! You can't fail to go back. It's against the law! You know what can happen to you if you don't." The idea of defying the Germans terrified him. Both he and David seemed to have been brainwashed into believing that Jews were helpless and Germans omnipotent, and that if we were told to work, we worked, and if we were to be killed in the process, then that was the way it had to be.

"Every day you are here could mean trouble for us," Karol said bitterly. "They will come looking for you."

"They will be looking for Marian Pretzel," I said.

He frowned. "What does that mean?"

"I am going to change my name."

"How, Marian?" Giza asked.

"I know how to forge documents," I told her quietly. If they had known I was actually planning to forge German documents under their roof they would have been panic-stricken.

But Karol was right, of course. Trouble seemed to be following me. To be honest, I took risks that attracted it. I did not like wearing my armband; confident that my looks would not give me away, time and again I left it off.

One day when I was not wearing it I noticed a young man, a Pole who had lived not far from us — a year ago I would have called him a friend — coming towards me from the opposite direction. Not knowing how he would

react to the absence of an armband on my sleeve, I stepped off the pavement and quickly began to cross the road. Before I was halfway across he called my name. Useless to pretend I had not heard him. I turned and greeted him with great surprise: "Jozek!"

I saw his eyes fly to my sleeve then look away. "Fancy running away from an old friend!" he said jokingly.

"I wasn't running away from you, why should I? I'm not frightened of old friends."

We walked along together, laughing and chatting, and I began to feel that everything was all right. I offered him a cigarette, and after lighting it for him I put the packet in his hand. "You can keep the rest. I don't smoke much."

He pocketed it without bothering to say "Thanks". In Lvov in 1942, very few Poles would have said "thank you" to a Jew. They believed they had the God-given right to grab any Jewish possession they could put their hands on. Without a trace of embarrassment he told me what bad luck he had at cards the night before. Could I possibly lend him any money? I took out my wallet without hesitation.

"Always glad to help an old friend in need; you're welcome to whatever I have." I opened my wallet and took out the contents. I never carried much in my wallet; without a safe place at home to leave my money, I stowed it in large notes inside my socks. He pocketed the money, checked my fingers for rings, gave my old watch a look of disgust, then said, "I've always wanted a sports jacket like yours, but I've never been able to find one anywhere."

I knew what that meant. Goodbye, jacket! No wonder he wanted my jacket. It was olive-green, made of heavy pure wool, in a bold herringbone pattern. It was my pride and joy. I wore it only on special occasions when I ventured to the city without my armband. Being well

dressed was a kind of protection, a confidence builder. I promised to bring the jacket to his house that evening; he said he preferred it now. We continued our cat-and-mouse game with friendly smiles, until, with my jacket over his arm and my money in his pocket, we came to the parting of the ways.

"How about lending me some money for the tram home?" I asked.

He laughed pleasantly. "You've got money in your other pockets!" he said, and elbowed me towards an empty house where he went through all my pockets and frisked my body. Luckily he didn't think of looking in my socks. When he couldn't find anything more, he tucked my lovely jacket securely over his arm.

"The walk will do you good," he said and walked away still smiling.

I waited for him to disappear, then took out a bundle of notes from my sock and put one note into my wallet. Grinning to myself, I whispered: "Oh, you stupid bastard!"

The walk home did me good. I made up my mind, then and there, that I was getting out of Lvov as soon as possible.

I was not bitter about Jozek; he only behaved as many other Poles would have done. One got used to this sort of behaviour. Clothes, an apartment, furniture — there was nothing a Jew could do to protect his possessions, and at least Jozek's operation had been conducted with a smile and he had not reported me to the Gestapo, something that many others would have done.

But I had had enough; I wanted to get away from a place where such things were everyday occurrences.

I became much more cautious about walking around the city without my armband. Next time I might not be

so lucky. But wearing the armband could be just as dangerous.

It was a time when we all lived on our nerves. For a Jew, even walking on the street could be a hazard. If some German soldier, SS man, or militia man wanted a job done, official or private, he was likely to grab the first Jew he saw as convenient slave labour. The lucky ones might get away with hours of dirty work and some bruises, but many suffered abuse and severe beatings; some were never seen again.

A short while later — this time I was wearing my armband — I was stopped on my way home. A Ukrainian militiaman with a sinister grin on his face grabbed my shoulder and pushed me against a wall.

"Wait here!" He was young, huge, and looked mean and eager. Scared out of my wits, I did what I was told. Turning around, I found myself in the company of two other young men standing close by. Curiously we watched the militiaman stopping other young men; some were allowed to continue on their way. Eventually there were six of us. With a wave of his truncheon, he pointed to a truck standing at the kerb. Silently we climbed up while the Ukrainian got into the driver's cabin, started the engine and drove away.

The six of us now had the chance to look at each other. Our terrified glances went from one face to another; in each I saw the same fear I was sure showed in mine. We did not dare to speak. But something struck me as being very strange. We were all about the same age, of similar height and were quite well-dressed. Did that mean anything? Dry-mouthed I watched the familiar streets go by. Would this be the last time I would ever see them? We had still not plucked up enough courage to talk to each other by the time we felt the truck bouncing over cobblestones and making a wide slow sweep before coming to a halt in

front of a large building.

"Out! Everybody out!" the Ukrainian shouted, and we all stumbled out of the back.

He made us follow him through a wide gate into a large courtyard enclosed by a grey four-storeyed building in which the windows looked like dark horizontal stripes. There were many window-boxes; some were bright with flowers and green leaves, others tatty and neglected. There was not a sound to be heard, not a soul to be seen. In the middle of the courtyard were large stacks of tables, chairs, steel cabinets and bookshelves.

We stood uncertainly.

The Ukrainian very slowly walked round us, looking us up and down. Then he stood in front of us, looked over at the office furniture, then at us again, taking each face one by one.

All we could do was look back at him in blank terror.

Suddenly he leapt back, waved his arms, and broke into a torrent of abuse — in Yiddish! I had never heard such profanity — or so many swear words used with so many gestures, such vigour. Our terror turned into open-mouthed astonishment, and our reaction seemed to delight him. He threw back his head and burst out laughing. He said it all again, more slowly but louder, every gesture more expressive — and laughed again.

"What's the matter with you," he spluttered. "Don't you understand *Mommy Loshen*. Don't you know your mother-tongue? I will tell you again, but I will tell you in Ukrainian this time! Get that furniture inside!"

We fell over each other to do as we were told. There was a lot to carry and he ordered us all over the building, jeering at us and laughing all the time. As we passed and repassed each other we exchanged incredulous looks. At last the courtyard was cleared except for a few chairs.

"Oh, sit down! Sit down," he said, suddenly pleasant

as could be. Wearily we followed his order. He sat down too, stretching out his legs in front of him, tipping the chair back. He seemed to be thoroughly enjoying himself. "When I was a young boy, we lived up near the Russian border, next door to a rabbi, and we were poor. I ate more food and spent more time in the rabbi's home than I ever did in my own. By the time I was twelve I could speak better Yiddish than Polish."

We could not imagine what that had to do with us.

"The rabbi had two sons," he continued. "Ben was a year older than me. Shlomo was two years younger." He looked from one to the other of us. "We grew up together. They were my friends." He was not shouting now. There was even warmth and affection in his voice and expression.

We were not used to Ukrainian militiamen behaving like this. We did not know how to take him; we were still desperately afraid of what was going to happen to us. He looked again from one to another of us as though awaiting our reaction, but we were too dazed and afraid to speak. He jerked his thumb at the young man sitting next to him.

"Go to the truck and bring me the parcel in the cabin!"

The Jew got up quickly and ran across the courtyard. The Ukrainian gestured it away as he brought it to him.

"Pull the string," he said, as though talking to a child. "Open the paper."

The parcel contained three loaves of bread and six packets of cigarettes. We stared at the contents, then at him. His face broke into a grin. "Well, what are you waiting for?" he asked.

He drove us back to where he had picked us up and stared straight ahead as we mumbled thanks for the bread and cigarettes. We could hardly believe that, after all, we were safe. I am sure he knew how deep our gratitude was.

His face was quite impassive as he drove away; he looked like any tough young militiaman. I have often wondered what really went through his mind as he performed what seemed like half-crazy antics.

After all these years it is possible to feel some amusement. But to the six young men he had gathered together and driven away, who knew he had the power to behave in any way he wished with them, it had seemed anything but amusing at the time.

9

The atmosphere at the flat grew worse. I kept out of the way as much as I could.

Late one afternoon, as I was walking past a queue of people waiting to buy their bread ration, I felt a hand on my shoulder. Turning round, I was delighted to see my cousin Henek. We had not met since he and his mother had been forced to leave their flat, only five minutes from where we lived, to go to a single room in the Jewish sector.

"It's great to see you, Marian. Could you wait for me, then we'll go to my place to talk."

I had always been fond of Henek; he was my age and the only cousin I had in Lvov. Although he had no interest in sport and we mostly met at family gatherings, we really liked each other and I always enjoyed looking at the hundreds of drawings of cars he made, each with different modifications, and was impressed by the precise way he kept a record of any new idea he had. His one interest, as far back as I could remember, was auto-mechanics. There was no mistaking Henek's Jewishness; unfortunately he inherited his Rumanian father's physical characteristics. He was shorter than average with a long, thin face, a

hooked nose, small dark eyes which were close together and a bottom lip which always looked as though it had been stung by a bee.

When he came out of the shop with his bread, we put our arms around each other. We had tragic news to exchange. His mother, my father's only sister, had been taken away in the *aktion* in which I lost my parents. I was grateful that he had asked me to go to his room with him; I welcomed any chance to stay away from Giza's flat. We wiped the tears from our eyes and walked along, close together, talking and exchanging looks of affection. It was good to be with him.

His room was tiny, with a bed in the corner and a mattress on the floor. A small square table with three chairs, a wardrobe I recognised from his room at home, a little gas-stove and a sink completed the cheerless picture, but everywhere was neat and clean; Henek was meticulous in everything he did. I couldn't help looking curiously at the mattress on the floor.'

"I sleep there," he said. "I just couldn't take over my mother's bed."

As soon as we had taken off our coats he brought out his ration of bread, broke it in half, and, without saying a word, handed one piece to me. I was reluctant to accept it, but too hungry to refuse.

"Don't worry," he said, "I have plenty to eat."

Whilst he busied himself putting two potatoes on the stove to boil he told me that he not only found satisfaction in his work, but the Germans provided him with good hot soup for lunch and a thick slice of bread to take home. I felt less guilty about taking his bread.

I told him about my dreams and plans. He thought them unrealistic, with a very slight chance of success, but admired my determination and wished me all the luck in the world. "I am sure you'll need every bit of it!" he said.

"What about you?" I asked, "how do you see your future?"

"What future? Is there any? Look, Marian, at the moment I am prepared, or to be more accurate, forced to accept my present way of life. I simply live in hope that when the war's ended I'll still be alive to see better days. Since my mother has gone I haven't the strength to do any more."

Walking home, I couldn't stop thinking of the way he had shared his food with me; the natural, matter-of-fact way in which he had offered it touched me more than I could explain.

I went back to see him twice, but his door was closed and the people next door couldn't help me. He kept very much to himself and they hardly ever saw him, they said. I was determined to find him.

The garage where Henek worked was a military establishment. I kept out of sight of the sentry at the gate as I waited to try to catch him when he finished work in the evening. There was no sign of him among the workers streaming out and I was about to give up and go home when a group of Jewish workers, walking four abreast and escorted by six Ukrainian guards, came through the large iron gate; Henek, his canvas bag on his shoulder, his head bent with his eyes on the cobblestones, was among them. My heart sank. This was the way workers were marched to and from the concentration camps.

I edged closer, and by slipping some cigarettes to one of the guards was able to march alongside with him for a few minutes.

"I don't really mind being in the Czwartakow camp," he told me. His voice lacked the slightest trace of emotion. "At least I don't have to cook my meals and clean my room. My work is still as interesting and I am being protected wherever I go." His eyes indicated the guards.

I took a bundle of notes out of my sock and pushed it into his hand. "Use this to try to make your life a bit easier," I said. I felt I had to make some effort to help him.

I saw him a few days later and was delighted to find that he had used the money to buy cakes which he smuggled into the camp and sold.

"I always keep three for myself, as profit," he said. "I eat them last thing at night, in my bunk."

Weeks passed during which I took care to have a few words with him, or at least to wave to him, whenever I could. One evening I joined him again.

"How's the cake business going?" I asked.

"It's gone," he said with a sad smile.

Hurrying along, the cakes concealed under his coat, he had slipped on the wet road and fallen, squashing the cakes into an unsaleable mess. "But I had an after dinner dessert for a week," he said, and patted my arm.

I never saw him again and I never found out what happened to him either.

Milek, whom I had seen less frequently than I would have liked, was now working with his father in a factory making uniforms for the Germans. I watched with an aching heart this happy-go-lucky personality gradually become melancholy and dejected. His smiling eyes and quick wit were replaced by a look of defeat and bitterness. He showed no more interest in making false documents and had obviously abandoned all thought of trying to get away.

"It's not that I don't want to," he finally confessed. "I just can't. I can't endanger the lives of my parents and my sister. I don't have to tell you what would happen to them if I was caught. I'm sorry, Marian."

I put my arm around his shoulder. "Don't be. Be glad your family is still together and you have somebody to look after." I turned round and before walking away I added, "I wish I did."

I spent most evenings with another friend, Adek Sussman and his sister Felka. Adek and I had a lot in common. The Germans had taken his father and older sister in the last August *aktion*. His mother had been dead for some years; he and Felka were alone in the world.

Adek was very tall, with the broad shoulders and thick neck of a competition swimmer. He had peroxided his long brown hair and wore it pasted flat to his skull. He had a small moustache, which he fingered constantly, as though reassuring himself that it was still there. A long scar, the result of an accident on the ice-rink, stretched down his cheek to his chin. He looked very rugged indeed. The girls loved him and his carefree nature made him many friends. Now, with the rest of his family dead and the responsibility of looking after Felka, he had acquired a new seriousness, and the weary look of one who knows what it is to be under threat. He worked as a cleaner in a big furniture factory.

"Lvov is a place to get out of," he said, echoing my own feelings.

We began to lay plans, but did not get very far. Felka was the stumbling-block. She was about seventeen, still in severe shock from the loss of the father she had adored. Her large brown eyes, sad and distant, were usually focused on the ground in front of her. She hardly ever looked at anybody or anything. It was as though her will to live had gone with the death of her father and sister.

Adek and I were concerned about her condition, realising that she must be included in anything we planned.

"Shock doesn't last for ever," said Adek. "She's bound to return to normal and become her bright happy

103

self once again. Surely you've noticed some improvement already.''

"I certainly hope you're right, for both your sakes.'' I tried hard to share his optimism.

In early October, 1942, to our mutual relief, I was able to tell Giza that I was going to live with Adek and Felka in a room in the centre of the Jewish sector. Quite apart from the added ease with which I could work, I think Adek was glad to have my company.

We had to have money, and forging documents was the only way we knew how to get it. I had been doing quite nicely on my own small scale, but now, with Adek as my agent spreading the word about services offered, we saw no reason why we should not develop a flourishing operation.

We did. Once things got off the ground there was no need to advertise. Satisfied customers did that for us. Russian passports were in great demand. They had a blind embossed stamp over the photograph. The many hours I spent perfecting the technique needed to reproduce that stamp paid off extremely well. Jewish names on passports were scraped off and Polish ones substituted; sometimes I had to change only part of a name to make it look Polish. When Adek produced a typewriter we could use for Polish and German documents and certificates, and then another with the Russian alphabet, we were off and running.

If money was not available, we took payment in anything that was offered: shirts, shoes, watches, even food coupons that had belonged to people who had been taken away. While I was busy making documents, Adek would be out trying to sell the goods we received. The *Krakowska* (flea-market) was a flop. Poles and Ukrainians, knowing that a Jewish seller was probably desperate, would make ridiculously low offers. Adek was not having that. He found a Jewish dealer who would buy the goods

then hand them over to his Polish partner to sell.

In the meantime, besides the documents we were making and selling, we had found another way to earn money. A much easier way. Salek Meissner was interested in foreign currency. He travelled with his partner Otto all over German-occupied Europe, dealing in American dollars, English pounds, Swiss and French francs and even Italian lira. Gold coins of any sort were wanted. We went into the business of finding them for him and were amazed to discover how much there was around. We could make more from this venture than from forging, but we still had a steady stream of clients who relied on us for documents and advice, and we could not let them down.

In the Jewish sector of the city where we lived, everybody wanted Polish documents or some kind of Aryan papers, if not to use at the moment, to put aside "in case". It was as though we were supplying insurance policies. Most of these papers were probably burned along with their owners without ever having been put to use. A great number of those people had the most elaborately detailed plans to get out of the Ghetto and what to do once they were outside. Unfortunately their plans were never put into practice. I could not understand then, and even less now, the curious optimism which led people to believe that things were never critical enough to justify taking a risk.

Adek and I watched Felka's steady improvement with a great deal of satisfaction, especially since we were able to afford special delicacies like butter, eggs and sausage on the black market. This supplement to our meagre diet helped her to regain physical strength and her mental attitude improved as well. By now she was able to do typing for us, eager to help in any way; I even noticed an occasional smile and sparkle in her eyes.

One evening we were sitting in our little room, talking quietly, when there was a sudden violent pounding on the door. Karol, looking half out of his mind, came storming in.

"I knew it would happen!" he shouted. "I've always said you'd get us into trouble! Now my wife has to pay for being stupid enough to take you in!" He shoved Adek aside and pushed his face close to mine. " 'Marian could never look after himself!' " he mimicked savagely. "What bullshit! The one person you *can* look after is yourself, and you don't give a damn who suffers for it!"

I would have hit him but for Adek's restraining hand. Instead I said: "Pull yourself together, you crazy fool! What's happened?"

"The Ukrainians have got Giza. And they'll only let her go if they can have you in exchange."

Bit by bit we got the story out of him.

The German authorities at the Wilniczka farm had notified the Ukrainian militia of my defection and ordered them to bring me back. When they went to Kochanowski Street and could find no trace of me, they badgered the tenants for information in their usual high-handed fashion. Finally one of the women had protested: "How should we know where he is? Why don't you go and ask his sister?" Since nobody could tell them Giza's married name or address, it had taken the militia until now to track her down.

"They've got her holed up in the flat!" Karol concluded. "If you don't come back with me, God knows what they'll do to her . . ."

Adek cut him short. "Why didn't they come here themselves? Why send you?"

Karol's faced changed. He was suddenly lost for words. I have never seen anyone look so furtive. Light dawned.

"How much do they want?" I asked. He avoided my eyes.

"How much?" I shook him roughly by the arm. "*How much*?"

He waved his arms distractedly. "They didn't say! They just said silence costs money."

I gave Adek a look and he shoved Karol's limp body into the corner of the room and kept him with his face turned to the wall. Quickly I took my bankroll from beneath one sock.

"Here," I said, turning him back to face us. "That should keep them happy." It was a lot of money; more than the militia could have hoped for, I thought.

Karol snatched it and began to riffle through the notes. "What if they want more?" he said craftily.

"Then you'll have to find it," I said through my teeth. "It's all I have and I'm willing to give it to save my sister. How much will you give to save your wife?"

I did not expect to get an answer. We glared at each other, then, still muttering abuse, he let himself out.

"What are you doing?" Adek said in alarm as he saw me pulling my socks over my trouser-legs and retying my shoe-laces.

My mind was made up. In case the Ukrainians, for whatever reason, insisted on taking Giza to the Gestapo, I was going to approach them and give myself up. Once Giza was released I would have to find a way to escape. Of one thing I was certain, there was no way I would let them take me to the torture chamber in the Gestapo headquarters.

I raced down the stairs, but had to stop suddenly when I noticed Karol under the dim light near the entrance door, counting the money I gave him. I waited until he had finished and disappeared outside, then running through side streets to his flat, I arrived there before he did. I stayed in the shadows on the opposite side of the street and waited. Soon I saw Karol enter the building.

In about ten minutes, two uniformed figures came out of the door; they seemed to be laughing. I crossed over the road and began to follow them. They only went a little way before they stopped, doubled up with laughter; their guffaws grew louder and more uncontrollable. One of them leaned against the wall. "These Jews!" I heard him say in a strangled, incredulous voice.

I did not wait any longer. At least I knew Giza was safe. I would have given a lot to know what had happened in that room and how much Karol had actually handed over to them.

This incident made me realise I was a wanted man. The more I thought about it, the greater was my fear. Now it was imperative for me to get out of Lvov. Adek and I decided that we had talked about what we were going to do long enough. The time had come for action.

"If we go to Przemysl to start with, I have Polish friends there who will help us," Adek said. "There's no point in wasting time writing to them. We'll just go."

Przemysl was a town of about sixty thousand people, some seventy kilometres west of Lvov.

We bought a couple of rucksacks and a small canvas bag for Felka, to carry some of our belongings. We left everything else in our room.

"Look after these for us, will you?" Adek cheerfully asked one of the neighbours. "We'd be glad if you'd let your children sleep in our room until we get back. It will stop anybody else trying to move in!"

Full of high spirits despite our trepidation, and displaying every sign of looking forward to a weekend in the country to anyone who might be curious, we banged the door and went into the street. We walked quickly. It was good to get outside the Ghetto and its hated high timber fence. Once outside, we slipped off our armbands.

We took the tram to the farthest stop west of the city,

then picked up a taxi for the six-kilometre drive out to Brzuchowice, where we were to catch the train. We would not have dared to board it at the Central Station in Lvov. Denouncers and extortionists were always hanging about there looking for Jews. And Adek, who was quite a well-known sportsman, could have been recognised.

We did not know what things were like in Przemysl, and had no idea what we would do when we got there. The train was so crowded we did not dare to discuss it. It was a silent, unnerving journey.

It was three o'clock on a bitterly cold November afternoon when we arrived. We quickly left the platform and, in the big square in front of the station, we all started to speak at once.

"Here we are!" "I was thinking . . ." "What a relief we've arrived safely . . ."

"Go on, lead the way," I told Adek. "You know this place. I don't."

"The Kuziks have always been our friends," he said. "They used to visit us whenever they come to Lvov; and Felka and I have often stayed with them."

He had told me this at least three times before, but the release of tension was making him voluble. "This way, this way . . ." He shepherded us across the busy streets. "I know they'll be surprised to see us, but they'll be glad — particularly young Romek . . ."

As we walked, with Adek's voice running on, going over and over things he had said many times before, I only half-listened. I was too busy with my own thoughts. Now, more than before, I felt the loss of my father and mother. I no longer had Father to listen to my problems and give me advice. He had never given orders nor been dogmatic, he had just offered an opinion, pointed out where he thought I could be making a mistake, then left it to me to make up my own mind. My mother always thought love

would surmount any obstacle. I had always had them to depend on. At twenty I was still quite young for my age, and though it was exciting to know that I could make decisions without being answerable to anyone, it was also quite frightening to know I had to make the right ones, fast, otherwise I might not get another chance. "Think," Father used to say. "A problem has many sides. Observe and analyse before you decide."

Now, as we walked through the streets of this strange town, I tried to get my thinking together and to use my mind as he would have done. I broke into Adek's monologue. "Nobody's wearing an armband! All the way from the station there hasn't been one person wearing an armband."

He shrugged his shoulders. "They're probably all in the Ghetto."

"Not all, surely. In Lvov, Jews are out on the streets, even if they're only cleaning up the gutters! What do you think it means?"

"Don't ask me. Anyway, we'll soon know. We're nearly there!" His face alight with excitement, he rummaged in his rucksack and produced a bottle of vodka. "Will they be glad to see us!"

He stopped before a wooden gate opening on to a brick path which led to the door of a pleasant looking house. I could not help noticing that the garden on each side of the path was neglected, the soil lifeless and ash-grey. With a flourish Adek made a cheery rat-tat-tat with the knocker and turned to Felka and me smiling, as we waited for the door to open.

"The Kuziks?" said the man who opened the door to us. "They're not here. They've been gone for months."

I have seldom felt more sorrow for anyone than I did for Adek now. I put my arm on his sagging shoulder. "Can you please tell us where they are?" I said.

"I've no idea. No idea at all." He looked at us suspiciously. "Good day to you." The door we had hoped would open to welcome us in was closed with a bang.

Back on the street with its muddy footpath and puddles making eerie reflections of houses and trees, we stood helplessly, not knowing which way to go.

Adek lifted his face to the sky as if pleading for guidance. "I'm sorry," he said brokenly, "I'm so terribly sorry. What a mess I've got you into."

We could not hang about. We started to make our way to the town. Still Adek could not keep quiet. He went on and on.

"Oh, shut up!" Felka and I said together, and then we actually laughed.

"You're mad," Adek said. "There's nothing to laugh about. What are we going to do now? Where are we going to stay? We'll never find a room here!"

We found one very easily. But we were not pleased when we discovered the reason. There were rooms available in the town because the authorities had cleared out all the Jews. Przemysl, like many other towns in the area, was being made *Juden-frei*. It was our good fortune that we did not look overtly Jewish, but in a place where denouncements were encouraged and even Poles were frequently accused of being Jews in disguise, three strangers would soon come under scrutiny.

The only work available at Przemysl seemed to be for highly skilled tradesmen in the building or engineering trades; we did not dare draw attention to ourselves by looking for work as labourers, and nobody seemed to want waitresses. Two days later we were back in Lvov.

Felka, despite her marked improvement, was terribly conscious of being a burden to Adek. Now, back in our room in the Ghetto, she was beginning to take part in our interminable discussions as to what to do next.

"I've heard there are jobs in parts of Russia the Germans have occupied," Adek said. "You could make us references, Marian, to prove our previous experience in whatever trade we want to get a job."

"I can speak Ukrainian and Russian," Felka said. "Surely I could find a position for myself too." We looked at her in astonishment. It was the tone of her voice rather than what she said which startled us. That note of confidence was something we had almost despaired of hearing. "I can type, too," she went on. "And I speak German and Polish. They must need interpreters and typists."

It seemed that the Przemysl fiasco could have been a blessing in disguise. Adek gave her a quick hug and a kiss. Suddenly we were all laughing.

"I'll make you some most impressive references," I said, smiling at Felka. "I'll go into the city first thing in the morning and see what I can find out. I'll pick up as many newspapers as I can and we'll go through them to see what jobs are offered."

We went to bed encouraged and quite cheerful.

10

I let myself out of the flat just before seven in the morning. I wanted to get into the city and lose myself in the crowds going to work before it became really light. Winter clouds lay heavy over the city and steady drizzle was reducing visibility to a few metres. It should be easy to slip outside the Ghetto fence without being seen.

I had no sooner taken a few steps away from the door of the building when I found myself face to face with an SS man carrying a pistol.

Shock made me stumble.

"Move!"

As I regained my balance I stared at him. He twisted me round and shoved me forward with a vicious prod between the shoulder-blades. "Hurry!"

Ahead of me, in the murky half-light, I saw an untidy mob of people. To my horror I recognised the uniforms not only of the Ukrainian militia but of the SS as well — I saw truncheons and rifle-butts lifted above the struggling crowd of men, women and children being driven towards the high wooden fence of the Ghetto, and the next minute I was among them, head down and arm lifted to ward off the terrible blows. Hysterical screams broke out as people

113

stumbled and were trampled underfoot in a human stampede; when rifle-fire broke out, panic turned many people witless. They broke away from the mainstream and ran about blindly, screaming, until they were shot down. Parents who had lost their children ignored peril to themselves as they tried to turn back to find them; they were either shot or trampled to death. Babies and children were lying on the road, some dead, some badly hurt; parents were wailing over their dead infants and bewildered, terrified infants were crouched beside dead bodies.

It was hard to keep on my feet as the press of people from behind grew stronger. Caught up in the hysteria of the crowd, I knew if I did not keep my head I would be one of those crushed to an unrecognisable pulp. "Stay calm!" I had to keep telling myself. "Think! THINK!" Not for the first time in my life, I was grateful for my height. Fortunately I was among the first to reach the high fence. The crowd behind me was at least ten-deep, pressing ever tighter together; I was protected from the continuing bestial attacks by that thick human wall. We were driven along the fence to an opening at the end of the street where SS men were separating men and women, forcing them through different gates. Some couples refused to leave each other; they died together rather than be driven apart. Little children, clinging to their mothers, kept up a continuous keening wail.

We were made to walk four abreast, then two, and then, about fifty metres from the gates, in single file. As I waited my turn I realised to my terror that the papers I had on me were the forged passport and birth certificate in the name of Marian Smolinski, Polish-born . . . but I had been picked up in the Ghetto! What should I do? Should I get rid of them before the Germans found them and started asking questions? The decision had to be made at once! It came clear and hard. NO! Those papers were

my only key to eventual freedom, no matter how doubtful that might seem now. It was better to gamble on being able to use them one day than to give up all hope before I had tested my chances.

Already it seemed a lifetime since I had stolen out of bed so as not to wake Adek and Felka.

Shuffling slowly forward, I could see tram carriages and army trucks drawn up on the street outside. Some men were being directed to the trams, others to the trucks. Who was going where, and why? I tried to work out a pattern of selection, but from a distance it was impossible to assess the age or physical condition of the people in either group.

At last it was my turn to face the SS officer at the gate. He was examining each of us, then with a wave of his hand, indicating a tram or truck. This slight movement meant life or death to many thousands of those waiting to face him, as I later learned. It all depended on his personal whim.

"*Ich bin ein Automechaniker,*" I told him. My German was loud and clear. I wanted him to be in no doubt that I could be useful.

He gave me a hard look, obviously not approving my daring, then shrugged and waved me to the right, where men, many hurt and bleeding, were being hustled into one of the trams. We were packed in with shoves and shouts, until there was no more standing room. The tram lurched and began to move. We were all in a state of shock. Most of the men were blank-faced, their eyes hooded against horror. Some were praying silently, their lips moving. Others chanted our ancient prayers, moving their bodies backward and forward.

This was my first encounter with physical and mental suffering on a large scale. I was to learn that it was easier to watch men die quickly than to see them endure degradation.

Death, after all, was the only sure refuge from the inhumanities inflicted upon them. With relief I realised there was nobody I knew among them . . . but, Oh God, what had happened to Giza, Adek, Felka? My stomach cramped with worry. What had happened in the Ghetto since I was picked up?

The tram clanked over the tracks and on through familiar streets. The smell of fear grew stronger.

"Janowska Road", one of the men said in a terrified whisper as the bell rang and the tram changed direction. We all knew what it meant.

Janowska labour camp had been in existence for nearly eighteen months and was notorious for the sadistic behaviour of its commanders and guards. Inmates were forced to work in appalling conditions for fourteen hours a day with no more than two slices of bread, some watery soup and a cup of black coffee. Indiscriminate shootings, beatings and hangings occurred every day. Our prospects looked grim.

The tram shuddered to a halt.

"Out! Out!"

As we struggled our way free from the crush of bodies and into the fresh air I saw the gates of Janowska about five hundred metres ahead.

"Line up. Four abreast!"

We fell into rank as best we could. There must have been thousands of men in the different groups.

"*Run!*" the order came.

Half-stupid with shock, with little strength left, we hesitated.

"*Run!*" The order became a scream. We obeyed, some of us more quickly than others. The guards used their truncheons to help the slower ones maintain the pace. Some, trying to dodge the merciless blows, stumbled and fell, sometimes bringing down the man nearest to them.

I could not take my eyes off the gates. I knew I was running for my life when I heard the screams and rifle-shots behind me. Weak with fear and malnutrition, it was impossible for many to keep going. Only a small group of us who had been on the tram reached the gates of the camp alive; the road behind us was strewn with the bodies of those who had fallen exhausted and been shot. For the first time I had taken part in the pitiless process of natural selection, the survival of the fittest.

Once inside the camp gates I was forced to stand in a queue which must have been about a kilometre long. I was desperately tired, both physically and mentally, but at least I had not been wounded. I was astonished to find, as I stretched my arms and legs and moved my head from side to side, that I was completely unharmed. It seemed a miracle!

Around me, others less fortunate were trying to make bandages out of handkerchiefs and shirt-sleeves to staunch their blood or bind up dangling or swollen limbs; the air was thick with the exhalation of low moans and tortured, ragged breathing.

It was close to midday. I could not imagine what the rest of the day would bring. For hours it provided nothing but the exhaustion of standing still, shuffling forward, then standing still again. The long day dragged to a sullen evening. The air was cold and dank; as daylight dimmed it began to drizzle; soon the drizzle became heavy rain. The camp searchlights swept over the camp, corner to corner, with relentless monotony. No one gave us any food. I could feel myself starting to become weak from hunger. It was obvious that we were all waiting to be registered — and would, of course, be searched. My forged Polish passport was still in my pocket. There was a substantial amount of money in my sock. I wasn't so worried about having the money, but the passport, in which was pinned

the forged birth certificate, could mean trouble. To allow myself to be found with these documents and have to give them up seemed virtual suicide, but there was nothing I could do about it. I could only inch forward, following the man in front, and pray for another miracle.

Under the searchlight I saw a man walking towards the queue. His stocky silhouette looked familiar. In mounting excitement I waited until he was within earshot.

"Henek?" I called softly.

He turned his head. I saw, to my unspeakable joy, that it was indeed Henek Barlach, my former gymnastic instructor at *Dror*. He glanced around quickly. The guard was walking down the line away from us.

"I am sorry to see you here," he said. Henek was an accountant. He had a job working in the clerical section of the camp, I later discovered. There was no time for preliminaries.

"I have Polish papers and some money," I said. "Will you look after them for me until I need them?"

Without hesitation he nodded. I gave him the passport with the birth certificate folded inside, took the notes out of my sock, undid my watch-strap and pressed these into his hand.

"I'll be needing them back in a few days."

"Yes, of course." He must have heard this sort of remark many times before. He patted my shoulder and was gone before the guard turned to come back down the line.

I lifted my eyes to the cloudy starless sky. "Thanks," I muttered. It seemed too crass to think of this as mere luck.

Although Henek had walked away with the possessions which represented my only chance of staying alive, and though I wondered whether I would ever see them again, I was able to face the search and registration in a calmer frame of mind.

A young woman sitting behind a desk covered with

papers questioned me while a camp inmate searched my pockets and took away everything but my handerchief and a comb. He dropped my woollen gloves into a box containing other gloves, my empty leather wallet into a different box and my loose change into yet another. The floor around the desk was covered with boxes containing the possessions of the men who had preceded me.

"Name. Birthdate. Any profession?" Her young voice was expressionless. "Your *Kenkarte*?" (Identification card).

I shook my head.

"Other documents?"

"I lost them all in the *aktion*," I lied.

She wrote down my particulars. "Move on."

As I went through a door on the opposite side of the office and entered the camp proper, a man with a large brush and a bucket of red paint made a wide red stripe the full length of the back of my overcoat. He did the same with each new arrival. Then two "Askaris", Russian prisoners-of-war who had volunteered to work at the camp, herded a group of us together and drove us past the huts to a patch of higher ground where what looked like skeletons in rags were lying huddled together. The sight of so many sick and dying men churned my stomach. Around each man's waist, attached to a cord, was a tin dish and spoon.

One of the Askaris reached down, wrenched a dish and spoon free and held it up to us. "Help yourselves," he said. "They won't be needing them any more'.

The cruellest thing I have ever been forced to do was to take away the dish and spoon from around the waist of that bundle of bones wrapped in loose, dirty yellow skin, barely recognisable as a human being. To get at the dish I had to move him away from the figure against which he was leaning. The top half of his body fell forward, making

the knot in the cord, which must have been tied months ago, impossible to undo.

"Knife!" I shouted, almost out of control.

An Askari produced a knife and I cut the cord. It was like severing a lifeline. The spoon clanged against the dish as I pulled the cord free. What a requiem!

As I walked to the barracks carrying my new possessions, the large, bruised, hollow eyes of the previous owner watched me from inside my head.

Each barrack block was divided into three areas: a dormitory with wooden bunks without either mattress or blankets; an open area with tables where food was eaten; and a washroom. Outdoor latrines were used by a number of blocks. At night the barracks were locked and two big buckets were left near the door to be used as urinals. These buckets invariably overflowed, making smelly puddles on the floor.

Soon after we settled in our barracks, two inmates brought our dinner. One carried a large loaf of bread which he cut into thick slices, while the other served black coffee from a bucket.

I ate the bread and was anxious to drink the hot coffee to get some warmth into my body, but each time I tried to drink, I had to put the dish away. The transparent face, the pleading look in half-closed eyes of the man from whom I had wrenched the dish, were looking at me. This image haunted me for days and days. Eventually I closed my eyes and quickly gulped the hot dirty water they called coffee.

Overcrowding was severe. The recent *aktion* had begun before the Nazis had built extra accommodation, but the authorities regarded the inconvenience as temporary; they knew there would soon be more room. The food was deplorable — supper was a couple of spoonfuls of dirty water containing potato peelings and a piece of black

bread. It soon became clear that if I did not escape within the next two weeks I would have no chance of survival. I had to get away before my skin acquired the grey look of starvation, before I started to look cowed, before my clothes had taken on the concentration camp odour of sweat and filth, and, above all, before I caught the dysentery raging through the camp. If I once began to look or smell like the figures I saw carting stones or pushing wheelbarrows of coal, I was finished; even supposing I did manage to get away, I would not get across the road before I was picked up.

After we had eaten our supper, an SS man came in and called for volunteers to work on the railway the following day. My hand was one of the first to go up. Any job outside the camp would have to be better than staying inside it under the eyes of the countless SS, Ukrainian and Askari guards.

At eight o'clock the light went out and the door was locked. The hard wood of the bunks made my bones ache; it was impossible to sleep because of the discomfort and the noises made by men enduring the same misery. In addition, the cold November night and the whistling, icy wind penetrated our clothes. Just as I was slipping into an uneasy sleep I was shocked wide-awake by the sound of rapid machine-gun fire. What could it mean at this time of night? Was someone trying to escape? Sleep became even more impossible. I shivered in my bunk, then followed the example of other men, who were walking around trying to increase their blood circulation to frozen limbs.

Suddenly I heard the noise of the door being opened, followed by an ear-piercing whistle and shouts: *"Get up! Get up!"* The little light globe in the middle of the ceiling was switched on and we were pushed towards the washroom. Quickly we washed then hurried to the mess hall,

where we joined a long queue outside waiting for breakfast. Although the weather was extremely cold, we were grateful that at least the rain had stopped. Standing in the line, I looked towards the place where the man I had taken the dish from had lain. He was not there, nor were the other skeletal figures. My mouth went dry as I realised what the sound of that machine-gun fire in the night had meant. On reflection, I am certain these unfortunate remnants of what once were human beings welcomed the bullets which terminated their indescribable suffering.

At six-thirty we lined up for inspection. It was painful and terrifying. We stood in line and had to obey a barrage of orders. "Caps off! Caps on! Number off!" Then we were formed into work groups of twenty. SS men walked around beating anyone who was not standing straight, or who was slow to obey orders. Some men were beaten so badly that they were left to die where they fell. Obersturmfuhrer Gebauer and his assistant, Wilhaus, the men who ran the camp, stood among the SS officers and watched the display of cruelty. When we were finally dismissed, the SS guard in charge of the railway group formed up our twenty workers, four abreast, and we marched out of the camp in the charge of four Ukrainian guards.

It took us about twenty minutes to walk to Central Station. We were grateful for the temporary relief from danger that short walk represented. Our job was to clear away the rubble of some demolished buildings and prepare the site for rebuilding. We were given picks, shovels and wheelbarrows and put to work under the eyes of the guards, who sat and smoked, or rested against their rifles, but watched us every minute, constantly urging us to work faster.

About midday I heard someone call my name. Looking round, I was delighted to see a man who had lived in the same block of flats as Adek and I, with whom we had

become quite friendly. Dr Simon Wiesenthal was an architect, employed by the Germans as head of the drawing-office at the station.

I waved to him, pointed at the guard and shook my head, but he came across to me.

"Not you too!" he said. "I must see if I can do something for you. I'll try to get you a job in the office."

My heart leapt. Simon Wiesenthal knew that I had made documents for people — this could be a real chance. About fifteen minutes later an important-looking German official, splendid in railway uniform and monocle, came up to one of the guards and began to talk to him, pointing his finger in my direction. The Ukrainian looked at him blankly and shook his head. He did not understand German and he was not impressed by the uniform. I watched with a sinking heart as the German threw up his hands in disgust and turned on his heel. My brief hope died. The pick grew heavier to use. But it seemed the German was not prepared to be ignored; in a few minutes he was back again with an officer of the Ukrainian militia. I could hear the Ukrainian telling the guard in charge of our group that I was needed for special work in the office. The guard argued but he was out-ranked. He had no option but to let me go.

Thankfully I put down my pick and followed the German away from the dust and din of the site to an office a short distance away. The office was in a small building where, I was surprised to see, the draughtsmen and typists all wore Star of David armbands. I was taken to where Simon was waiting. He lost no time in coming to the point. "I have a job for you," he said.

Under cover of the work in the office he thought it would be possible to make the "W" and "R" badges which Jews employed by the Germans were required to wear. They were quite small, just a piece of white cloth

showing an embroidered letter and the stamp of the issuing department. "W" denoted employment by the Wehrmacht, "R" by the *Rustung* (Armament and Supply Department). The important thing about these badges was that the wearers were able to work outside the Ghetto, provided they returned there each night.

"We can make the badges. Can you make the stamps?" Simon asked. He had already organised quantities of white cloth and blue cotton, and women willing to be embroiderers. Could I make the stamps? Just let me start! He locked me in the darkroom of the photographic department, collected all the implements I needed and locked the door.

In three hours, working alongside two women busy embroidering the letter "W", we produced eight badges. Simon was delighted. The badges would be smuggled out by workers allowed to return to the Ghetto for the night and given to people in hiding there. I spent the first rewarding day I had known for a long time.

"I have to get out of Janowska," I told Simon, "and I have to do it before they shave my head."

Due to the overcrowding, the barbers in the camp had not been able to keep up with their job. I still had a full head of hair.

"Even if you get past the guards what could you do? Without documents you haven't a hope."

"But I have documents, and money, and I know where I could hide outside Lvov!" I told him about Henek Barlach, and said I thought it would be possible to go straight to Przemysl for the first few days in spite of its *Juden-frei* policy.

Simon looked thoughtful. "Leave it with me," he said. "Get your documents back and be ready. We'll find some way . . ."

At the end of the day all the workers at the station were

marched back to the camp and I lost no time in finding Henek.

"Can I have my things back? There's a chance I might be able to get out."

His face lit up. "Great! Meet me at the workers' collection point right after inspection in the morning." He moved away quickly before we could be seen talking together.

I spent a restless night.

In the morning I was horrified to find no sign of Henek at the six-thirty inspection. He was not at the collection point, either. I waited in torment, until at last I was forced to join the group being marched out of the camp. We passed through the first gate and were now on our way to the main one; there was still no sign of him. I felt sick with disappointment and disillusionment. I did not want to believe that my trust had been misplaced, that Henek was capable of letting me down and stealing all I had. Not Henek, not a Jewish boy from *Dror*.

Within sight of the main gate I took another despairing look behind. There he was, running as fast as he could to catch up! He fell into step beside me. The guard at the head of our squad did not turn his head.

"Papers. Money. Watch," he said, unobtrusively passing them to me as we marched.

I pressed the watch back into his hand. "Keep this — with my thanks."

We exchanged a long look. "Good luck," he said as he eased himself away.

After the war I tried many times to find him, but without success. I would dearly love to have been able to thank him properly for saving my life.

With my papers and money in my pocket I was impatient to find some way of escape. When I got to the draughting office I found that a group of women in the

Ghetto had worked late into night and made thirty badges which had been brought into the office for me to complete. Again I spent my time locked in the darkroom, working feverishly. It was well into the afternoon before Simon came to see me.

"There's a piggery at the back of the main workshop here," he said. "Two of our men have loosened timber on the walls which run along the street. They'll help you to squeeze through. You'll come out close to the station exit and you should be able to lose yourself among the crowd without much trouble. It will be dusk at four-thirty; people will be going home from work. Be ready then. I'll take you to the piggery."

It was twenty to four. I had less than an hour to wait!

What would I do when I got out? I could hide out in Przemysl for a few days, that part was easy, but long-term plans would have to be made in the Ghetto and would have to include Adek and Felka. Yet the idea of returning there was repugnant. I had seen enough during the last *aktion* to know it was only a matter of time before all the occupants would be either killed on the spot, or slowly tortured to death in a place like Janowska. Other people must surely know this too, yet they reacted so differently.

I knew people who were still trying to play the game according to peacetime rules; they kept to their code of ethics and remained the decent citizens they had always been. They preferred to die with their dignity and decency intact. By contrast, others became mean and selfish and would stop at nothing to preserve their own skin. The Ghetto stank with despondency and stagnation; people lost their will and initiative, each day sinking deeper and drowning in their own apathy and helplessness. That upset me more than anything. Maybe it was because the Jews had learned, over the centuries, that to fight was useless, that passivity was the real key to survival. To outlast the

126

horror of the moment was the important thing.

I did not believe the present horror could be outlasted; I knew that I had to do something, not watch in idleness while people around me were tortured and slaughtered. I was not going to wait for my turn to come. Together with men like Salek Meissner, Otto Feuereisen and Adek Sussman, I believed we had to fight for our survival. I knew I could not afford to stay in the Ghetto, where conditions bred hopelessness; I had to get out before my mind was contaminated and I was no longer able to separate facts from unjustified optimism. Any return to the Ghetto would have to be brief. To me, the Ghetto spelt the beginning of the end: I was looking for the beginning of a beginning.

At exactly half-past four I slipped through the window at the back of the office. Simon was waiting. He hurried me to the piggery and introduced me to the two men there.

"We'll get you out," they said.

"Thanks. By the way, could you sell me some cigarettes and matches? I'm dying for a smoke."

Between them they scraped together four cigarettes and a few matches.

They pointed out a Ukrainian guard patrolling outside the piggery and adjacent timber buildings, stretching some eighty metres.

"You'll have to time your escape to perfection," one of them said. Peering through the gap in the wall, we counted the number of steps the guard made before turning at the end of his short walk. It seemed to give me a reasonable amount of time to get out and walk in the opposite direction. I was ready to go.

In the last forty-two years I have many times thought of that moment and the words that were said.

Simon Wiesenthal took my hand in a firm grip. "They'll pay for it all. By God, we'll make them pay!"

He kept his promise. His whole life has been dedicated to bringing Nazi murderers to justice. He is still working to make them pay for their crimes.

We wished each other luck all round, and just as I was about to squeeze myself through the planking, one of the men hissed: "Your overcoat! It's got the red stripe down the back of it!"

I struggled out of the overcoat, grabbed my handkerchief from the pocket and dropped the coat behind me. "It's yours," I said.

Soon after I was through the gap and gulping the air of freedom. As Simon had said, the street was crowded with workers returning home, too busy to notice a young man sneaking through a small opening in the wall. But on such a cold November evening a man without an overcoat could be conspicuous. Avoiding other guards at the gate of the railway yard, I headed for Grodecka Street, where I knew there were secondhand shops. Within five minutes I was walking back towards the station wearing a short overcoat and gloves.

A light drizzle was falling; as fog settled over the city, visibility became almost non-existent. At least I could be thankful for that. I was worn out with the stress of the last three days. As I walked through the dark wet streets, pangs of hunger slowed my steps. I was grateful beyond measure to see the dim lights of a little restaurant.

The place was empty except for two lovers sitting at a table, holding hands. I went to a table at the far end of the room. Waiting for the food to arrive, I was both surprised and disappointed to find that I felt no elation. The escape had been so easy it was almost anti-climactic. It all seemed like a bad dream, lacking any reality.

Hot potato soup, bread and a cup of ersatz coffee were soon in front of me and I gave myself up to enjoyment of the nourishment so badly needed. Warm and comforted,

I pushed the plates away and lit a cigarette as I drank my coffee.

It was going to be very different travelling to Przemysl without Adek and Felka. I summoned my courage and marched into the station. There was no time to make the trip by the roundabout route through Brzuchowice. The station was crowded. The danger of being spotted by a head-hunter was as acute as ever. Hastily I checked the timetable and was shattered to find that all the trains to Przemysl had gone. I would have to stay in Lvov until morning. Distressed and disappointed, I walked away from the station as quickly as I could.

What should I do next? Where could I stay overnight? To try to get a hotel room without any luggage was a very dangerous procedure. I was cold and soaking wet, walking in this rain. I took shelter from the weather in the open entrance door to a block of flats.

I decided to return to the restaurant to think about the situation over a cup of coffee. At least it was dry and warm there. The table I had sat at before was occupied now by two elderly men. I picked up the newspaper a previous customer had left behind and sat down.

The young waitress gave me a smile as she took my order. "You must like our coffee, to come back for another cup." I returned her smile, lit a cigarette and looked at the newspaper. A prominent advertisement caught my eye. A German construction company needed tradesmen and semi-skilled workers for their branches in the Ukraine; good pay and conditions were promised to successful applicants. Glancing through the paper, I found five similar advertisements. It was as Adek had described it. I sat back and thought hard. In the light of this, was there any sense in going to Przemysl? Why shouldn't I go back to the Ghetto, have a few days rest and then apply for one of these jobs? I had my Marian

Smolinski papers. I could be lucky. The idea appealed more and more. The Ghetto, which only a short time before had been the last place I wanted to be, now became inviting. My armband and the badge showing "W" with the stamp of the railway authorities, which I had the foresight to bring with me, would get me safely back inside the wooden fence along with other returning workers.

I folded the newspaper, put it in my pocket, then paid for the coffee and made my purposeful way to the place I had been so desperate to avoid. My spirits lifted with every step. By the time I was back inside I was positively grinning. I thought about the events of the last three days. Time and again one thought brought a smile to my face; if the Germans had *really* wanted me to stay inside their camp they should have provided better physical and mental conditions!

Then came the sobering thought: I might be free, but what had happened to Adek and Felka? And what about Giza?

11

I walked quickly through the dark streets. The rain was not very heavy now but the thick fog made the streets look even darker, as if viewed through grey sheets of glass.

I was back in the Ghetto, returning to the little room I shared with Adek and Felka. Back to the place where all efforts to retain human dignity were hampered by short tempers and arguments, especially when waiting outside the common bathroom or lavatory shared by everyone in the building. None of us bothered to use the kitchen, which was overcrowded most of the day and evening. Accusations of stealing or "borrowing" each other's food supplies were frequent and aggressive.

For the sake of Felka's privacy, our room was partitioned with a blanket on a rope stretched across the room. Our furniture consisted of a wardrobe, a chest of drawers, two single beds and a folding stretcher bed which I bought when I moved in with them. We also had a card-table and three chairs. The remnant of a once attractive carpet was still on the floor. I was assured that it kept the room warmer.

After two nights in the Janowska barracks this room would make a welcome change, and how good it would be

to see my friends! Facing the house where we lived, I stopped. The smile on my face disappeared. I might be safe, but what about Adek and Felka? Had they been picked up too? There had been no sign of Adek inside Janowska camp but I could easily have missed him — there were several thousand men there.

I was more concerned about them than I was about Giza, for she at least had a "good" job in the laundry of a big army barracks, where she was responsible for looking after officers' clothes. She would surely have been issued with a "W" badge to show that she worked for the Wehrmacht: that would have given her some protection.

Milek, who worked now with his father in a factory which made army uniforms, would be similarly protected, but Adek and Felka had no badges, and I shuddered to think of the tales people in the camp had told me of what went on in our streets after I was taken away. They said that the Ukrainians and Germans used ferocious Alsatians and Dobermans to flush people out of the houses, and that those who were hiding were mauled before they were shot; anyone too ill to get out of bed was also shot on sight.

My mouth was dry as I knocked and opened the door. I was almost too scared to enter.

Adek was sitting at the table playing chess with our next-door neighbour. We could only look at each other without words.

"Good to see you," was all we could mutter at last. Adek answered my unspoken question. "Felka is safe. She just went to see her friend on the first floor."

Thank God.

"I wish I could offer you a drink," he said.

"I wish you could!" I would have given anything for the comforting warmth of a large glass of vodka.

"We've been out of our minds," he went on. "Whatever happened to you?"

132

I told him. His face was a study of incredulity and wonder. "And I thought we had a bad time!"

"So what happened to you?"

He grimaced. "I wouldn't want to go through that again. We were fast asleep and then there was this hell of a commotion outside . . . you could hear the dogs barking. When we looked for you, you were gone. I soon realised what was going on and there was panic, I can tell you! I ripped up a white handkerchief, found some blue ink, and painted "W" on two pieces. We got dressed and I pinned them on our coats. Then we sneaked out of the place. What had we to lose? Any minute they could have come in and got us! And we were lucky! Just as we came out of the downstairs door, a group of Jewish workers were being marched past on their way to work. We joined them. When we were outside the Ghetto we managed to slip away and hide in a cemetery. God, I've never been so cold! We stayed there all day — and then — you'll never believe this — we saw the same lot of workers being marched back again! So we joined them. We were back in the Ghetto, without any trouble. Once we got inside the flat we stayed put. We haven't been outside the building since. Did you ever know such luck?"

We had all been incredibly lucky.

But what about Milek and Giza? The next day I ventured out. There was always a period of quiet after an *aktion*. To my unspeakable relief I found that Giza was still working in the barracks laundry, and Milek and his father were making uniforms for the Germans. This *aktion* had left them untouched; how much longer will their luck last, I wondered.

Life, such as it was, went on. My mind was full of plans to escape from our wretched situation. Giza seemed resigned to it, living from day to day, trusting in God to save her and waiting for His help to arrive. I was more

than willing to hurry up the arrival with some help of my own.

The jobs in Russia seemed to offer a real opportunity to escape from the Ghetto. False names and documents would be needed, of course. I heard of some young people who had already tried this course of action and failed: they suffered badly in the attempt. I realised the plan was dangerous, but I saw it as a key to open a gate, not necessarily to freedom, but to a fighting chance of survival, especially for those who did not look particularly Jewish. A job . . . somewhere to live in relative security. At least I could be confident of my appearance. And I had the confident step of the competent sportsman. I had many times tested my ability to "pass" by walking around the streets without my armband, and my experiences in the concentration camp, even though they had lasted a mere two days, had convinced me that I had to take my destiny into my own hands.

I was determined not to allow myself to be degraded, made into a subhuman, tortured and finally killed. I was not going to wait for somebody to take away my tin dish and spoon because I would not be needing them tomorrow; no German, Pole or Ukrainian was going to add my name to his scorecard of Jews accounted for. I was twenty years old and failure had never been part of my way of thinking.

A few days later I went to see Giza. Karol was there too, slumped in a chair in their cheerless room. I couldn't get Giza to agree with me. Karol had long ago made it clear that he wanted nothing to do with me and my "mad" schemes.

I lowered the newspaper I was reading and took a surreptitious look at Giza, who was sitting on her bed on the other side of the cold little room. It was heartbreaking to see how she was deteriorating. She had lost more weight,

her eyes were black-ringed, and most disturbing of all, her hair was stringy and untidy and her shabby jumper stained and spotted. It was not like Giza. She had always been meticulous about her appearance, spending hours in front of the mirror. She was reacting badly to being forced to live in this one room in the Ghetto, where she had to share kitchen and bathroom with two other families. And my being taken to the concentration camp had had a disastrous effect on her nerves.

I circled an advertisement in the newspaper and passed the paper to her. *"Tradesmen and semi-skilled workers needed for reconstruction jobs in occupied Russia."*

She read the ad then gave a contemptuous look. "I thought you were never going to work for the Germans again," she said. She did not bother to show the advertisement to Karol.

The atmosphere was as cold as the room. Karol, unable to face the situation they were in and powerless to change it, took out his frustration on other people. As he sat in his chair he was trying to work out their finances; his impatient questions increased the resentment which had grown up between them. It was no place for me. The negative atmosphere was too depressing.

Nothing could stop me. The next day I decided to apply for a job in Russia with the construction company *Hans Kunze Baugesselschaft* of Stuttgart.

"Do it," Adek and Felka urged. Despite Felka's new-found strength an enterprise of this proportion was beyond them.

"We are not ready yet," Adek said, "we don't have your confidence . . . But we mustn't hold you back."

My confidence began to evaporate as I made my way through the city to find the company office. It was raining again. It always seemed to be raining. The dirty grey buildings and the dirty grey trees were blurred in the dirty

grey mist.

"You are Marian Smolinski, a Pole and a bricklayer's assistant," I told myself. "You *are*."

Now it was not just a matter of walking the streets without an armband; I would have to face someone sitting on the other side of a desk who would ask me questions. That someone could be a German or a Pole — or a Ukrainian. Answers to their questions had to appear confident and unswerving and show no trace of hesitation. Could I do it? No! I could not! With an upsurge of panic I realised I had reached the office building. I kept on walking.

My heart was thumping; I was hot, I was cold, my hands were sweating and my legs felt like rubber. Women were standing talking outside shops; traffic was passing. I kept on walking. This was no good. I was walking nowhere. With an enormous effort of will I slowed my steps and then turned around and made my way back to the office building.

"You *can* do it," I told myself. "What you can't do is to give up without trying." I pushed the street door open, walked up to the second floor and found myself in a dingy hallway. A naked electric light globe gave insufficient light to illuminate the signs above doors. Peering, I found the sign that read: "*Hans Kunze Baugesselschaft. Please enter.*"

A middle-aged woman, sitting behind a desk spread with papers, did not look up when I knocked and entered the room.

"Good morning," I said, "I have come about the advert. . . ."

Without lifting her eyes she pushed some papers across the desk. "Fill in this form. There's a pen over there."

I took the form over to the desk on the opposite side of the room and looked around. There were three more tables; at one, two young men were discussing various

conditions of employment, the other two were unoccupied. The typewritten sheet contained about ten straightforward questions: Name, Christian Name, Religion, Date of Birth, and so on. The last question: "Name and address of next of kin" brought home the fact that I was playing a very dangerous game indeed. I hesitated, then put my father's first name and my newly acquired surname, "Smolinski". I used my old home address, Kochanowski Street 45. Casually I glanced through the "Conditions of Employment" section, and found that the rate of pay was fine. Courage and confidence slowly returned as I signed the form, "Marian Smolinski". It was the first time I had made open use of my new name.

I took the form back to the desk.

"Passport."

I produced my forged passport complete with forged birth certificate. This time she lifted her head and looked at me. She seemed satisfied that my face matched the photograph in the passport and immediately gave it back to me.

"Here you are," she said, scribbling on a small card. "Ring this number in three days time. You'll get your instructions. Make sure you are ready to leave at once if necessary."

She was not bothered as to whether I was suitable for the job. It was clear that all she wanted was heads — she was probably being paid on the basis of the number of workers she could come up with.

I thanked her and left the office grinning. So much drama for so little reason! It had been so unexpectedly easy. Now I began to wonder what my workmates would be like. For a young Pole to volunteer to go to Russia to work was like a Frenchman volunteering to join the Foreign Legion — he was either desperate or out for an unusual type of excitement. They would probably be the

loud types I had seen throwing stones into Jewish shop windows.

Adek and Felka were jubilant for me, but still reluctant to make a move themselves.

"You have to go, Marian. You know that. Once the Gestapo is after you they will pressure the Ukrainians to find you. Next time, most probably, Karol will give them our address." Adek hesitated, then, trying to sound cheerful, continued: "We'll hibernate through the winter here, then join you in Kiev. We'll find you through your office. If they send you somewhere else, leave your forwarding address there."

During the next three days I packed and repacked my rucksack. The things I needed for my "business" had to be packed separately from one another; some went into the pockets of my jacket, others into my overcoat pockets and different sections of the rucksack. If they were found together their purpose could be obvious. I put my ink into a small medicine bottle; I could always say it was a good peasant remedy for chills and cold. I had extra passport photos taken on an automatic machine in the city and tried to impress on my mind what kind of childhood "Marian Smolinski" had had, and all the things he would have done in the last twenty-one years.

The night before I was due to leave I went again to see Giza and Karol. "Remember the advertisement I showed you last time I was here?"

"Mmm," Giza replied, without turning around from the dishes she was washing.

"I got a job and I'm leaving for Kiev tomorrow."

She spun around. "What did you say?"

"He is going to Kiev tomorrow," Karol volunteered.

All of a sudden Giza was full of questions and half-accusations. "What is the job?" she did not wait for me to answer. "Why do you always do things behind my

back?'' Her voice was full of reproaches.

I was almost speechless. When I wanted to talk to her she didn't want to know, but when I went ahead and *did* something she accused me of not telling her that I was serious! She had listened to so many people day-dreaming and doing nothing that she had not realised I was serious.

"You really are going, aren't you?" she said. "Then all I can say is good luck! I am sure you'll need plenty of it."

"Yes, I certainly will," I answered, disappointed at her attitude. It was so different from that of Adek and Felka.

"How much money are you taking?" Karol asked.

When I told him he swallowed hard. "It isn't wise to take all that," he said. "You ought to leave at least half of it here for when you come back."

"No fear! I don't know how long I'll be away and I might need every cent. Besides," I added so that only he could hear, "who can you trust these days?" I had only half the amount I had told him, but the chance to impress him had been too good to resist.

"Look after Giza," I said. "And good luck to you both."

Giza came down to the street to see me off. The Ghetto, ugly and depressing in the daylight, was shadowed. We could not find words to show what we felt. Conversation began and broke off, leaving us in uncomfortable silence. I knew that she was trying, as I was, to conceal the thought that this might be the last time we ever saw each other. I pressed money into her hand.

"Please spend it on yourself. Buy some warm clothes, and maybe a nice cake of soap and some shampoo."

"Thanks, Marian," she said. "You know I admire your courage, but I question the wisdom of your decision."

"What you call courage is fear," I replied. "If I weren't scared of what might happen if I stay, there'd be no point in my going. There are times, Giza, when not taking a risk is greater than the risk itself."

We were both crying now.

"God be with you," she said as I turned to walk away. The forlorn words reminded me of those farewells we had not been given the chance to say.

It was just as hard to say goodbye to Adek and Felka. Over the last few months we had become very close and dependent on one another. I had become fond of Felka, and was pleased to see how much she had changed since the first day I met her. Adek and I shook hands, stood for a while looking into each other's eyes, then spontaneously stretched out our arms and tied ourselves in an emotional hug.

"It's not goodbye," I said, "it's *au revoir*."

"*Au revoir*," Adek answered.

I walked up to Felka and gave her a kiss on the cheek. "*Au revoir*."

"I'll miss you," Felka answered, blushing.

My instructions were to meet the transport leader and the rest of the men under the clock on Platform 4 of Central Station at seven-thirty p.m., in time to take the train which departed at ten past eight.

Central Station was still the most dangerous place in Lvov, a hunting ground for hooligans on the lookout for Jews without armbands trying to get away from the city. The bounty of a hundred zloty and a bottle of vodka for each Jew denounced and arrested by the Gestapo had turned many into professional head-hunters; their ability to detect inner tension from an awkward movement or a covert glance was notorious. They played a cruel game, blackmailing their victims and promising them safety, then pocketing the loot and turning them over to the Gestapo. Even today any mention of Central Station, Lvov, sends shivers down my spine.

It was essential that I present myself with the confidence and smiling face of a young Pole with his papers in order, off to make himself some money and perhaps have a little fun. I must show no trace of the uneasiness the station produced in me. I arrived at the entrance hall half an hour early and wandered around among the crowd. I stopped at a news-stand and took a leisurely look through the various magazines before buying a German sports paper. I strolled past the ticket office in full view of the people waiting there. I had no intention of sitting in a dark corner trying to conceal myself behind a newspaper.

There were several knots of youths hanging about. One of them looked at me with what seemed more than usual interest so I gave him a cheerful wink. I *was* Marian Smolinski. As I wandered around I imagined myself deeper and deeper into the role. The pretence was over. Now I had to *be* him. At exactly half-past seven I walked up to the group of men laughing and talking under the clock on Platform 4. There was no mistaking the leader. He was in his late twenties, with a bushy moustache and broken nose. I presented myself.

"Smolinski," he said, shaking my hand firmly. "I am Kazik." He introduced me to the rest of the men. There was a lot of hilarity; it was clear they had already started drinking. "This is the fourth transport I've taken out," Kazik said. "It's always the same!"

He rounded us up, checked off our names on the list and gave each of us an envelope containing money. "Let's have your passports," he said. We all handed them over. I was most unhappy to part with mine. I felt lost without it.

The train was already waiting. Kazik led us past carriages full of German soldiers to the cattle van at the end. A German railway official was at the door. As he called out the name of each man, Kazik presented the corresponding passport.

The van was empty, with a little straw spread around the walls and a hurricane lamp strung up in the centre.

There were twenty-six of us. Most of the men seemed to know each other, for they immediately started to form into groups and get out their vodka bottles. I sat myself down beside a small middle-aged man wearing a shabby Polish army overcoat several sizes too large for him, and a fur cap. He looked a bit overwhelmed and tired. Before the train started Kazik gave each of us enough food to last until we got to Kiev.

"You'll be able to get hot coffee at stops along the way," he told us.

"Not bad!" I said to my neighbour. The half loaf of bread, the couple of cans of meat, the piece of cheese and the packet of cigarettes were more than I had expected the Germans to give us.

"We'll be working for a good boss," the man replied. "My son's been working for him in Kiev for the last three months. He's so happy with the job he persuaded me to join him. We're carpenters. What are you?"

"Bricklayer's assistant."

"We'll probably be working with each other. I'm Piotr Zareba." He offered me one of his cigarettes.

The train pulled out and we all settled down as best we could. Six of the men sat in the centre of the van under the light and played poker and drank nearly all night. Their bursts of laughter and boozy arguments brought repeated cries of "For Christ's sake, shut up and go to sleep!" which had no effect. As the train clacked its way through the night, Piotr talked and talked. By the time I managed to get some sleep, I felt that I knew not only his life history but that of everybody in Piastry, the town from which he came.

When daylight entered the van through small windows high on the walls I was able to take my first good look at

my companions. I sat back and began to study each face like someone studying photographs of the cast of a play in a theatre program before the rise of the curtain. Apart from Kazik they were an unremarkable bunch of rough young fellows, except for . . . I took a second look. That boy of about seventeen who was looking back at me was a student I had seen at the Jewish high school and occasionally at *Dror*! The speed with which we both looked away told us what we least wanted to know. We were each aware of the other's identity.

My mind raced. I had gambled on not finding a Pole who could denounce me on the transport but I had not expected to find another Jew, though why I should have imagined I was the only one likely to be taking the chance I don't know. But surely no Jew would denounce another Jew. I certainly had no intention of betraying him; why should I fear that he would betray me? Once I had rationalised the situation I determined to forget it. I talked to Piotr and ignored the lad.

"What's going on down there?" Piotr asked later in the morning, nodding his head towards Kazik and two of the men who were sitting with their heads together, talking earnestly. To my alarm I saw that they were beckoning the boy to join them and that he had fear written all over his face as he struggled reluctantly to his feet. We were not close enough to hear all the conversation but the vehemence with which the word Jew was spat out made it more than loud enough to reach us. The boy did not even attempt to deny the accusation, but flumbled in his overcoat lining and brought out a small packet. It disappeared into Kazik's pocket in a flash. I hoped that would end the matter, but no, the boy began to plead and clutch at Kazik, who kept shaking his head and trying to push him away. One of the other men, annoyed by the commotion, pointed to where the boy had left his rucksack and roared: "Piss off!"

It was awful to see the white, hopeless young face as the lad did as he was told. He put his few belongings into the rucksack, fastened it, then sat motionless with his head between his knees. They were obviously going to put him off the transport. Would he be going alone or with the "help" of the Gestapo? It was agony to have to lie only about two metres away and watch him, quite unable to do anything to help. The slightest show of sympathy on my part would have brought disaster upon me. I could not bear the sight of him sitting there any longer; what with the strain of joining the transport, the lack of sleep and this fear, not only for him but for myself as well, I was stretched to the limit. Worn out, using my rucksack as a pillow, I fell asleep.

God knows how much later, the altered movement of the train began to make me restless. Piotr gently kicked me on the foot.

"We are coming in to Kazatin," he said. "Time for hot coffee."

My eyes flew open and I looked immediately in the direction of the unfortunate boy. He was pleading with Kazik again.

"I'm letting you go," Kazik said with heavy humour, "what more do you want?"

"My papers. You can't put me off the train without my papers!"

"Can't I? You'll see!"

To turn the boy loose without papers was as bad as condemning him to death; Kazik's big, quite pleasant face was split in a grin.

As the train jolted to a stop and the men began to stream out of the van towards the station canteen, I stayed as close to Kazik and his victim as I dared. The boy was hurrying beside the man, plucking his sleeve. "Please," he kept saying. "Please." Then he said something else which

made Kazik stop. I held back but was still close enough to hear Kazik reply, in astonishment, "If I give you your passport back you will tell me *what*?"

I forgot all about the coffee and doubled back into the cattle van. Was the boy going to betray me? Maybe I had imagined it and he didn't know me after all. Maybe there was another Jew he recognised in the transport. Uncertainty and fear nearly choked me. It seemed ages before the men straggled back and the train resumed its journey. It was getting dark now. There were still four hours to go before we arrived at Kiev. It was cold, the straw was flat and thin.

In the half-light there was nothing to do but talk and I gradually became aware that remarks were being made especially for me to hear. Jokes about Jews became louder and more offensive. The gratitude of the Gestapo towards people who helped them in their work was stressed, with the flick of an eye and a half-grin in my direction. The blood rushed to my head and my knees began to shake. Either Kazik was determined to hand me over to the Gestapo or he was softening me up for blackmail. If it was blackmail, how far could he be trusted to keep his word? I had no idea what had happened to the boy. Maybe he was wandering around without documents and Kazik had refused to pay for the lad's betrayal of me. I was certain now that he had betrayed me and just as uncertain as to what I could do to save myself. Those four hours to Kiev were torture.

I opened my rucksack several times to take out my half-bottle of vodka for a comforting drink, but each time I closed it up again, leaving the vodka untouched. Agitated as I was, and much as I needed a drink, I had the good sense to know that if ever I had needed a clear head it was now. Unfortunately, my clear head was of little help. When the train began to slow down for the approach to

Kiev station I still had no idea what to do. It was Kazik himself who gave me a much needed clue as to what action to take.

As the train was grinding slowly to a halt he stood up and shouted instructions. "We're in Kiev now. Gather your luggage together and wait by the door on the left-hand side of the van. Don't wander about when you get on to the platform. All stay together in one place and wait for me!"

Men began to move about in the semi-darkness, clutching small cases, rucksacks or bags in readiness for the stop.

In the *mêlée* I edged towards the door on the right-hand side of the van and began to ease it ajar. Timing the action to when the train began to shudder to a stop and everybody was busy steadying themselves, I dropped my rucksack on to the track and squeezed myself out after it. I landed in deep snow. Picking myself up as quickly as I could, I struggled back to where my rucksack had fallen, and, clutching it, began to hurry back down the track into the darkness, away from the dim lights of the station. I knew that as soon as Kazik discovered my disappearance he would have the Gestapo on to me. I had to get far away from the station as quickly as I could. I wanted to look back but I did not dare. I was no longer Marian Smolinski, confident Pole with all his papers in order; I was Marian Pretzel, Jew, on the run without any identification papers at all.

12

It was about nine o'clock and the night was piercingly cold. I struggled up the embankment and found myself in a wide, dark street without any tramlines or bus stops. It was quite deserted. Large snowflakes floated slowly down on a light wind and rested gently on the blanket of snow. A peaceful, Christmas-card scene — but there was no star to guide me. I assumed that these must be the outer suburbs of Kiev. I could not stay where a stranger would be immediately noticeable; I had to find my way into the heart of the city and gamble on remaining undetected until I had time to work out what to do next. I began to hurry in what I hoped was the right direction. The crunching of my feet on the snow sounded much too loud. I tried walking more slowly, but it made no difference. I might as well make the best time I could.

After walking fast for about half an hour, I became aware that I was not alone on the road; there was a figure ahead of me. I was in an area now where there were houses and tram-tracks. I speeded my pace even more and caught up with the man. If there was to be trouble, better to face it at once.

"Hello", I said in Russian. "Any hope of getting transport into the city?"

To my relief he laughed. "You too!" he said. "The last tram went ten minutes ago. We'll have to walk!"

We fell into step side by side. He glanced at me curiously. "What are you doing out here at this time of night?"

My facility to lie quickly and with ease came to my rescue. "You might well ask! I was on my way from Lvov to Kharkov with some friends to take up a new job. I got out at Kiev station for a hot drink — by the time I got back the train was moving out. My friends saw me and chucked my rucksack out for me — oh, my God," I went on, stopping to beat my fist against my forehead, "I've just realised! All my documents have gone on to Kharkov with the transport leader!"

The stranger was quietly sympathetic. That was bad luck, but there would be another train tomorrow.

"Will I be able to get on one without my documents?"

"You can only try," he said. "But meanwhile, where are you going to stay tonight?"

"I'll have to find somewhere."

I knew what the documents issued to German employees inside Poland looked like; there was no reason why those issued outside would be very different. I planned to do something about that tomorrow.

We walked in silence. Even in the darkness I could see that the streets were enormously wide. The absence of traffic and pedestrians made the roads look like a glistening, ice-covered river.

"There are some lovely churches and monuments here in Kiev," my companion observed. "What's it like in Lvov?"

Conversation became comfortable as we swung along. After about forty minutes he stopped outside a suburban cottage with a small garden and a few trees in front of it.

"This is where I live," he said. "I'm sure my wife will

be glad to find you a bed for the night. By the way, my name is Nikolai Yvanovitch.''

"Marian Smolinski," I told him.

He cut short my heartfelt expression of gratitude. "Mid-December is no time to sleep on a park bench in Kiev! Come along in.''

The wonderful smell of simmering onions met us.

"Where have you been, Niki?" a woman's voice called. The attractive middle-aged woman who came bustling in put her hand to her throat when she saw me. Her face paled.

"It's all right, Anna. Just a young boy in trouble.''

Everybody lived in fear under the Germans. Here in Russia, strangers might be secret police, Germans on the lookout for faulty documents or even Russians working as underground agents. Her husband calmed her agitation gently, his soft voice surprising for such a big heavy man. She watched my face as he told her my story. For the first time I could see him clearly. He was pleasant looking, with a bushy, nicotine-stained moustache, and although his face was young, thinning grey hair made him look close to fifty. His small smiling eyes suggested a good sense of humour and a constant search for a source of amusement; even my story, which did not seem at all funny to me, brought a smile to Anna's face, the way he told it.

"We have a son about your age," his wife said at last.

I gave them the half-bottle of vodka I never had a chance to drink and the cheese and meat left from the train journey. We had a wonderful dinner.

When it was time for bed, she took me to a nicely furnished room. "This belongs to Yuri," she said. There were photographs of him as a boy and a young man, and several sporting trophies on a chest. She readjusted each one of them with loving hands. I noticed a beautiful, very

old ikon in the corner, and as she followed my glance, she crossed herself.

"He's in the army. We haven't heard from him for such a long time. We try not to worry . . ."

I knew then why she and her husband were being so kind to me. I hoped that somebody, somewhere, was being as kind to Yuri, their son.

I got undressed, put my clothes on the chair and climbed into bed. But sleep would not come. My nerves were too tightly strung. Their friendly, relaxed manner and the way they welcomed me in their home had taken me by surprise. I felt so grateful for this reprieve after the excitement of the last thirty-six hours. Lvov railway station, the ordeal on the train, my escape and the good fortune of meeting this kind man . . . the combination of all these things kept me awake.

After tossing and turning for about an hour I switched on the bedside lamp and took a packet of cigarettes from my rucksack. Lying there, watching the straight silver-blue line of smoke rising from the cigarette becoming gradually distorted and then dispersed, the designer in me took over and I began to play at creating patterns, trailing the cigarette along slowly, puffing out smoke now softly, now strongly.

What was I doing? The realisation that this, of all times, was not one for idleness hit me forcibly. In a few hours I had to be on my way. Where? How? The problems I would have to face tomorrow had to be solved tonight.

By now my passport had probably been handed over to the Kiev office of Hans Kunze Baugesselschaft, the employer I had hoped to join, or to the Gestapo. There was no hope of getting it back.

But — and now I was beginning to think clearly — nobody working for a German firm was likely to get his passport back until the job was done; this would ensure

that an employee could not run away or change his job.

So I could do without a passport for the time being. What I wanted was the document I would have been given in exchange for it. In a city like Kiev everyone would need a document of some sort as proof of identity. Realisation came in a flood of relief. I had the extra passport photographs which had been taken before I left Lvov! The type of document that German firms issued showed a photograph of the holder, certified his identity, stated that he was a tradesman employed by the firm and that his personal papers were being held for the duration of his employment. It should be relatively simple to forge something that would get me by. Here in Russia, typewriters naturally had keys showing the Cyrillic alphabet; machines with German-faced keys were likely to be rare in the smaller towns. As long as the document was in German and carried convincing stamps, there was no reason why it should not be handwritten.

For such a terrific idea I rewarded myself another cigarette. The question now was, who would I claim to be employed by? It obviously could not be Hanz Kunze Baugesselschaft, but was it better to invent the name of an employer or to use the name of a real company? A real company, I decided. The name could be checked and if the office staff said they had never heard of me, I could always say I was new there and they probably hadn't got around to processing information yet: the intake of new employees must have swamped them. Good enough. Good enough! And that was enough hard thinking for tonight. I switched the light off. My brain and tired limbs began to relax at last. . . .

I woke up coughing, my eyes stinging. The room was full of smoke and there was a red glow beside my bed. I had fallen asleep with the lighted cigarette in my hand. It had dropped on the rucksack and set fire to it!

I ran to the window and tried to open it. It was stuck fast. I ran to the door. It was locked. I banged frantically on the stout wood, shouting as loud as I could.

I put the light on and saw most of my possessions smouldering away. I had only my bare hands with which to try to put out the fire. Were all the efforts of the last few months to end in disaster? Was I to die trapped in a fire of my own stupid creation? It seemed too cruel to have escaped the horrors of the camp for it all to end like this. I banged and shouted louder than ever. By now I could hardly keep my eyes open. The smoke which had replaced the oxygen in the room choked me. I couldn't breathe. I started to panic, and knew real terror before I heard the key grating in the lock and Nikolai opened the door. I ran out gasping for air, then collapsed on the floor in the living-room. When I came to, my half-burned rucksack was lying in the snow outside.

It took three cups of tea before we all calmed down. Slightly shamefaced, Anna said that they locked the bedroom door "in case"; they could not be *really* sure that I wouldn't rob them or even . . . And they always nailed the windows during the winter. I said I was sorry about the cigarette. She poured out more tea all round.

Fortunately there was no real damage to their house and though the rucksack might be a write-off and the clothes in the top part of it ruined, the important things inside, my forging implements, were safe. Still shaky, we went to bed for what was left of the night. They did not lock my door this time.

At breakfast the next morning, I began apologising all over again but Nikolai cut me short.

"No harm done," he said, "but there could be if I let you stay here without reporting you to the local police.

It's their strictest rule. All strangers have to be reported to them and registered.''

"I'm going," I said quickly. "I can never thank you enough — and I'm so sorry . . .''

"No more of that!" he said. "Now, is there anything you need to help you on your way?''

"I could do with some writing paper. And may I stay just for the morning so that I can write home and tell them what has happened?''

Anna brought me a cup of tea and some writing paper and I sat peacefully in their quiet dining-room and set to work.

This was my first experience of making a document for my own use. I had done this kind of work for other people, for money, for food or clothes and for free. Now I was going to test it for myself and find out how good a forger I really was.

I had seen the sign of the company "Ludwig von Stuck & Co., Munich" in a street where demolitions were taking place. Their name would do and the document could quite logically have been issued two months ago in Kazatin, a small town between Lvov and Kiev.

I glued my photograph to the paper and began to make the stamps. I did not have stamps to copy, so I had to design them. There had to be an oblong one for the top left-hand side of the paper and a round one showing the name of the employer to go over the photograph.

I designed the stamps, carefully traced them, then transferred the tracings to the back of an old photograph — this gave a mirror-reverse image, reading from right to left. I used a fine mapping-pen and stamp ink to ink in the lettering and design, and attached the mapping-pen to a compass to enable me to make a perfect circle around the lettering of the round stamp. Milek's discovery of newspaper as the blotting agent was used thankfully, and

before long I was able to press the drawings against the paper in the required positions and rub the back of the photograph gently with the edge of a comb to make sure all parts of the stamp were legible. I had to wait until the stamps were completely dry before rubbing out all traces of the pencil tracing.

Now I had a document which proved that I was an employee of Ludwig von Stuck's and that my passport was being held by them in their central office. Studying it carefully I was amazed how simple the forging process had become; it now took only about ten minutes. I gave the document one more critical look and with a smile of approval folded it neatly and put it into my wallet. Now to see if it was as good as I thought!

Kiev railway station did not hold the same terrors for me as the Central Station at Lvov. Nevertheless, any station was a hazard; all travellers came under inspection from officials of one sort or another.

Possibly because the cold weather made the idea of moving south more attractive than farther east, I had changed my destination from Kharkov to Dnepropet-rowsk, on the River Dnepr. Both cities were about four hundred kilometres from Kiev, and it was quite logical to have come to Kiev to pick up an express train south. The sergeant at the German Transport Office was a mild man who listened without showing surprise or even much interest to my story of being left behind while the train went on with my companions, my passport and travel documents to Dnepropetrowsk.

"Fortunately I have this," I said, showing him my recent work of art. He looked at it and sighed.

"I suppose I'll have to give you a substitute document so you can catch up with your work transport, but there isn't a train till this evening."

"That's all right."

I was outside the station with a new travel document in my pocket in no time at all.

On my way back to say goodbye to Nikolai and Anna I bought a bottle of vodka as a thank-you present and a briefcase to replace my burnt rucksack. I needed a fresh supply of paper to make my stamp-making equipment ready for further use, and though my extra clothing was a write-off, I was at least fortunate that the clothes I put on the chair the night before had been saved. The half-burned towel was still of use and so was my shaving gear. I had been lucky yet again!

I gave Anna the vodka. "I hope the war is over soon and that Yuri will come home safely." Her eyes brimmed with tears as she wished me good luck. Nikolai insisted on accompanying me part of the way back to the station, in spite of obviously being tired out by the long hours and rotating shifts the Germans made him work. Before we parted we shook hands and I thanked him for his help from the bottom of my heart.

"If anything goes wrong with your trip, don't hesitate to come back to us," he said.

When I hear people talk about humanity and sincerity I always think of Nicolai Yvanovitch. Here was a kind man. A Russian. He picked up a stranger at night and not only invited him to his home but continued to help him even when the stranger almost set his house on fire. He took a personal risk in helping someone he had never seen before and would probably never see again. Such kindness, I have found, belongs more to the uncomplicated people who behave by natural instinct than to the well-educated and sophisticated members of society.

Once again I travelled in a goods van; this time my mind was much more at ease than when I made the last journey. My main feeling now was one of intense loneliness. Loneliness made me think of Giza, Milek, Adek and Felka. In

155

fact, Felka was on my mind more than I was willing to admit, even to myself. After living in the same room with her and Adek for the last three months, I had become fond of her. Now the fact that I was missing her disturbed me. I did not want to get attached to anybody. I was not ready for it and did not want any responsibility. My obsession to survive did not include any outside distractions.

It was a long and blessedly uneventful journey and I had all the time in the world to think and to lay fresh plans; but thought proved fruitless. Every idea I had seemed as good as the one before. I could not make up my mind about anything. I could not even make an objective assessment; it was as though, all ideas having come from the same source, that source was refusing to challenge its own brain-children. I needed the cut and thrust of debate with my friends, their sharpness of mind to set against my own so that the all-round view could be taken and the correct decision made. But I had no friends I could turn to; nobody I could depend on but myself, and if the decisions I made were wrong I would not live to make any more. That cold and frightening thought took possession of me and all speculations became futile. In the final analysis I had to rely on my own intuition and good luck. I felt desperately lonely, and I did not know whether to be glad or sorry when at last the train reached Dnepropetrowsk.

I got away from the vicinity of the station as quickly as I could. It was a pleasant enough town and the day was crisp and windless, with the sun occasionally showing through the clouds. I bought a hot *piroski* and a mug of tea at a food stall, then picked up a local newspaper to see if any jobs were advertised, and took it into a park to read. I brushed the snow off a bench by a frozen pond and began to look through the paper, but I could not concentrate. A new

156

idea was beginning to niggle at my mind and I was growing excited.

I decided to go back to Lvov!

I had managed to talk my way into getting travel documents from Kiev to here; was there any reason why I could not talk my way into getting travel documents from here to Lvov? Audacious it might be, but it was worth trying. With all I had learned recently about what kind of papers are required, and my proven ability to make satisfactory forgeries of them, perhaps — no, not just perhaps, most definitely — I would be able to get back to Lvov, and once there, help Giza and my friends make their escape! At last the way ahead beckoned. I had made a plan and had a fair idea how I could carry it out.

I took a piece of paper from my briefcase and began to make notes. I decided that the easiest way to get to Lvov would be on an *Urlaubschein*, the document given by an employer to an employee who was going on leave. It was directed "to whom it may concern" and asked any authority to whom it was presented to give the bearer assistance in travelling both to and from his destination. My German might not be perfect but it was good enough for such a simple request, especially as the first documents Milek and I made for Salek had been *Urlaubschein*. I had looked at them often enough to be able to remember the exact wording. The first thing I needed now was a typewriter with a German typeface.

I left the newspaper on the park bench and went straight back into town. I soon found an office advertising typewriters for hire.

"Have you a German typewriter I could use for about half-an-hour?" I asked the woman in charge.

"The charge is in fifteen-minute units," she said, quoting an outrageous figure. It was a case of take it or leave it, as we both knew. I sat at the typewriter and after four

attempts had a perfectly good *Urlaubschein*. Ludwig von Stuck & Co. of Munich came in useful again. This time they issued a polite request to any authority Marian Smolinski might approach for assistance in travelling to Lvov for four weeks leave, starting on 19 December.

By the time I had finished typing it was just after five o'clock and already getting dark. Heavy grey clouds hung in the sky like old army blankets, intensifying the oppressive gloom. I would have to find somewhere to stay for the night.

I bought food and a bottle of vodka at a market, then set out to find a narrow street of small houses. The poorer the neighbourhood the less the risk would be.

Peering through the curtains of a house which seemed promising, I saw an elderly woman and two little girls sitting at the table eating. The house looked clean and tidy and the woman's behaviour towards the children was affectionate. She looked as though she might be willing to give a bed to a young stranger travelling alone.

I knocked on the door gently so as not to frighten her. She opened the door only a crack and my well-used tale of how I had missed my train did not impress her.

"I don't allow strangers into my house," she said, "and there's no spare bed."

It was a moment for quick thinking. "That's a pity," I said. "I didn't want to have to eat outdoors in this cold weather. I have plenty of food and a bottle of vodka. Couldn't you let me at least come inside to eat? I'd be happy to share some of it with you."

She gave me a long look, measuring me from my toes to the top of my peaked cap. I replied with a friendly smile. Her eyes finally came to rest on my bulging briefcase and stayed there. I could see that she was tempted. After a few anxious seconds she clicked her tongue and nodded her head.

"All right, then. Come in." And she opened the door wide.

The room was bright and warm. To show my good faith, I put all the food on the table as soon as I had taken off my overcoat. My hostess's eyes never left the bottle of vodka. I opened it at once, Russian fashion, by hitting the bottom of the bottle with an open palm until the cork rose sufficiently to be pulled out easily. Two glasses appeared on the table with the speed of light.

"*Na zdorovye!*" (Good health!) I said.

"*Na zdorovye,*" she replied.

The two little girls were about eight and ten and it was good to see the way they tucked into the food. The thin borsht they had just eaten had obviously not filled them and their eyes lit up when they saw the sausage I gave them.

"And there's enough for tomorrow," I told them.

"What's your name?" the woman asked when she came back from putting the girls to bed. "Mine's Kazarin. Elena Kazarin."

"Marian Smolinski."

"Well, young Smolinski, how about the rest of that bottle?"

I poured out two more glasses. She settled down on one side of the fire and put her feet up, gesturing to me to take the chair on the opposite side. It was wonderful to feel so warm and comfortable.

"Now we will drink to my husband," she said, "dead and gone — but never forgotten." We drank to him.

"Now to my family — far away in Russia. Fill up the glass."

Clearly it was not the food or money I had offered which had made up her mind to let me stay. We drank to the future of the two poor orphaned little girls; then we started on the blessed saints. I took only moderate sips

159

because she was determined to include every saint in the calendar. I kept my eye on the amount of vodka left in the bottle; by the time we were below the last quarter she was crooning Russian songs to me.

"*Polatchok*! *Polatchok*!" (Young Pole!) she sang, her voice surprisingly sweet. She had a soft spot for Poles, she told me. "Kindly people! I do washing and ironing for a Polish family and they don't forget me when they make their *somogon*." I knew that *somogon* was a most potent moonshine spirit made from beetroots or potatoes.

"They might bring some tonight. Won't they be surprised to meet another Pole!"

The last thing I wanted was to be confronted by fellow Poles and their inevitable questions. I poured out the last of the vodka and took a deep drink. Then I let my head drop. "I'm sorry, but I'm so tired I can hardly keep awake and I have to be away early in the morning. Could I please go to bed?"

"I wanted you to meet my friends," she said, sounding genuinely disappointed.

"It would be nice, but . . ." I let the words trail off and closed my eyes, rocking gently in the chair.

"Ah, well . . ." She went to the room where the two girls slept, lifted one sleeping child from her bed and put her in with her sister. I tried to protest but she frowned me into silence.

The bed was beautifully warm from the child's body and very comfortable. I really was exhausted and it was wonderful to lie there, my mind for once at rest. Things were working out better than I could have hoped. I enjoyed imagining the reaction of Giza and my friends when I appeared back in Lvov after only being gone for a week. There was, however, a slight worry still about Mrs Kazarin's Polish friends.

I had only been in bed a short time when I heard voices

and the sound of laughter and excited conversation. I turned my face into the pillow and pulled the blanket high.

As I feared she would, Mrs Kazarin was soon at the door calling softly, "*Polatchok*! *Polatchok*!"

I made no answer and kept breathing deeply and evenly, hoping desperately she would go away. She waited for a second or two, then as she began to close the door I heard her say, "Poor boy. He was so tired, and he had a lot to drink. Probably not used to it. It would be a shame to wake him."

I had the best night's sleep for months.

"You were tired," she said to me in the morning. "My friends were sorry not to meet you." She had put out the rest of the food I had given her on the table and the little girls were already sitting down and tucking in.

"It's a better day outside, thank goodness. How soon do you want to be off?" she asked.

"Would you mind if I write some letters before I go?"

"Of course not. Eat up, then I'll clear the table."

The children smiled shyly as I sat down with them. The rest of the sausage was soon gone.

The table was cleared and the children shooed away to leave me in peace, and I was able to settle down, unobserved, to make the necessary stamps for the leave pass. I kept my working tools concealed beneath a piece of paper in case Mrs Kazarin came back into the room unexpectedly. Making the stamp did not take long. It looked good to me. The typewritten sheet with the *Urlaubschein* would surely not excite suspicion. I put everything away very carefully and gathered my things together. "Time to go, Mrs Kazarin!"

"Don't miss your train this time!"

I gave her money for her kindness. "And that's to buy some sweets for the children."

161

"Spaseeba Polatchok."
We said quite affectionate goodbyes and then I was on my way to the station.

The leave pass with the stamp *was* good. The German railway official to whom I handed it read it, made out a travelling pass for me and said there would be a train in an hour's time.

The tantalising smell of food was coming from an army canteen where I saw that food and food parcels were being handed not only to German soldiers, but also to civilians in shabby quilted jackets and fur caps. I hung about outside the canteen and stopped one of them as he came out.

"How is it that you're allowed in there?" I asked.

"I work for a German company in Sebastopol. They gave us a document which entitles us to get food supplies from the army canteen."

"My firm didn't give me one," I said, offering him a cigarette. "I reckon they ought to have done. All I got was this." I showed my document. "What did they give you?"

He brought out a *Marschbefehl* (an order to travel). It was very like my leave pass, but in addition to the company's stamp it had a round army unit stamp, showing the unit number and the German eagle. It was identical to the stamp Salek Meissner had given me to copy first of all. I could practically make it blindfolded!

The knowledge was invaluable. I was sure I could make use of it, but I would have to check it first. Where would I carry out the experiment? I decided on the town of Cherkassy. I could stop off there on the way to Lvov quite easily.

I found an empty corner with a lot of straw in a carriage where there were a few young men wearing Western-type clothing among the locals. To avoid having to talk and

162

leave my face open to scrutiny, I pulled up the collar of my overcoat, put my head down on my briefcase and settled in for a long journey.

It was mid-morning when, stiff and cold, I joined the soldiers pouring off the train at Cherkassy. They headed for the canteen, eager for a cup of hot coffee and a few minutes by a warm stove before continuing their journey. I waited about on the platform as unobtrusively as possible. The twenty minutes before the engine gave a sharp whistle and puffed out a great cloud of steam to announce its imminent departure were spent in rehearsing my new ploy and working up my confidence.

I waited for a few minutes after the train had gone, then walked briskly into the canteen. It was empty except for a Red Cross nurse and a sergeant behind a desk. I went up to him, and as I had seen done so often, I raised my right arm smartly and with great inward reluctance said my first ever: "Heil Hitler!"

He looked at me but did not bother to answer.

"Could I have a *Marschferpflegung* for two days, please. I am on my way to Lvov for holidays." I put my *Urlaubschein* in front of him. His tired eyes measured me from top to toe, before even giving the document a glance. He had an odd face, expressionless and pale. The colour must have left it a long time ago; he looked like a man who had been sick for years. His eyes were puffy and half-closed, as if he was ready to fall asleep. He picked up the document, peered at it and started reading it slowly, checking the stamp, and finally handed it back to me.

"This is an army canteen. We provide for army personnel only. Sorry."

I stood there looking at him, trying to remember all the arguments I had prepared since the idea first entered my mind.

"I know. That's why I'm here. I am working for the

Wehrmacht and I am getting paid by the Wehrmacht."

"If you are working for the Wehrmacht, how come they didn't endorse your *Urlaubschein*?"

The logical question staggered me. I could not think of an answer. Finally, in a voice full of naive ignorance, I said: "I don't know why the stupid Russian clerk didn't get it for me. It wasn't my job to check the document. I was given *this* piece of paper and was told I could collect a food supply on the way." I smiled.

He did not smile back. "Sorry. I can let you have food in the canteen but I can't let you have a travel supply. Not without the proper document."

This was an argument I had to win. Too much depended on it to give up easily. "But I've still got a hell of a long way to go," I said. "Of course I am entitled to food supplies. My firm is a semi-government organisation and we work for the army and get treated well. Do you think they'd send me all this way if they thought I wouldn't be able to get food?"

Four soldiers had entered the canteen and gone straight up to the Red Cross nurse who was serving food and coffee.

"Go on; get yourself a warm drink. The food is over there as well."

I decided not to argue any more. What I needed now was time to think. "Thank you," I said. "I am very grateful."

The huge room was filled with wooden tables and benches. In one corner there was an iron stove on which three large urns were steaming. Aluminium mugs and plates were stacked on a table in front of it together with a shallow box containing cultery. The Red Cross nurse stood between the table and the stove, a tall, buxom woman of about forty. Her reddish hair was scraped back from a pale face bare of make-up and was tied tightly at the back of her head.

One of the soldiers pushed past me, holding up his index finger to indicate one serving of food.

"*Jawohl*!" The pride and efficiency with which she placed before him a steaming dish of soup, a large chunk of bread and a mug of coffee left no doubt at all this was her domain and that if anybody had other ideas they had better watch out.

"Next!" I edged forward and held up my index finger. She plonked my serving in front of me. I went and sat at the table near the sergeant. The hot thick pea soup with big chunks of meat in it was the best food I had had for a very long time. I ate slowly with deep enjoyment, every now and then stopping to concentrate upon my next move.

"Don't let your soup get cold, young man!" the woman called, wagging her finger at me like a school-mistress.

I turned and gave the sergeant a look, and we both half-smiled.

"It *is* good!" I called back.

And if the food in the food parcels was as good as this, there was no way in which I was going to be without one. If only I had the right stamp I would be able to travel at will on German trains and the Germans would feed me.

More soldiers were now coming into the canteen; that could only mean that the train was due. I had finished my soup; the dish was wiped clean with bread. I got up from the table and went over to the sergeant. He was just closing a large ledger and looked up with something of a smile. His face was not unkind.

"I am very grateful to you," I said, "that was a wonderful meal. I needed it." Then I went on: "If I were in Archev where I work or Lvov, where I'm going for my holidays, I'd get a food card automatically, but because I got stuck in Cherkassy I can't. I know it's my own fault. I should have listened to my mother; she always told me

to do things for myself and not rely on other people." He was listening. "I shouldn't have left it to that clerk — I should have got my document stamped myself — so — if I go hungry for the next two days I've only myself to blame." I gave a wry smile and a shrug. "It seems that mothers are always right!"

The watery-blue eyes under the puffy lids softened. He seemed to be looking at me with a new friendliness.

I took my document out and showed it to him once again. "Look, you can see the name of the company I work for. Surely that is proof I'm not trying to get something I'm not entitled to."

He fiddled uncomfortably with the fountain-pen in his hand.

"Please," I said. Although I hated to plead, it had to be done. It was not just the stamp for food for this journey I needed, I must know what the stamp looked like, to be able to copy it for future travels. I kept the document in front of his face, willing him to take it and stamp it.

He clicked his tongue and sighed, shaking his head. "Well . . . I suppose nobody wants you to starve." He took the document, studied it again, then brought out a stamp from the desk drawer, and pressed it carefully first on the stamp-pad and then on the document. He opened the ledger again, carefully copied down all details of the document, and turned the book round to me and handed me his pen. "Sign there." "*Marian Smolinski*," I wrote.

"Hand in the paper over there and they'll give you enough food for two days. That's more than enough to get you to Lvov."

"Thank you! Thank you very much."

He looked almost pleased.

I collected my food parcel and went out to the platform. My knees were beginning to shake. I could hardly believe

my luck. I lit a cigarette and pressed my forehead against a frozen window-pane. The shock of ice went right through my body. I pulled myself together and looked around. Soldiers were coming out of the canteen, blowing on their hands and sending up white steam; a few Russians, wrapped in their *fufajkas*, fur caps pulled well down over their faces, were walking briskly up and down the platform, swinging their arms to keep the circulation going. The snow-covered face of the clock said ten minutes to two. The train would not be long. In two days I would be back in Lvov. I wondered what Giza and Karol would think to see me back in the Ghetto . . . Then realisation struck. To get back into the Ghetto I would need an armband and a "R" or "W" badge. I was walking out of the station within a second, looking for a market-place to buy a white handkerchief and safety-pins.

Cherkassy was not a large town. As I walked, I was struck by a thought, the insanity of which at first brought a smile to my face, then made me laugh uncontrollably. I felt that I was on a winning streak. I could not stop laughing and was eager to try my luck. I was cocky. Why not? I kept asking myself. Even if I was refused the refusal would certainly be accompanied by an apology, something like: "Sorry, but I can't give it to you," or "Sorry, you're not entitled to it."

If I could persuade the Germans to supply me with food, why shouldn't I persuade them to give me accommodation too? Besides, another official stamp added to my collection could be invaluable. My story was already forming in my mind.

Back at the station, I had a good look at the timetable for the following day and quickly rehearsed what I would say. Then, gliding into the office of the Transport Kommandatur, I went up to the corporal sitting at the nearest desk and produced my papers.

"Could I ask you a favour?" I said, "I am on my way to Lvov for my leave and my sister works in a hospital some twenty-five kilometres away. I would dearly love to see her but there's no train there until tomorrow. Could you find me accommodation for the night?"

He was most hesitant. Not giving him a chance to refuse, I quickly pointed to the newly acquired supply stamp and continued. "As I was entitled to the *Reiseferpflegung*, surely the same would apply to being given a bed for one night?"

He studied my face for several seconds. It seemed a lifetime to me. He must have seen the logic of my argument, for he stamped my document and told me how to find the billet. To justify his action he said with a smile: "You're fortunate the Wehrmacht *Ubernachtungsheim* (army overnight accommodation) is practically empty now."

I walked out in a daze of joy. Much more important than the food supplies or the bed for the night were the three official stamps on my document, and the knowledge of how to obtain them. To have original, up-to-date stamps to copy was most essential. I was gradually coming to realise the *real* importance of a stamped document. By virtue of these stamps, my forged document became authentic. To a German, one stamp on a document meant that someone had checked and passed it; several stamps meant that several officials had checked and passed it. Respect for official procedures was ingrained; a well-stamped document was unlikely to be questioned. Know your enemy. The German mentality was odd; the trick was to find ways in which it could be exploited. It seemed I might have found one.

The army barracks was a warm, welcome refuge from the cold and windy weather and the two soldiers in the room I was given were friendly and incurious as to what

The Pretzel family in 1934

Giza Pretzel, Lvov, 1939

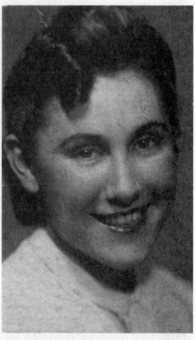

Binka Lipper, Giza's best friend, who, with
her family, shared the Pretzel's family holiday

The tools of Marian, the forger

Ludwig von Stuck
Baugesellschaft G.m.b.H.
MÜNCHEN

Zweigstelle *Kazatin*

Kazatin 18 Oktober 1942.

Bescheinigung

Es wird hiermit bescheinigt dass der polnische Arbeiter Marian SMOLINSKI *geboren am 15 März 1921 in Tarnopol bei unserer Firma angestellt ist. Diese Bescheinigung mit dem hier angeschlossenem Lichtbild und seine persönliche Unterschrift ist zwecks Feststellung der Identität des Obergenanten ausgestellt worden (als provisorischer Personalausweis)*
Seine Personaldokumente
a) Geburtsschein
b) Russischer Pass № P/17752/L
sind in unserem Büro hinterlegt.

Im Auftrage
Lena Unaschorn
(Amtsleiter)

The first document Marian forged for his own use, Kiev, December 1942

Dniepropetrowsk den 19 Dezember 1942.

U R L A U B S C H E I N

Der bei uns Angestellte Polnische Arbeiter
 Marian SMOLINSKI
ist vom 21 Dezember 1942 bis 22 Januar 1943
beurlaubt und begibt sich nach Lemberg und zurück.

Er soll am 23 Januar 1943 den Dienst hierorts wieder
antreten.

Es wird gebeten ihn ungehindert passieren zu lassen
und jede notwendige Hilfe und Unterstützung
ihm zu gewähren.

Im Auftrage

Amtsleiter.

The "leave pass" Marian used to return to Lvov

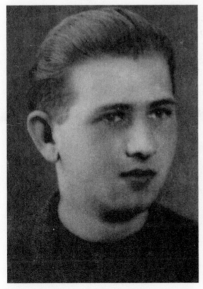

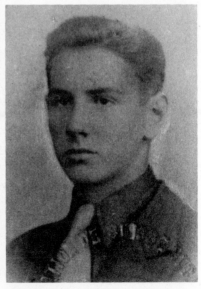

Marian in Kiev, showing the effects of three
months of idleness and good food

Janek Fuchs, Marian's lifelong friend, as
Marian first knew him in Kiev, 1943

A church in Dragasani

(From right to left) Rysiek Pfau, his girl-friend Annia, and Marian share a park bench in Dragasani with a friend.

Sitzplatz
Exk. 4.5.44 W/G 5/18

Geprüft
Tscherkassy 30/5/944

Otto Stingl
Baugesellschaft
WIEN – MÜNCHEN

Zweigstelle Archev.

Marschverpflegung
Erhalten Archev 1/5/44

Wehrmacht
Übernachtungsheim:
Fastov 3.5.1944

GEPRÜFT:
Fastov 3/5/44

M A R S C H B E F E H L

Der bei uns angestellte Volksdeutsche
Marian SMOLINSKI

begibt sich am 2 Mai nach Wien (über Budapest).
Infolge der Auflassung der Archev Zweigstelle
ist er zu; unserer Haupstelle Wien abkommandiert.

Es wird gebeten ihm ungehindert passieren zu
lassen und jede notwendige Hilfe und Unterstützung
zu gewähren

Wehrmacht
Übernachtungsheim
Nikolayev 3/5/44

Dienststelle
Feldpost

Otto Stingl
WIEN MÜNCHEN
Baugesellschaft

Im Auftrag
Hpt.

Amtsleiter
Marschverpflegung
Erhalten 2/5/44
Tscherkassy

Archev den 1 Mai 1944.

Forged document used on the journey to Budapest to rescue Helen Sobel

Bronek Katz, Bucharest, 1944

Marian in Bucharest, 1944, after
returning from Budapest with
Helen Sobel

Janek and Marian make a deal with a Russian soldier in a Bucharest street.

Marian, Rysiek and Annia in Bucharest

Marian in Bucharest in 1944, wearing his Tyrolean Borsalino hat

Young men about town, Bucharest, 1944

a civilian worker was doing there. They were relaxing in steamy warmth, feet up, and holding mugs of coffee in their hands. Before long, with polite goodnights, we all turned in.

Lying in a comfortable bed, in complete safety, my stomach full, my mind at ease, I realised that the places I feared most might have been the safest: the proverbial "lion's den". Would any Wehrmacht NCO suspect a young Polish labourer asking for a bed overnight to be a Jewish escapee from a concentration camp? Then my thoughts drifted to the Jewish boy who had made all this possible. Had he really denounced me? I could not blame him if he had. I did not know how I would have reacted in similar circumstances. Did he get his papers back or did Kazik cheat him? Wherever he was now, I wished him all the luck in the world.

But what an incredible twist of fate! Instead of feeling hostile towards him, I felt grateful. But for my fear of what he might have done, I would never have got away from the train, I would have gone on to Kiev and worked for the German building company, and then, one day, I might have been discovered. . . There was no need to pursue the thought. The irony was that as far as he would know if he *had* betrayed me, I would now be in a cell in Kiev being tortured or waiting to be shot, instead of which . . . Whether I would have felt so benevolent towards him if I had been caught is, of course, a different story.

For the German-Italian occupation of Europe in 1942, see map 4, p. 340, and for the Russian front in 1942, see map 5, p. 341.

13

I enjoyed a good night's sleep in the barracks and had an excellent breakfast in the company of the two cheerful German soldiers. Then I walked back into town. I made myself a white armband with the blue Star of David and felt that under the circumstances a celebration was called for, so on the way to the railway station I bought a bottle of vodka. Sitting on a park bench, enjoying the cold, crisp morning air, I bent my head back, tipped the bottle up and took a deep satisfying drink. The spirit hit my stomach, spreading an immediate warmth, and gradually, as I took another drink, and another, a glow spread through my whole body. Relaxed and happy, my thoughts grew more positive as the level of vodka in the bottle sank. Hope had been overcoming despair from the time I received the food supply; the ease with which I obtained overnight accommodation and my acceptance by the German soldiers made it even stronger. Now, all that I'd learned in these few days fell into place. Realisation dawned. I had found a way to survive the war! I could always travel on German trains, eat German food, sleep in German barracks and mix with German soldiers without fear!

I had an overwhelming urge to tell somebody. I wanted to stop people walking past and shout: "I've found the way to survive." I felt like singing at the top of my voice: "Nothing, no one can stop me now! I did it! I did it!" And not only that — given commonsense and a bit of luck I could help Giza and my friends to survive, too!

Aware that the vodka I had consumed might have had something to do with my exhilaration, I forced myself to control these feelings.

Looking back now, I realise how great a part luck played in my eventual survival; there were so many fortunate incidents. No particular one was solely responsible, but the discovery I made on the 21 December 1942, alone on a park bench in Cherkassy, must surely be one of the most significant of all.

The railway line ran beside the road. Refreshed and happy, I dropped down to the track and began to walk beside the lines towards the station. I was already making a mental list of people I would try to bring back here with me; I felt sure that the Ukraine was the place where we could wait safely, perhaps even in comfort, for the end of the war.

About a kilometre from the station I saw a long train with Italian markings in a siding. It had passenger and goods carriages as well as table-top carriages holding tanks and guns. Bunches of soldiers were clustered in groups along the train; from their laughter and lively gesticulations I could tell they were Italians. As I came closer, two of them broke away and came over to me, and though I had no Italian and it was their only language, a spirited mime soon showed that they hoped I would buy some of the goods they were thrusting at me: blankets, pistols, hand-grenades, rifles — even machine-guns. I showed them my empty pockets and when they realised I was neither German nor Russian, their friendliness increased.

"*Polonia*!" they cried, patting me on the back and calling some of their comrades to join us. The strong wind and heavy snow made it difficult to talk, so they invited me into their goods carriage for shelter.

I found out then just how well people of goodwill can communicate without a common language. With arm-waving and eye-rolling, comically histrionic expressions of joy, fear and every emotion in between, they gave me to understand that they were on their way home to Italy after spending three months helping the Germans to besiege Stalingrad. It was clear that they had had a gutful of Germans, the war, and especially the cold Russian winter. They could not wait to get home and were prepared to sell everything not nailed down to find money for wines and spirits. I managed to ask them if their westward journey home would take them through Lvov. They did not really care where it took them as long as they got home, and when the train started I did not care where it was going either, it was such a pleasure to be in friendly company.

The Italians treated me with the pleasant attention one gives to a guest, and when I brought out my bottle of vodka, which was still nearly three-quarters full, the effect was magical. Out came great hunks of beautiful cheese, bread and cold meats; a cloth was spread on the floor of the carriage and we had a real feast. When the vodka was gone they brought out bottles of red wine and the party started all over again.

The little iron stove in the middle of the carriage was kept well stacked with wood and we sat around its warmth, singing and laughing. Gradually, men began to fall asleep and only the quiet humming or whistling of relaxed soldiers accompanied the rhythmic sound of the wheels on the tracks as we travelled.

To keep the conversation going, I asked one of my companions: "Where are you from?"

172

"Turin."

"And you?" turning to one of the others.

"Palermo. In Sicily. And where do you come from?"

I took a pencil from my pack, and, on a piece of paper in which the cheese had been wrapped I began to draw a map of Europe. I pin-pointed the principal cities. I indicated Poland, Warsaw, and then made a great circle around Lvov. "Home," I said.

They were much more interested in the fact that I could draw than in the location of my home town.

"*Artiste! Artiste!*" they said excitedly and called out something to a big fellow with cheeky, smiling eyes and a big moustache, who looked more mature than the others. He laughed, opened his kitbag, took out a book and brought it across to me. It was about the size of an exercise book, fifty or sixty pages of light cardboard bound together with white ribbon; the cover showed an illustration of a young girl and seven dwarfs.

"*Bianca Neve*," they said, grinning with delight as I opened it and took a look at the first page.

"Ah, Snow White!" I said.

There can never have been a *Snow White and the Seven Dwarfs* like this one. On every page was a magnificently detailed drawing in ink and watercolour. The technique was exquisite, the humour sophisticated and naughty. Each illustration showed Snow White making love with her dwarfs, now with one, now with two, now with all of them at once. The facial expressions ranged from frustration, agony and jealousy to the beatific ones of satisfaction and fulfilment. The drawings were pornographic in the extreme, and no matter how long or how often one looked at them there was always another detail to be discovered, inviting more laughter. We wiped our eyes and passed the book around. One after another pointed out his favourite illustration.

What an artist that man was! His imagination and sense of humour was fantastic, and if he practised what he drew he must have made some lucky girl, or girls, very happy indeed. It was all a wonderfully warm, funny human experience and I felt so much at home with the men that, but for the thought of Giza and friends, I might have been tempted to go all the way with them to Italy; I am sure they would have gladly smuggled me in, one way or another. Unfortunately, when we got to Tarnopol, I found the train was bypassing Lvov. I had to say goodbye. But even today I still smile in affectionate reminiscence whenever anyone mentions Snow White and her seven dwarfs.

I took a local train for the last leg of my trip and got off at Kleparow, a suburban station, rather than risk going on to Lvov Central. After hanging about until dark, I took a tram into the city. It was snowing heavily and an icy wind cut through my clothes, chilling me to the bone. I put on the armband and badge, then waited in the shadows by the corner of one of the main streets until a group of Jewish workers returning to the Ghetto came along. The men barely looked at me as I joined them.

"My own group's gone ahead," I said. "I had to see my mother — she's not in the Ghetto and she's sick."

They were too cold and tired to be interested.

I went straight to Giza's place but there was no one there. The same neighbour who helped me before came out of his flat when he heard me knocking on the door. "She's not back from work yet, she's all right, but they took Karol to Janowska three days ago."

This shocking news confronted me with the reality of life in the Ghetto.

"I am sorry to hear that. Tell her Marian is back, will you."

"I'll tell her."

I went at once to find Adek.

"God, am I glad to see you!" he said as we shook hands. "But what are you doing back in Lvov?" I was equally glad to see him. Briefly I outlined my experiences and the reason behind my return. Adek and Felka, sitting close together, were deeply absorbed in my story and concentrated hard not to miss the smallest detail.

"All I need is three weeks," I told them, "then we can all be on our way. Let's see how many more friends we can convince to come with us."

Adek made it clear that the situation in the Ghetto had deteriorated even further since I left a week ago. Was it only one week? It seemed incredible that so much should have happened in so short a time. Depressing as the picture Adek painted might be, I was glad to have someone to talk to, and to be in a place where I didn't have to worry whether I was being watched too closely. The next three weeks would be busy, filled with preparations, excitement and anticipation. Here, unobserved, I could begin to carry out my plans. Then, with Giza, Adek, Felka and as many friends willing to join us as I could find, we would be on our way to the Ukraine! The exultant feeling grew. We would not just be running away. We were leaving for a destination of our own choice, and we would stay there until we decided we wished to move on. It had all become marvellously, incredibly simple.

"All I need is three weeks," I repeated.

It was about eight-thirty when I put on my overcoat and went to see Giza. The streets looked like a monochrome indigo painting diluted by millions of glittering snowflakes. The wind was pushing them sideways, forming a pattern of white diagonal lines. Shadowy figures were moving quickly in the foreground, with a few distant dim lights scattered around.

I found Giza sitting at the table, her head resting on her hands.

"Hello, Giza." I took off my overcoat, gave her a kiss and sat next to her, putting my arm around her shoulder. She did not seem surprised to see me. Obviously her neighbour must have told her about my earlier visit. "I heard about Karol. I am terribly sorry."

She looked up and nodded her head. Her eyes, full of tears, were void of expression. They stared into infinity, without the desire or ability to focus on anything. "I came back to take you with me in three weeks time."

With my arm around her, we sat in silence.

"Would you like me to stay here with you?" I asked.

"No, thanks. David will be coming any minute now. I'll be all right."

I looked around the familiar room. It was much worse than I remembered. The stained blank walls, the old, shabby furniture, a piece of plywood replacing a broken panel of glass in the window, a few pieces of old carpet lying in front of the beds, and Giza at the barren wooden table. In the corner a minute iron stove, quite inadequate, with a few pieces of wood piled next to it. An aluminium saucepan on the top indicated its dual function: cooking and heating.

It seemed as though the neglect of personal appearance closely followed the deterioration of domestic surroundings. Or was it the other way around? Here lay the reason why I was so determined to run away from Lvov, I thought to myself. No matter where. No matter how dangerous or how much effort I'd have to put into it to succeed. Anything was better than to live like this.

David arrived carrying a bag full of cut pieces of old fence and put it next to the stove. "Oh, you're back. What went wrong?" He could not imagine my returning to the Ghetto unless things were desperate. I chose to ignore his remark.

The three of us sat at the table, our hands around hot coffee mugs, trying to warm our frozen fingers, each engrossed in our own thoughts. There was not much one could say. What kind of consolation could I offer them? We all knew Karol was a condemned man, with no chance of ever getting out of the camp alive. Even more painful was the knowledge that nobody could do anything for him.

"I'll see you on Sunday morning," I promised Giza. I kissed her and walked out. The windy night did not seem cold any more. I was thinking of the atmosphere in the room I had just left.

The following two days kept me busy contacting friends who might be willing to join me on my return trip to Kiev. None of them said a definite "no", but nobody said "yes" either. They were all undecided. I was hoping that in a few days time they would realise that what I was offering was one of the very few chances of survival. The fact that I had been to Kiev, and was prepared to go back there must surely speak for itself.

On Sunday morning I found Giza in a much more relaxed state of mind. It was an encouraging sign.

"Good to see you, Marian. Let me have a look at you. You're all right?"

"Yes, I'm fine."

"You look well. But where have you been? Why did you come back? Did you really go to Kiev?" The questions came in nervous, rapid phrases.

Eventually I was able to reply. "I was in Kiev, and I came back to take you there with me in three weeks time."

But Giza was not interested in my plans for escape; all she could think of was Karol, locked away in Janowska camp. David was spending more and more time hiding out with Irka and she was left alone most of the time, growing more despondent every day. Her pallidness and listlessness worried me.

177

"I am only staying here until 22 January," I told her, "and when I leave you are coming with me." She shook her head. There was no fight in her at all. I decided not to pursue this subject any longer. Let her have a few days to think about it, to get used to the idea. Instead, I told her all about my trip and the chance the Ukraine offered.

Four days later I called again. Her attitude was still the same.

"Listen to me," I pleaded. "They killed over forty thousand in August and sixty thousand more in the November *aktion* and they haven't finished yet. Do you want what happened to our parents to happen to you?"

She covered her face. "I can't leave Karol," she whispered.

She had said that so often that I now had to be cruel to be kind. "Have they let you see him?"

"No."

"Are they ever going to let him out?"

I watched her wetting her dry lips as she looked anywhere but at me. "I don't know," she said after a long pause.

"Giza!" I was fighting not to lose my temper. "You know the facts as well as I do! Stop dreaming and come down to earth. They're never going to let him out and there's nothing you can do to help him. If you want to stay alive you'll have to do something about it!"

"I want to be with him," she said, beginning to cry.

"*I* want us to be safe at home with our parents. We can't be! But I still want to live." I stopped, then added: "And I will! Giza, please listen . . ."

It was no use. She found some reason for not agreeing with whatever I suggested; it was as though she was trying to justify her lack of will and initiative. Her attitude was beyond my comprehension. I kissed her and walked out before I said something for which I might be sorry.

I had the same sort of trouble with many of my friends. I knocked on doors and waited on streets to be able to talk to them, but all I met was apathy and reasons why they should stay where they were; a mindless sort of refusal to look facts in the face. Others, like Milek, would love to have joined me, but family ties were too strong to be broken, aged parents or younger sisters or brothers could not be deserted. Tragically, they had no choice.

Frustration turned to bitterness at the unexpected resistance to my offer; I hadn't expected to have to plead with friends to try to save their lives. As I looked around the Ghetto, all I could see were people shuffling across the dirty snow, heads sunk on their chests, their only sign of life the lifting of hands to mouth to blow warmth into frozen fingers. Apathy had reached epidemic proportions. There seemed to be something in their minds which created its own Ghetto, as though the pogroms suffered by Jews down the centuries had entered their collective consciousness until the hopelessness of resistance to persecution was ingrained. Some fooled themselves that they were safe — they were needed by the Germans, they told me. Others had made arrangements to hide which gave them a false feeling of security.

How wrong they were; it breaks my heart to think that had they taken the chance I offered, many might have survived the war.

It was essential for me to talk to Salek Meissner about getting away to Kiev. His advice, based on personal experience, would be invaluable and he would surely know people who might be of help to us once we were there.

To my dismay, I found that his mother and all the Jewish tenants in the block where she lived had been

forced to move out. No one could tell me where either of them were. It took a week before I found him in the outer suburbs, in a flat that he and Otto used during their short and infrequent visits to Lvov. I told him everything I had done since I saw him last, and everything I hoped to do in the future. I told him about the documents and stamps I thought we would need.

"Good. Excellent," he said. "I'm glad to see you make good use of information. Will you have enough money to live in Kiev? If you haven't you'll have to try to get work, and that could be very dangerous, as you well know." He wrote an address on a small piece of paper. "Memorise this and burn the paper. When you get to Kiev contact me through this address; I go there often, I'll help you in every way I can."

"Thanks. Do you need any help with documents right now?"

To my surprise he said he didn't.

We shook hands warmly.

"You'll be all right," Salek said. "Just don't get too cocky."

Finally I had to accept the fact that there were only four friends willing to take the chance with me.

Adek and Felka, with our previous successful trip to bolster their confidence, agreed without hesitation, and once the plans were explained, Rysiek Pfau and Walter Greif were more than willing to come along with us.

Rysiek was my own age. He had studied architecture at the Polytechnic; we had often met at dances, at the swimming pool and ice-rink. He was short and solidly built, with a fine moustache and a stupid looking haircut, parted in the middle. He was a fine sportsman with a happy disposition, and though nobody was fonder of a prank, he was absolutely reliable and a good friend to have in a tight situation.

Walter was older than we were, about twenty-five, slightly built and very pale. He had an exceptionally keen mind, and his invaluable asset was that his German was better than his Polish, since he had been born in Bielsko, in the western part of Poland, where the majority of the population spoke German. I had never met Walter before. We were reserved at first, but I knew that after our initial shyness we would relate to each other. Being more mature, he could well prove the stabilising force among excitable youngsters.

Time and again we discussed every detail of our plans, and tried to work out all possible questions we might be asked and how we would answer them, all the things that could go wrong and how we would deal with them. It took me a long time to make our documents. They were identical; we all worked for the same firm and were on our way back from Christmas leave, we had decided. This meant that we each had to have an *Urlaubschein* and a document similar to the one I had made in Kiev. All the stamps that I had acquired on my way from Dnepropetrowsk had to be copied.

To my joy, a week before we were due to leave, Giza decided to come with us after all. She gave me her photograph so that I could make the documents she would need. I worked late into the night to get everything ready on time. I continuously checked each document, again and again. They seemed faultless to me. In two days we could leave.

I went round to Giza's flat. She was not there.

"She hasn't been here since Saturday night," I was told by the neighbour. That was three days ago. According to our travelling papers, we had to leave on Thursday. Giza knew that. With a sinking heart, knowing her as well as I did, I realised her disappearance must be due to two aspects of her situation. Firstly, her feeling of guilt at

leaving Karol behind — I strongly suspected that David would have something to do with that. Secondly, she had lost her nerve and could not face having to tell me she wasn't coming after all. She was probably with Irka again, and I did not know where Irka lived. I found myself in an impossible situation. Not only was I unaware of Irka's address, I had no idea what her surname was. For obvious reasons, she would have retained her maiden name. The only person who could help was David himself — but, according to the man I spoke to, he and Giza had left together. During the next two days, I made several visits to her flat with the same result. In the meantime, I called on friends still living in the Ghetto, and left them identification and travelling papers that would take them to Kiev. I also gave them Nikolai's address. Nobody ever called there.

I was searching for a way we could delay our departure. It was no use. Rysiek and Walter had both given up their rooms, and were staying with us for the last two nights. Adek had sold his furniture to a family who planned to move in the following day. Another even more difficult obstruction was the fact that all our documents had the date of our return to Kiev. Any delay meant that I would have to make five new sets of documents. I would not have minded that, if only I knew that delay would be justified. In all honesty, I had to agree with my friends that Giza had made up her mind; even if she returned to the Ghetto, she would still refuse to join us. Finally, I realised that it would not be fair to the others; their excitement and anticipation had reached such heights that it would be extremely cruel to make them wait another three days. I waited as long as I possibly could; when the time came I had no choice but to leave Giza behind. It was a most terrible decision to have to make.

Totally wretched, I went to say goodbye to Milek. In

some ways this was even more agonising. With Giza, I could at least try to convince her, point out the hopelessness of the situation she was in. I could argue with her, plead with her. Facing Milek, I had nothing to say. He was a victim of circumstances, with no options given. The responsibility of looking after his ageing parents and younger sister rested on his shoulders. How could he desert them? Was there anything I could say to help?

I gave him the documents I had made for Giza, together with some money and Nikolai's address, where she could contact me. I knew that as soon as she returned to the Ghetto, the envelope would reach her. I also left Milek two sets of documents for himself and others for Artus and Poldek, both working in Czwartakow Camp. They used to come to the Ghetto every Friday after work, but I was unable to see them on my last Friday there.

I said goodbye to Milek's father, kissed his mother's hand, thanking her for everything, then gave Milek's sister a kiss on her cheek. I wished them all luck and with heavy heart walked out. Milek came out with me. We shook hands, unable to speak. Tears were running down our faces. With our arms around each other we were locked in an embrace. We both knew this was our final goodbye.

After the war, I found out that both Artus and Poldek survived. Artus lives in Israel, while Poldek, after living for a few years in Poland, migrated to the United States. We correspond, and I visit them whenever opportunity arises. Milek perished with the other 120,000 Jews in Lvov.

Through all those years that have passed since that fateful day of departure, when I had to leave Giza behind, I have been tormented by one question: was there anything I could have done to make Giza change her mind? It was a tragedy. If she had come with me, she could very well be alive today.

Part Three

Kiev . . . Odessa . . . Bucharest

14

On 22 January, Walter, Adek and Felka went to the station together. A group of five could have looked conspicuous, so Rysiek and I followed them. Central was always busy. As we had planned, Walter talked very loudly, abusing the others in his perfect German. His raised voice soon became impossible to ignore.

"*Du Polnische Schwein*", he was shouting, waving his arms in front of Adek and Felka as they tried to push him aside and walk on. The clipped and perfect German left no doubt as to his nationality — we hoped. A German shouting at two Poles must surely make the perfect cover; no blackmailer lurking in the background to pick up escaping Jews would ever think escapees would draw such attention to themselves. We saw Adek put his arm protectively around Felka, hiding her face, and hurry down the platform to where the doors of the waiting train stood open. He pushed her inside as Walter pursued them. Adek closed the door of the carriage in his face and Walter, shaking his fist and shouting, was left, thwarted and angry outside. We saw him throw up his arms in disgust and get into a compartment farther down the train. A wonderful performance.

Rysiek and I waited until the train doors were closed, then as the whistle screamed and the great engine puffed out steam and gathered itself to move off, we quickly opened the door of the second last carriage and, unnoticed, boarded the train.

It was packed. We had quite a struggle to move along the corridor and find the others. We couldn't show any jubilation, but we let off steam by complaining loudly: what was the use of having a permit to travel on a passenger train if there weren't any seats? We only managed to find two among the five of us but, for me, it all made a nice change from travelling in a goods van squatting on dirty straw. We had our rucksacks to sit on, but Walter, who had an elegant suitcase, befitting a German, and a portable typewriter to look after, was often allowed one of our seats; that typewriter was very precious and we could not risk its damage or loss. It wasn't a comfortable journey.

The train halted at Kazatin for twenty minutes.

"Come on," I said to the others and made my way confidently to the army canteen. We exchanged smug, triumphant smiles over our bowls of steaming soup. I really enjoyed watching Felka's look of disbelief melt away and Adek's quick grin of appreciation.

It was early afternoon by the time we reached Kiev.

"Have a walk round the park while I go and see Nikolai and Anna," I said to the others.

"Got the vodka and the *kraski*?"

I patted my rucksack. "You bet."

I saw the window curtains move after I knocked on the door. I was bunched up in the heavy overcoat and fur cap I had bought for the Russian winter, and I pushed the cap back from my face to make sure Anna recognised me. The door opened at once.

"Oh, it's you, Marian!" She seemed as genuinely glad

to see me as I was to see her. "Come in!"

Nikolai was not yet home from work, but that did not stop us opening the vodka. "*Kraski!*" She said with delight, unwrapping the parcel we had brought her. Now I can dye some of my old clothes and make them look like new!"

Her pleasure heartened me. We had been right to bring plenty of *kraski* with us; clearly we would have no trouble selling it to the local women, who wove their own linen.

"And what are you doing here?" Anna asked.

"I've got a new job in Kiev — there are four friends with me. I wondered if you knew where we might find a flat."

"Not offhand, but there's a noticeboard on a fence just down the road. We all use it. Things for sale, accommodation, requests for news of missing relatives — all that sort of thing."

"Marvellous! Look — I hope you won't mind if I don't stop now. I'd like to get us fixed up before dark. I'll come back to see Nikolai tomorrow."

"You must. He'll be so pleased."

We had no trouble finding the fence the locals used as a noticeboard, but we had trouble finding the notices advertising flats or rooms to let among all the pieces of paper nailed there. When we did find them we realised that we had no way of knowing which would be suitable, because we had no idea where the streets and suburbs were. We gave a boy of about fifteen some money to pick out some flats which were closest to the city, and to take us to the office of the superintendent of that area. There we were introduced to a middle-aged, surly looking woman whose job was to show us flats available for rent. She was far from talkative, and the only answers to our questions were "yes" or "no". The second place she showed us was ideal, a two-bedroom flat with a large

189

living-room and a huge kitchen with a stove so big that it covered half the area. The bathroom, although old-fashioned, was adequate. We were delighted to learn that the bottom flat of this duplex belonged to an elderly couple who were living in the country at the moment and seemed unlikely to come back.

Back in the office I filled in a form, then met the superintendent. He was an old man, at least seventy, with a grey moustache and small smiling eyes. We shook hands and he told me that he had supervised this area for more than twenty-three years. He pointed out some of the conditions printed on the form, asked me to sign it, and, in return for one month's rent in advance, handed me two sets of keys. We shook hands again, and I invited him to come and see us one day, after we settled in. (I crossed my fingers, hoping he wouldn't take up the offer.)

We tossed for who should sleep where. Walter won. He chose the living-room. Adek and Felka had one bedroom, Rysiek and I the other. We were in clover. We had enough money and things to sell to keep us going for two or three months, so we went out and splurged on buying pots, pans and cutlery, a radio, a floor lamp and two packs of cards to add to our comfort and entertainment. Feeling very satisfied with ourselves, we settled in.

We had to pretend we worked, of course. I got busy and made two sets of documents for each of us; one set was for a day-shift worker, the other for a night-shift worker. This would cover us nicely in case anyone came to the flat and found us playing cards during the day.

"You are a hospital cleaner," I told Felka. "We work in a railway repair shop."

We had to be cautious about being seen outside. One of us slipped out to the market to buy food and cigarettes every few days, and sometimes we chanced going for a walk after dinner, when it was dark.

I went round to the address that Salek Meissner had given me but he was not there.

"I've no idea when he'll be here, either," his friend told me. "He and Otto just arrive, and don't stay long . . . you'll have to be lucky to catch them."

"If he comes, will you give him my address? I'll come back every few days."

The weeks went by and there was no sign of Salek, but after our life in the Ghetto it did not take much to keep us happy. We sat around, talked, ate, played cards and chess and ate some more. It came as quite a surprise to find that we were becoming bored. We knew this peaceful life could not last indefinitely; we wanted to get on to the next thing. It was also frustrating not to be able to take a proper look around Kiev, a lovely historical city with beautiful parks and old buildings. The Soviet government was restoring many of the old churches, not because of their religious significance but because of their historical importance; on our brief forays outside we had seen how their walls were damaged by bullet marks. Sometimes whole wings had been destroyed by mortar fire or bombs.

It was a great relief when a note came from Salek asking me to meet him at his friend's house.

He was as brisk and businesslike as usual. "It's shocking about Giza," he said, giving my arm a quick squeeze. "And I just can't understand the others."

I met Otto for the first time. I had heard so much about him, and I liked him at once. It was easy to see how he had earned his reputation as an outstanding sportsman. He was tall and lithe, his face calm and intelligent.

"Now," said Salek, wasting no time. "Listen carefully. There are German building and construction companies here doing jobs for the army. Most of their tradesmen are Germans. The companies are responsible for housing and feeding the men on the job and also when they are

191

travelling from one job to another. They have to supply a list of the names of the men entitled to ration cards to the German Supply Department, together with a covering letter, then the Department hands over the appropriate number of cards. Some workers are in a job for only a few days, then move on. Long-term employees are dealt with differently. What I want you to do is this —.''

He gave me three sheets of paper. Each one was headed *"Bescheinigung"*. They were dated ten days apart. Each paper had a list of names pinned to it. One list had twenty-nine names, one of the others forty-six. They were all pure German names.

"What you have to do is to make stamps for the documents to go with these names. We need an oblong stamp like this to go on the left-hand corner of the sheet." — He showed me a stamp which gave the name of a firm — "and a round one like this — a stamp of authorisation — to go on the bottom above the signature. In addition, you'll have to make another round army unit stamp as an endorsement from the Wehrmacht. Here's a sample of the covering letter."

My mind was working furiously as he explained the procedure. I put the papers in my pocket. "Would tomorrow night do?"

"Good man. Now let's have a drink."

It was good to sit talking for a while. There was always such an air of safety and confidence around Salek.

"Now tell me your problems," he said.

I raised my glass to him. "I have no problems any more — thanks to you!"

When I got back to the flat I was confronted by four anxious faces. We now had only enough money left to keep us going for another four weeks or so.

"Can he get us work?"

"Not work. Something much better!"

Almost before I had finished explaining, Walter had his typewriter out and was making copies of the covering letter. We spent a busy evening. I made the required stamps without too much difficulty.

"What are you doing now?" Adek asked me as I set to work again.

"You'll see." I made another document — a fourth one. It requested ration cards for twenty-three German workers who were to stay in Kiev for the next ten days. "This is for us," I told him. "Give me some more names. Come on, use your brains." Laughing, we reeled them off — the names of soccer players, musicians, authors, actors, even Gestapo officers. We soon had a list of German names so pure that even Himmler himself would have been proud to call them relations. We surveyed the finished documents for Salek and the one I had made for our own use with pride.

Salek was delighted with my work and took out his wallet.

"No, thanks. You've already paid me," I said. I took out the document I had made for ourselves and showed it to him.

"You cheeky little devil!" he said, and roared with laughter. Neither he nor Otto seemed to mind that we had adopted his idea and were prepared to use it.

"Just don't overdo it," they warned me. "Don't try it too often and don't apply for too many cards at once."

They explained the procedure in greater detail. The ration cards were divided into seven parts, one for each day of the week. If a worker was staying for less than a week the issuing officer would cut off the coupon not required; if he was staying several weeks he would be

granted enough cards for the length of his stay, but they could only be collected at two-week intervals. Rations could only be bought at three special stores operated by local people. Only Germans were employed in the offices and in supervisory capacities.

"So watch your step," Otto said.

"I certainly will."

Now I had the answer to a question that had puzzled me for a long time; I realised why Salek and Otto visited Kiev so often. It was an ideal place for their scheme, since so many army personnel and civilian tradesmen employed by the Wehrmacht passed through the city, as well as employees of firms with branches in other parts of the country. With the huge amount of building and reconstruction taking place, the turnover in ration cards must be tremendous.

Words cannot describe how much I and many other people owe to Salek Meissner; but for his wickedly clever ideas we would not have been able to survive the war — certainly not in comfort and on a full stomach.

I had dated our document for two days ahead. We needed a little time to get ourselves mentally prepared — and I had another job to do. We had to decide who would collect the cards. It seemed obvious that Walter, with his perfect German, should be the one, but it would have to be his decision, not ours.

"All right, so it has to be me," he said. "I don't want anybody coming with me; on my own I should be able to talk my way out of any difficulties, I hope." The rest of us felt relieved but uneasy; we would not be able to forgive ourselves if something happened to Walter.

"What will you lot do?" he asked.

"We'll follow you and hang about outside. We won't let you know where, or which clothes we are wearing — in case . . ."

"I know, I know. That's sensible."

We could not take chances; at least he would not be able to describe us under questioning.

"You go first, then we'll follow you," I said. "The walk and the tram ride should take about eighteen minutes."

It was time to act. We shook hands all round and wished ourselves luck. In the next thirty minutes we were certainly going to need it. We watched Walter walk away. His small, slight figure looked quite jaunty. It took us five minutes to change our clothes, then we let ourselves out of the flat. Exactly eighteen minutes later we were in the city with the great bulk of the German supply building in sight. It was a huge, partly demolished block near Khryshatek Road in the centre of Kiev. Before the war, all the Government department offices, the State Parliament, the Ukrainian Communist Party Headquarters, all the Public Service departments and the largest department stores were situated along this once beautiful street. When the Russian Army was forced to retreat from Kiev they left in a hurry, and the Germans were able to take over all these magnificent buildings, install their high-ranking officials in the offices and set up their army headquarters there. Ten days after they were installed, the whole street blew sky-high. The Russians had correctly anticipated the German action and allowed them a little time in which to grow complacent before the time switches set off the huge quantities of explosives they had concealed in every building. In retaliation, the Nazis rounded up tens of thousands of Jews in the gully outside the village of Babyi Yar and shot them all. It was one of the most infamous massacres of the war.

Rysiek and I climbed up the steps of a partly demolished house. From here we had an excellent view of the entrance to the supply office. Soldiers and civilians,

individually or in small groups, were going in and out in a never-ending stream. Every so often, an army truck or a car would stop to let somebody out. There was not very much snow around for mid-February, usually a very cold month. The bright, warm sunshine was much appreciated by us.

On the opposite corner we could see Adek and Felka standing inside a damaged shop, engaged in animated conversation. Minutes passed without any sign of Walter. I looked at my watch. Rysiek's eyes followed mine.

"It's only eight minutes, there's nothing to worry about." He did not sound very convincing. Unable to relax and wait in one place, I climbed a little higher and sat on a pile of bricks. Rysiek was right behind me. He lit two cigarettes and handed me one, and we smoked in silence. More people went in, more came out, but not Walter. Now it was Rysiek's turn to look at his watch. Suddenly I saw the small, familiar figure of Walter fighting his way through the huge revolving door. I poked my elbow into Rysiek's side. "There he is. Look! He's alone!"

We checked our watches; it had taken him fourteen minutes. Was that all that was needed, fourteen minutes? We stayed in position and let him walk away, our eyes never leaving the entrance, to make certain that he was not followed. There was no commotion, nobody rushed out of the building, nobody else who came out went in the direction Walter had taken. A few minutes after he had disappeared in the tram which would take him towards the flat, we decided it was safe to follow him. On the way I stopped off at the market and bought a bottle of vodka.

When we got back to the flat we found Walter lying back in a chair helpless with laughter. On the table was a stack of yellow cards.

"Enough to keep twenty-three hungry Germans in food

and cigarettes for ten days!'' he burst out.

"And five Polish Jews for a long, long time!"

We laughed until our sides ached.

"*Veni, vidi, vici*," Walter kept saying, "I came, I saw, I collected!" A sobering thought suddenly hit him. "Oh God! When you think of it! I could have been arrested . . . and then what would have happened to all of you? Where would you have gone?"

As an answer I took out an envelope from my pocket and threw it on the table. He looked at me inquiringly as he opened it. Inside were four complete new sets of travelling documents.

"We'd have been on a train within minutes," I said without a trace of modesty. He started to laugh again. "I might have known! Good old Marian, always one step ahead."

When we had calmed down we took a good look at the cards. There were coupons for different foods, with a choice of alternatives: one dozen eggs or six cans of fruit; a bottle of brandy or vodka or a carton of cigarettes; a kilo of salami or a kilo of cheese, and so on. We could foresee arguments developing.

"Look," I said, "we'll each make out our own list of what we want, we'll use eight cards — and this afternoon Walter and I will go shopping."

What a day — and it was not even lunchtime.

The huge store was stocked with supplies, everything neatly arranged and carefully marked; each commodity had its own counter with stacks of large paper bags ready for packing. German precision was much in evidence. I let Walter make the rounds, consulting his lists and accumulating more and more bags. We would need a *droshka* to get all that back to the flat! I rushed out, and to my joy

found one of the horse-drawn taxis drawn up outside. Today, everything was with us.

That night we all got drunk, even young Felka. We made ham omelette after ham omelette, washing them down with vodka. We were too happy to go to bed until very, very late.

The next day, still happy, but definitely not at our best, we sat down to work out what to do next.

We had now learned that even if we did not travel and make use of those facilities, we could still live comfortably. It took longer for us to realise that we could not only sell surplus food on the black market, but surplus cards as well.

The importance of the knowledge we now possessed slowly sank in. We could travel all the German-held territories, because we knew all about the documents we would require and how to forge them. We knew which were needed for food *en route*, we knew what to do to obtain temporary accommodation while we travelled

Under the watchful eyes of the Wehrmacht and SS, five young Jews on the run could be at ease, well-fed and comfortable.

We laughed every time we thought about it. But there was something else we could not stop thinking about. Looking at the mountain of paper bags full of delicacies, it was difficult not to cast our minds to the thousands upon thousands of starving people in the Ghettos and concentration camps. If only there had been a way we could have shared our good fortune with the ones we left behind. Time and again, feelings of guilt overcame us.

15

We settled down to a life of unlimited food, drinks and no exercise. As long as we did not do anything stupid, we were safe. We played cards, chess, checkers, every party game we could think of, and Bridge. Felka was no Bridge player but the rest of us were keen. There were endless post-mortems on the games and heated arguments which lasted well into night. Felka was glad when we gave up Bridge for the old German game called *Quer loss*; like Bridge, it requires four players, each playing for himself. It was a sort of poor man's Bridge — without arguments. We had chess tournaments, which Walter won every time, with me coming third after Rysiek. We tried to set up a handicap system, but could not find a formula we could all agree on. Rysiek was a good draughtsman, and he and I would amuse ourselves drawing or sketching our friends or setting up a still-life. Our caricatures, and pencil and coloured crayon drawings were pasted all over the walls.

One morning, coming back from the local market, I was amazed to run into Olek Nacht, an old acquaintance from Lvov. He used to live near my family. We had played soccer together and used to meet occasionally without actually becoming close friends. Now we were

delighted to see each other. I think he was as glad as I was to see another Jew making an effort to save his life.

Olek was about three years older than me. He was tall, good-looking in a rather rugged way, with an enormous amount of charm and confidence. I remember him being always an immaculate dresser, a real lady-killer. He started to study dentistry abroad, but dropped it after a while to join his father's business, running one of the many garages he owned. During the Russian occupation, I saw him quite frequently at functions and balls at the Institute; one of the prettiest students there was his girlfriend. I remember the envious looks he received whenever he and his girlfriend appeared.

He was wearing a full-length leather coat, an elegant hat, and an expensive pair of gloves; he looked well-fed and untroubled.

"Come to my place and have a drink, we must have a good talk," he said. He took me to a pleasant suburban house with a large garden which must have looked lovely in summer. The owners obviously made good use of their land; there were a number of hen houses and other small buildings that could have been for other animals or vegetable storage. Olek seemed very much at home. We went to his room, took off our overcoats and settled down in front of the cosy little iron stove to catch up on each other's news. It was good to have someone other than my flatmates to talk to. And Olek had a fascinating story to tell.

"I survived the August *aktion* by hiding in the house of my father's mechanic, and then I decided to run away from Lvov. The same mechanic introduced me to a German engineer who was recruiting German-speaking tradesmen willing to go to occupied Russia. The mechanic gave me his son's papers and I came here to work in the Wehrmacht repair shop."

I had to interrupt him. "Hey, where's the drink you promised?"

"Oh, I'm sorry," he apologised. He opened a small cabinet and produced a bottle of vodka and two glasses. "*Na zdrowje!*"

"*Na zdrowje!*" I replied.

Olek poured another round of drinks and continued his story. "Now, where was I? Oh, yes. I rented a nice room, but the middle-aged landlady got fancy ideas about me, and when I failed to respond to her advances, she became quite unpleasant, making my life a misery."

"You poor bastard! Still as fussy as ever!" I said mockingly. He seemed to appreciate the comment.

"Don't laugh about it! Anyhow, I mentioned this predicament to some people at work, and to my surprise, the very next morning a new office-girl, Liuba, walked up to me and said that if I was still looking for somewhere else to live, her parents were willing to let a spare room in their house. "So," he said, smilingly, "here I am."

That, however, did not wholly account for his general air of prosperity.

"And what's this Liuba like?" I asked.

My question caught him as he was walking out to the kitchen to get some food. He turned his head, grinned and disappeared. Whe he came back with a large tray of food, I recognised it immediately as coming from the same store we patronised. I couldn't wait to hear what else he had to say.

"A nice room complete with a pretty young girl," I said. "Not bad. Not bad at all." I don't think he detected the trace of envy in my voice.

Olek's racket was very neat. He was friendly with one of the Russians working in the German food store and between them they had worked out a very satisfactory deal. Olek bought ration cards on the black market, one

at a time, and took them to the store where his friend would give him supplies for five or six cards. Very often, he wouldn't even cut the coupons out of the one ration card offered to him. The procedure was repeated up to four times a week and then the food was sold in the market in Kiev and other towns. Liuba's parents had organised distribution in the countryside around Kiev; each week they took a cart loaded with supplies to one or more villages, where their relatives would sell the goods on the black market for them. They also provided food supplies for the local partisans. I realised then what the small buildings in the garden were really used for.

"What a marvellous set-up!" I said.

"There is a snag."

The Lishkovs not only wanted Olek as partner, they were determined to make him their son-in-law. They had no idea he was Jewish.

"I don't want to get married! It's the last thing I want!" he said. "Liuba's a tremendous girl and I like her a lot, but the war will be over one day and then I hope to get back to Lvov and take up a normal life. Lovely as she is, she wouldn't fit in there. I do like her, though," he assured me.

I could see his dilemma. He did not want to lose his lucrative business, yet marriage was too high a price for him to pay to avoid being kicked out and losing all that food stored in the sheds.

"Don't ask me for advice!" I said.

He grinned. "It's just good to be able to talk. This is the first time in five months I've been able to speak freely and be with someone who knows me for what I really am."

We enjoyed our afternoon together and Olek invited me to come again to meet Liuba and her parents. I went back a few days later — and walked in on a great celebration.

It seemed that Olek had decided on marriage after all, and they were in the process of making wedding arrangements.

Liuba was a very tall girl, with dark-blue eyes and yellow hair tied in a bun at her neck. She was about nineteen, with the solidly built body of an athlete, and was obviously deeply in love with Olek. She seemed the sort of girl who knew what she wanted and took care to get it. I surmised Olek had never had a chance.

I congratulated them both. Liuba was radiant and Olek certainly did not have the appearance of a man who felt himself trapped. "Once I made up my mind it all fell into place," he told me. "The future will take care of itself. Why should I worry?"

The wedding was to be in ten days time.

"I was wondering," he said with a touch of embarrassment, "if you would mind being my best man?"

I did not mind at all; it was natural that he should have someone from his hometown with him, and I thought it would be a lot of fun. If I had realised what a Russian Orthodox wedding entailed, I would not have agreed so readily.

Liuba's parents were very nice people and typically Russian, melancholy at times, but always ready to laugh at a joke or amusing story. Their two sons, both older than Liuba, were in the Red Army. Mrs Lishkov was always dressed in black, with a shawl over her shoulders. She told me that she still went to church to pray in front of her favourite ikon and that the services were well attended; although most of the worshippers were elderly, very few of the young people who were still around stayed away. This was in great contrast to the reports put out by the Communist officials before the war began.

Her husband, an accountant, was an accomplished chess-player and a wizard with the abacus, besides being a keen sportsman who, pre-war, had been an ardent sup-

porter of the Spartak soccer team. I found them both friendly and generous, and it was clear that they welcomed Olek into the family with open arms and an open heart. He was a lucky man.

Life at the flat continued to be directionless and monotonous and our restlessness grew as the vacuum became increasingly difficult to fill. Then, one afternoon, there was an unexpected knock on the door.

Adek and Rysiek had just returned from collecting our rations from the German store; we froze with sudden fear. Only our eyes moved as we silently asked each other — *what now*? The knock came again. The door would have to be opened.

Standing closest to the window, I moved to the side and took a quick look at the street below. Snow was falling heavily, there were no cars and no people in sight. I turned around to face the others. Their eyes were wide with inquiry. I shook my head. There was another knock; it had no urgency, but it seemed to echo around the silent flat. Quick as a flash Adek whipped the food parcels from the table and took them into his bedroom. We braced ourselves and then I opened the door.

A tall, slight, well-dressed boy was standing there. He looked very uncertain. "Could I come in for a few minutes?" he asked in Polish. "I won't take much of your time." He brushed back the lock of hair falling across his forehead and I knew at once that this was no Pole. He looked Aryan, even a little aristocratic; he would have passed almost anywhere — but one Jew can always recognise another. I stood back and beckoned him in. "My name is Janek Fuchs," he told us, "but my papers say I am Jan Orlicz." He was clearly uncomfortable under the scrutiny of five pairs of eyes. He looked too young to be dangerous.

"I come from Lvov," he said.

"What do you want with us?" asked Rysiek.

"Why have you come here?" Walter said.

"I saw two of you when I was walking past the food store — you were speaking Polish — so I gambled my last roubles on a *droshka* and followed you home."

Adek and I exchanged a glance. We would have to remember to guard our tongues in future. Snow on his overcoat started to melt; we suggested he take it off and sit down.

"What are you doing in Kiev? Are you alone here?" I asked.

"I came here with my father and elder brother about two months ago; we had jobs in the railway workshop. I speak Ukrainian and German as well as Polish so they made me an interpreter."

With an impatient movement Felka cut him short. "Are you hungry?"

The boy looked at her with a tired apologetic smile. "I've had hardly anything to eat for the last two days."

Felka gave us all a glance and went into the kitchen, leaving the door open to make certain she missed nothing.

The boy continued his story. "I persuaded the German manager to take me back to Lvov with him when he went to recruit more labour. I wanted to try to get my uncle and cousin out. But I found they were in Janowska camp. I dreaded having to come back and tell my father. But when I got back I found my father and my brother had disappeared. Here one day, gone the next, the neighbours told me. I didn't dare to show up at work . . . I've been wandering the streets ever since, trying to keep out of sight of the people from the railway. I've run out of money."

Listening to his tragic story I felt the warm rise of empathy.

"How old are you?" I asked.

"Eigh . . . seventeen. I'll be eighteen in April." He smiled at me and I returned the smile.

Felka brought in a large plate with hunks of bread, butter, salami and cheeses. "I've put the kettle on; I'll make some coffee as soon as the water boils."

"Thanks! — Is there anything else you would like to know?"

"Eat," said Felka. He shook his head although it was easy to see he was ravenous.

"Anything else can wait," Rysiek said. "We have all the time in the world. *Eat*."

Janek was three years younger than I was. Just a kid. The way he spoke about his experiences had a deep effect on me. There was no sign of hatred or complaint, no whine that life was unfair. Just plain statement of the facts, although his occasional pause, and the tears which filled his eyes, showed how much he cared for those he had lost. If I had had a younger brother I would have liked him to be just like this boy.

As he ate we all exchanged surreptitious glances. There was obviously a consensus of opinion.

"If you'd like to stay here with us," Adek said, "you would be very welcome." I remember the flash of gratitude which crossed Janek's face to this day. So Janek Fuchs, or Janek Orlicz, joined our group.

That night Janek slept on the floor in the living-room. We decided it was too late, and the weather too bad to go to the market for blankets. We all lent Janek our overcoats to keep him warm.

It was the beginning of one of the closest friendships two people could have. Today, forty-four years later, Janek and I live thousands of miles apart, but our friendship holds. It is as strong now as ever it has been.

It was good to have Janek with us. With the resilience of youth, he soon shook off shock and despair. We found

we had a lively companion to share our life of plenty and boredom. Something had to be done, though. We could not sit around much longer.

"Hey," said Rysiek one morning. "who are all these men we see walking round in German uniforms without any epaulets or insignia?" We all turned to Walter. With his perfect German he was the one who should be able to find out.

"I'll see what information I can get." He went out to phone the German supply department, and came back grinning.

"All I have to do is to put in an official request. Here are the names of the department in question and the officer in charge!"

"How did you manage that?"

"I rang the Wehrmacht information centre and was given the name and the phone number of the army supply department. I introduced myself as the manager of a building company, and told the officer in charge about five ethnic German foremen who are short of decent clothes for the kind of weather we are having now. I asked him whether it would be possible to obtain uniforms for them. Obviously, I wouldn't dream of giving them new uniforms, but anything in a reasonable condition would be good enough."

"You're learning quickly, Walter," said Rysiek.

"That's not all. I also told him that, as a manager, I felt it would increase their national pride and help to maintain discipline and the respect of other workers."

Straight away he sat down and typed out a letter which showed, beyond doubt, that the issue of five discarded German uniforms would win the war. I put my well-tried stamps on the letter. Then Walter telephoned the officer to whom the letter was addressed. This time he introduced himself as the director of the company, and advised him

that he was sending two men with a letter to collect the uniforms. He would appreciate it if the officer would make sure they were given clean ones in good repair. "I'll be round myself later in the day. I trust you like cognac," Walter concluded.

Armed with the letter, Rysiek and Adek presented themselves at the warehouse, where they found they were expected. Within minutes they collected five uniforms, signed a piece of paper, and left loaded with the goods. As these uniforms were not in as good a condition as we had hoped, the officer did not get his bottle of cognac. If he ever tried to locate the director of the building company who had let him down, he must have been sorely disillusioned.

Now, whenever the situation called for it, we could put on the uniforms and be confident that no one would dream we were Polish Jews. We even started going to the pictures. But the best part was that now we had enough nerve to meet girls! Sometimes we went home with them; sometimes we brought them back to our place. Poor Felka. She got sent to the movies to be out of the way, and was not very happy about sometimes being forced to see the same film three times in one week.

Conditions in Kiev were changing. Hardly a day passed without news of partisan, deserter, black marketeer or Jew being arrested or shot while trying to escape.

"Have you noticed," asked Adek, "how many people collecting food at the German store look Jewish?"

We began to worry, particularly when Janek found out that several groups of young Jews had arrived in Kiev. Could Salek and Otto have let other people in on our racket? It looked dangerously like it.

"It's time to move on," I said. Nobody argued.

That evening Adek took me aside, and after making sure that Felka was out of earshot, told me that later that

week it would be Felka's seventeenth birthday.

"Let's give her a little party," I said.

It wasn't easy to keep the preparations for the party from Felka. Spending most of the time together in a small flat, we needed an outside help. Liuba volunteered to organise food and her mother offered to make a cake. We bought candles at the market and a selection of little gifts. We concentrated on cosmetics and rather fancy items. She was growing up; powder and lipstick made her feel more like a woman. It was Liuba again who lured Felka out of the flat when the final table arrangements were made.

What a heartwarming experience it was, watching Felka laughing through tears of joy, trying to blow out candles. She was taken completely by surprise and could not thank us enough for the party and presents. She looked lovely as she walked around the table giving each of us a big kiss. It might have been my imagination, but I thought that the kiss she gave me lasted longer than the others.

From that day on, Felka and I repeatedly caught each other's affectionate glances across the room or across the table, but with four other members of the group always around, it was impossible to find a peaceful corner to sit in private and talk. Oh well, we would just have to wait until we left Kiev. Perhaps we'd find a larger flat; Felka might even have a separate room, I consoled myself.

16

It was March 1943. The Russians had annihilated the German army in Stalingrad and were pushing westward.

"How about making for the front and hiding out until the Red Army arrives?"

"How about going to Odessa and trying to get a boat to Greece?"

"Or Turkey?"

Now there was a thought! Or was it? We pored over maps and train schedules. We made schemes — then dropped them — then made some more.

We agreed that the idea of going to Odessa had much to commend it; even if we could not get a passage from Odessa we would at least be on our way to Budapest and Vienna, and could try to get through to Switzerland from there. We decided to delay our final decision for three days so that we could consider things more carefully.

Studying the maps of eastern Europe, we found something most disturbing. Odessa was now in Transnistria, a part of Rumania. To get there we would need a special pass to cross the border.

As good a forger as I thought myself, I had to admit this was beyond my capability. This pass was a specially

printed form with a wide diagonal strip, obtainable only from Wehrmacht offices. We had to find a way to overcome this handicap. But we also came across another interesting point. We found that on one particular route, trains for the south-east corner of the Ukraine, including Lvov, had to pass through Transnistria for about twenty-five kilometres. Between the two borders was a town called Shmerinka. All passengers going to Odessa would leave the train there, show their passes, then take another train to Rumania. The rest of the passengers would have to stay in transit on the train as long as it was on Rumanian soil.

This meant that I would have to make two sets of travelling documents for each of us. We planned to travel from Kiev on documents which showed we were going to Lvov, so that the Rumanian border patrol would just advise us to stay aboard the train. Arriving at Shmerinka, we would get off the train and leave the station after producing the second document, which would show that we had arrived *from* Odessa. We would stop in Shmerinka for a few days, then take the train to Odessa when we were ready.

The scheme seemed foolproof but it had to be tested.

"How about it, Walter?"

"Not me. I won't be going, I'm staying in Kiev." Walter had met some old friends from Bielsko and was happy where he was.

Damn! I could have done with him. I was so used to relying on Walter and his perfect German. Rysiek and I were the next most obvious ones to go. Adek would stay and look after Felka.

The next day we got ourselves ready. Our civilian clothes were hidden under our German army overcoats which revealed only our high boots. We were playing it from both ends. The overcoat protected us from

211

Jew-hunters and close questioning by German authorities but exposed us to the hatred of the local Ukrainian community. They might have no love for the Russians, but they certainly hated the Germans. Our papers bearing the German eagle stamp might open official doors, but we had to be prepared to discard our German camouflage if we found we needed help or accommodation from the local people.

After three months of sitting around, eating, drinking and playing cards, we had all put on weight. We had been undernourished and underweight when we left Lvov; now we almost faced an obesity problem. Rysiek, shorter and stockier than the rest of us, was really fat. Looking at him now, I remembered the day I introduced him to Adek in our little room in the Ghetto as our first passenger, a scruffy and hungry-looking young man.

Rysiek and I accomplished the trip without hitches. The information we had collected was correct and all the procedures were exactly as we thought they would be. We reached Shmerinka without any trouble. We found a guest-house and told the manageress, a pretty young woman called Mrs Morozow, who said she used to be a schoolteacher, that we would be happy to return and bring some friends to fill up her empty rooms.

Back in Kiev we walked into the flat with broad grins on our faces. "Everything was perfect," we reported. "All we need now is money." We needed more than we had been able to save from our sales of food and ration cards, especially since we might have to bribe someone to smuggle us aboard a ship or into Switzerland.

Olek promised to buy eighty ration cards from us, but at the moment he was up to his eyes in preparation for his wedding. "It will take time to get the money. It will have to be German occupational currency, though. I'll give it to you in three instalments — you couldn't change it all at once, anyhow."

One aspect of this deal bothered us. The valid currencies in Odessa were Rumanian leu and German marks; he was going to pay in instalments to give us a chance to change the money into marks on the black market. But time was getting short; we would probably be left with the bulk of the money, which we would have to try to exchange in Shmerinka.

Then Olek said: "You realise you can't leave until after the wedding?"

I nodded. "But we shall have to go two days later. We had an unnerving experience a couple of nights ago — it brought home to us just how dangerous Kiev has become."

"What happened?"

"Remember when we were all coming to your place for drinks and *piroski*?"

"Yes — and *you* didn't turn up," Olek said. "You never told me why."

"We had a bit of a fright. We were about to leave for your place when we heard a knock at the door. We looked at one another, checked that no food parcels were in sight and opened the door. We saw a young Russian in a fur coat and big fur cap. He smiled and introduced himself as Andrev, the new superintendent of the block, and asked for me by name. He said he wanted to meet me and my friends. I suppose he could tell that we weren't pleased with his unexpected visit, and he tried to put our minds at ease, explaining that it was just a routine call, to get acquainted with the tenants.

'I can see you are going out,' he said. 'Perhaps some other time would be more convenient.'

"I wouldn't have that. I wanted to know what it was all about. You know as well as I do that those visits are never 'just routine'."

Olek was obviously absorbed in the story.

213

"I told him I'd stay with him," I continued, "and the others went off to see you and Liuba. The Russian looked at a piece of paper held in his hand and said: 'You are Marian Smolinski?' I confirmed it."

"How did he know your name?" Olek's voice was concerned.

"That's what had me worried as well. It was the first question I asked him after we sat down. His answer was very simple: I signed the rental contract — my name was on the receipt. Then I asked Andrev to take his coat off and sit down at the table, and I offered him a glass of vodka. He drank it before he even sat down. He looked around the living-room and into the kitchen, and commented on what a nice place we had."

"Surely he wasn't satisfied with just one drink?" Olek said.

"We began to chat. Sure, I offered him another drink. And another. But he was careful to see that for every drink he had, I had one too. His conversation was peppered with casual questions about our work, the Germans we knew, whether the five of us were related to one another. When he got up, I saw him take an elaborately casual look around. We're always careful to keep our food out of sight. I told him we got the vodka from a German foreman who was going home and wanted to be rid of his supplies.

"He tried hard to be the sole pilot of the conversation, but I asked him questions in return and he got tired of supplying me with answers. I had to drink much more than I wanted and keep a close watch on what I was saying. Anyhow, we drank for nearly two hours, with only one slice of bread and a piece of cheese, and finally he got up when I told him there was no vodka left. He thanked me for the hospitality and promised to come again and have a chat with my friends."

"You must have had quite a ball."

"Listen, Olek, it wasn't funny then and it's not funny now. The more I think about it, the less I like it. After he'd gone I fell on my bed. I felt both hot and cold, my head was splitting, the room whirled around me. When Adek and the rest came back some hours later I was still too drunk to be able to tell them what had happened. Even the following day I could hardly remember what we talked about all the time he was here. Next morning, we all agreed that while there was probably no need to panic, we ought to leave as soon as possible," I concluded.

The pomp and ceremony of a Russian Orthodox wedding amazed me; when I attended the rehearsal I had to walk around for what seemed like hours holding a small crown of flowers over Olek's head. This was not the crown which would be used during the actual ceremony, but the priest assured me that the real one was not heavy. Afterwards we all went to Liuba's house for a party. There was an abundance of food, and of course, plenty of vodka. Dance music was provided by an ancient gramophone, with records that were just as old.

One of the pretty bridesmaids, Shura, after a few dances and many drinks, became very romantic and suggested that we leave the others to enjoy themselves, and go to her place. It was a tempting offer, but then I noticed Felka's eyes following my every movement, and when my eyes met her gaze, she continued looking at me as if pleading with me not to get involved with this girl. Her quiet persistence annoyed me at first; then the reason for her behaviour became clear. Felka was jealous! I felt rather pleased finding myself in such a situation, although I was not sure what to do about it.

In the meantime Adek was whispering sweet nothings to

215

Mira, a slightly built cousin of Liuba's. They were both oblivious to what was going on around them, dancing cheek-to-cheek in dark corners; finally Adek caught my eye, pointed to Mira and left. At that moment something made me decide against following his example.

Girls in Kiev, and I guess in most of the Ukraine, were in an unenviable position. Most of the local young men had joined the Red Army and the others were with the partisans. The poor girls had the choice of staying at home and doing their embroidery, or going out with a German soldier or foreign labourer. Foreign labourers in civilian clothes did not arouse the antagonism of the local people very much, but Germans in uniform certainly did. The girls who consorted with them did it secretly. The trouble was that the foreign workers had neither money nor food to give away, while the Germans could offer both. Shura told me that one of the other bridesmaids had a German friend who called on her twice a week, bringing chocolate and food.

It was well after midnight when we decided to go home. Felka, not being able to find Adek, intended to wait for him, and it was my duty to explain to her what happened to her brother.

"I know where he went, but surely he'll be coming back here," she said.

I disagreed with her. "Do you think Adek has enough willpower to exchange a warm bed, with an attractive girl like Mira in it, for a cold winter night and a long walk back to Olek's house? I wouldn't be surprised if we don't see him till the morning. Come on, let's go home."

That was easier said than done. In my more than half-drunk state, it required a lot of effort to stay on my feet. Walter, Rysiek and Janek led the way, Felka and I followed. For a few minutes we walked in silence, Felka's gloved hand holding on to my overcoat sleeve. I wasn't

sure whether she needed support or felt that this might stabilise my erratic walking pattern.

Suddenly she stopped and looked at me with her big brown eyes. "Marian," she said, then immediately looked away, giving the impression that she regretted her action.

"Yes?" I waited for her to continue, but there was only silence. "I'm glad that both of us still remember my name," I said.

She turned around and continued walking. I followed and caught her arm. "What is it, Felka?" I asked softly. Her eyes were focused on the street ahead when she asked:

"Why didn't you go with Shura?"

Her question startled me. Why didn't I? I asked myself. Obviously there must have been a reason.

"She's not my type," was the only reply I could think of.

"I am glad." Her comment was hardly audible. "Am *I* your type?"

The cold air and now this conversation was having a strong sobering effect on me. I knew that no matter what answer I gave it would have to be a very responsible one. It did not seem fair to be asked this kind of a question, not after hours of drinking; yet I was aware that my answer couldn't be postponed. It had to be honest and should be instantaneous. *Is she my type?* I tried to analyse the question. What does it mean? I liked Felka, I liked her a lot. I found my eyes following her more each day, and every time I discovered something new about her. After two months of sharing the same flat with four young men, her teenage awkwardness was gradually disappearing, to be replaced by confidence and signs of sophistication. Does that make her my type? How do I know? Felka wanted an answer which I was unable to give.

"Of course you're my type!" I finally exclaimed, pretending to be even more drunk than I really was. "You are

217

a girl, you are from Lvov, so you must be my type, you see.''

"Don't make fun of me, please.'' She sounded hurt. "If you don't want to answer that's fine, but . . .'', she raised her eyes, pleading, "don't make fun of me.'' She started to walk fast and called out to our other friends, leaving me behind. I stood there, slightly ashamed, not knowing what to do. Slowly and deliberately I took a long way back home. I had to think. This situation had to be clarified, just as much for Felka's sake as for mine. Although I knew that eventually I'd have to make a decision I also knew that at this moment I was not fit to come to any conclusion.

By the time I returned home, Felka was in her room and there was no light under her door. I felt relieved.

The next two days kept me busy with the preparation of two sets of travelling documents for all of us, and helping Olek and his future in-laws with wedding arrangements. I succeeded in avoiding being left alone with Felka. The answer to her simple question was still as distant from me as ever.

The day before the wedding we put on our German uniforms, and reminding each other not to talk Polish in case anybody was hanging about trying to find Jews to denounce, we set off for the market to buy wedding presents and look for things that might be useful in Shmerinka.

The variety of goods on sale was enormous, ranging from old saucepans and spotted mirrors to magnificent bronzes, lovely old china, genuine antique chairs, marquetry card-tables and dressers with Italian marble tops. Unaware of their real value, many of the vendors were asking ridiculously low prices. It took a lot of willpower

on my part not to snap up some of the choice pieces. It was clear that they had been confiscated from stately homes or palaces during or after the Revolution. The new owners, ignorant of their worth, had kept them in their homes for years; now, when they needed money, they were willing to sell them for whatever was offered.

As Janek and I stopped to light a cigarette, I felt a pull at my sleeve. A boy wearing a huge overcoat opened it to show two pistols stuck in the lining.

"Want to buy?" he asked.

I was about to push him aside when Janek said urgently: "Follow me," He led us both towards a side-street. Away from curious eyes he took a good look at one of the pistols and the box of shells the boy was offering.

"Cash or food coupons?" he said. As I listened to him clinching the deal, I wondered why he could possibly want a gun. Then the youngster slipped the second one into my hand. It felt heavy and solid; the warmth of my fingers was quickly absorbed by the cold steel; the gun seemed to have become part of my hand. I knew then I had to have it. I paid the boy's price without bargaining and put the gun in my pocket, my hand holding it close and firm.

I had never considered it necessary to own a weapon; mine was the non-violent way of a forger, not that of the gangster or killer. I believed that violence bred violence and compounded any problem. I could never shoot first and ask questions afterwards; I preferred to rely on my mental powers rather than my ability to pull a trigger.

Walking home, Janek and I discussed the whole question.

"Who would you use your gun against?" I asked him.

"Police . . . blackmailers . . ." he said.

I thought for a minute. "The Gestapo and the Ukrainian militia always hunt in pairs; you wouldn't have much chance against two of them, would you?"

"I just think a gun could be handy. It's nice to have one in case the occasion ever arises," he said lightly.

"Blackmailers don't usually work in secluded areas, and there can be three of them at a time. What would you do if two or three of them walked up to you in a crowded place and accused you of being Jewish? Start shooting and try to run away? You wouldn't get far! Besides, blackmailers often carry guns themselves. One suspicious move on your part and you'd be full of lead before you had time to pull yours out."

"You don't *have* to use it just because you've got it, but at least you have the option of using it or not." Janek stopped walking and looked at me in exasperation. "So what the hell made you buy yours?"

It was the question I had been asking myself for which I could find no real answer. I grasped the gun in my pocket a little tighter. "I wanted one," I said.

I did not know then, and I do not know now, if I would ever have found circumstances which would have seemed to me to justify the use of that gun. It was a confusing experience.

We arrived home fairly excited and without further ado got Walter to type us a gun-licence each. The document described the make, calibre and serial number of the gun, and said that since we were night-workers, the company felt we should be armed to protect company property against thieves and hoodlums. I made two company stamps for each document and we instantly became licensed gun-carriers!

Hours later, we realised that we had come home without the wedding presents, and had to rush back to buy the first things which seemed suitable. Janek bought a carafe with six glasses, and I splurged on a set of cutlery.

The wedding day arrived. The others went ahead to the church; I followed with Olek in the official *droshka*. It was

a shame that this ceremony, which meant so much to Liuba, meant so little to him. To Olek it was a stage performance. He certainly played his part well, but then Olek could play any part; he was just as much at ease with Russian peasants as he was with important businessmen or high-ranking officers, and was popular with young girls and mature matrons alike. He enjoyed his popularity and he was enjoying this wedding; more than once his bright smile exploded into good hearty laughter. He was, after all, solving his immediate problem, and it was not hurting Liuba at all. She came into the church on her father's arm looking pretty and very happy in a short white dress.

The priest began the ceremony. I was handed the crown which, with my hat in my left hand, I had to hold with my right hand over Olek's head. After about twenty minutes of holding it aloft my right arm became very tired. There was no one near enough to whom I could give my hat so that I could change hands. I did not hear much of the ceremony; all my concentration was in keeping that damned crown in place. After it was all over it took more than half an hour to get my circulation back to normal and the arm was painful for the rest of the day.

Liuba's home was beautifully decorated with hundreds of coloured ribbons and candles; one of her aunts had baked a wonderful wedding cake. Her father made a speech, jokingly calling Olek "my supplier of bread and butter and vokda". Olek, looking embarrassed for once, made a short reply.

The party began about five o'clock and went on until after midnight. We danced to Russian tangoes and foxtrots, but the highlight of the evening was when Liuba's mother served hot *piroski*. Then we sang *chastushky* — traditional Russian limericks with never-ending verses. Next day, apart from Felka and Walter, who never drank much, we all had king-sized hangovers.

221

Now it was time to pull ourselves together and give our full attention to our getaway from Kiev.

Janek and I were to go first, Rysiek, Adek and Felka would follow the next day. Rysiek knew how to find the accommodation we had lined up in Shmerinka with Mrs Morozow, the pretty ex-schoolmistress, so there would be no need for Janek or me to meet the others at the station when they arrived. We went carefully through every point, checking our papers, train departure times, the procedure to be followed at the border, and the switching of the documents. We had to know when we could expect the other three to arrive. Timing was always important; if things went wrong, the sooner we knew about it the better, and this was one of the most crucial of our undertakings.

We were just beginning to relax after our long discussions when Adek said, "I'm going to say goodbye to Mira."

"Didn't you say that yesterday?" I exploded.

He had been spending more nights at Mira's place than we liked. What had started as an ordinary romance seemed to have blossomed into a full-blooded love affair. We had told him it was foolish to take risks, and when he answered: "Don't worry about me, I can look after myself, I'm a big boy now", we suspected that love was beginning to cloud his judgment. We were right. Just before closing the door he turned around and said: "By the way, I won't be coming home tonight. See you in the morning." He was gone before we could argue with him. I was furious but there was nothing I could do about it.

Felka ran after him, but came back shortly with tears in her eyes. "He just won't listen to anybody," she said.

I was no more pleased when Olek came and paid us the rest of what he owed — all in occupational currency. I anticipated certain difficulties in changing this amount of money in a small place like Shmerinka. We had already

exhausted all the facilities known to us in Kiev.

Janek and I were due to leave at two the following afternoon. By ten o'clock we were getting restive; Adek had not yet shown up. To kill time I decided to have a haircut.

The tram took me past the house where Mira lived. On impulse, I got off at the next stop. Fuming with anger, I ran back to the house and up the three flight of stairs to her flat. I was just about to pound on the door when something stopped me. It was as though a voice in my head was saying: "Don't knock. If he can't be bothered coming home as arranged it's not your job to chase him." I stood irresolute for a few minutes, irritated with Adek, irritated with myself, then I turned and walked out of the building.

I caught the next tram home without bothering about the haircut and started to worry whether or not I had done the right thing. When I got back to the flat, there was still no sign of Adek, and a tearful Felka was just leaving to go to Mira's place to find him.

With my arm around her, I stopped her. "You're not going anywhere."

"I must go. I must know where he is."

"You can't go," I said. "It's much too dangerous."

She looked at me with a blank expression as if I was not there. I knew I had to do something to prevent her from going after Adek. "Please, Felka, listen to me. If he is all right he'll be here soon. If not" — I paused and looked away — "neither you nor anybody else could help him."

She ignored my pleading, freed herself from my hold and in a cool voice filled with determination said: "It's not like him to let his friends down. Please don't try to stop me. I have to go."

Rysiek and Janek were standing close by helplessly witnessing this tragic scene. It was clear Felka had made her decision. Nothing short of brute force would stop her.

She waved to the others, planted a kiss on my lips and was gone. I followed her and from the top of the stairs called out: "Be careful! Whatever you do, be careful! Bring him straight back . . . and Felka!" I shouted down the stairwell, "come back! I need you!"

She stopped for a second or two, then went on without looking back.

I returned to the room and joined the others at the table. We sat in silence, just looking at one another. As the feeling of her warm lips lingered, the agony became unbearable.

"Do you think there was anything we could have done to stop her from going?" Rysiek asked. "We couldn't very well have locked her in her room."

"If we'd tried to use force to prevent her from leaving the flat she would never have forgiven us. I could see it in her eyes," said Janek.

"She has no choice." I broke the silence. "Poor sweet Felka. She could never face the future without knowing about Adek. And — if something has happened to him, the feeling of guilt that she hadn't tried to do something to help would haunt her for ever."

There was so little time left before Janek and I had to leave for our train. We had about one hour for Felka to come back with Adek and to know that our plans could go ahead as arranged.

Rysiek kept looking at his watch, then turning around to face us with a quizzical, worried look.

At one o'clock we were still sitting waiting. There was still no sign of either of them. We knew what it meant, but none of us was prepared to utter the tragic words.

"They have been picked up." It was Janek who found the strength to speak up. There could be no doubt about it any more.

But had they been picked up by the Gestapo or the

Ukrainian militia? Adek had been gone so long now. He might have been taken early in the morning, or even last night. In which case, they either had not been able to make him talk and give us away or . . . People who are dead cannot talk. We could not face that possibility. But it was obvious that we had to get out of the flat immediately. Janek and I were already packed, and while Rysiek flung his things into a rucksack, Janek went out to get a *droshka*. Waiting for Janek, we packed both Adek's and Felka's clothes.

By the time he came back with the *droshka* we were already waiting outside, on the opposite side of the street, our luggage hidden in the entrance of the nearest house. Just as we were about to leave, Walter, who had already moved in with his friends, arrived to wish us goodbye.

We told him what we thought had happened and a look of anguish came over his good-natured face.

"Thanks for all you've done for us, Walter, we're going to miss you."

"It's I who should thank you. Where are you going now?" he asked.

There was only one possible place. We were going to Olek.

We forgot about Shmerinka; all we could think of was how we could find out about our friends. I felt particularly bad about Felka; she was only seventeen and she had gone through so much; she had tagged along with us uncomplainingly, never letting herself become a burden. In spite of what I had said, should I have tried harder to prevent her from going to look for her brother?

We arrived at Olek's place in a state of shock. Olek and Liuba welcomed us as I knew they would. Olek asked Liuba if she would go to the area where Mira lived to see

what she could find out. She was *not*, however, to go to Mira's flat. Liuba put on her coat at once. After one of the longest hours I have ever spent, she arrived back, pale and weeping.

"Adek is dead," she said. "And the Germans have taken Felka."

It was dreadful news. Adek had been in bed with Mira when the militia burst into the flat and arrested two foreign workers who were living in the same flat, accusing them of being Polish Jews living and working in Kiev under assumed names. While they were waiting for them to get dressed they spotted Adek in Mira's room; they checked his papers and decided to take him along as well, just in case. According to Liuba, they told Mira's mother and Mira herself to stay where they were and not to leave the flat.

She said that as they were all being loaded into a truck, Adek made a run for it and was immediately cut down by gunfire. The truck, with Adek's body in it, drove away, but one militiaman was left at the flat to see if anyone else would turn up there. Felka did so.

"She's probably with the Gestapo now," Liuba concluded. She looked at us with puzzled eyes. She could not understand why Adek should have been arrested and Felka taken away. Surely there was nothing wrong with their papers? She could understand still less why Adek had panicked and tried to run away. "What had he to fear?" she kept asking. How little she knew! Since Olek had never told her he was Jewish, it simply did not occur to her that his friends might be Jews. She knew something about our way of life in Kiev, of course, but she must have assumed that, like her parents and Olek, we were simply black marketeers.

From that day to this I have wondered what kept me from knocking on Mira's door. I can still see it there, on

the right-hand side of the landing, lime-green paint peeling around the edges. Over the years the picture of that door has stayed vividly in my mind.

Shocked, sick with grief, we sat round the table unable to speak. Somehow I felt that the responsibility for what had happened rested on me. I had organised everything and brought the group out of the Lvov ghetto to Kiev; I should have told Adek that he could not stay with Mira. I should have stopped Felka from going to look for him when it was so obvious that something must be wrong. Yet — how could I have imposed my will on them? We were equally intelligent, we all had the will to survive. I did not feel superior to them and I would have hated them to think that I was trying to run their lives. There was no real comfort to be found; I could only tell myself that I did what I thought was right at the time.

Once again I found myself mourning the people I loved. In a way the grief was even more intense. Adek's and Felka's loss was so unnecessary! Oh God, how I was going to miss her! She had become a part of my life, and although I was reluctant to admit this, I knew I was in love with her. Thinking about Felka being interrogated and tortured by the Gestapo filled my heart with anger and despair.

"Why did you do it, Adek?" I cried out.

My sudden outburst startled Rysiek and Janek.

"Was it worth it?" I continued in agony. "Did you . . ."

"Stop it, Marian!" Rysiek cut in. "Torturing ourselves won't bring him back and won't do us any good. Admittedly he shouldn't have stayed at Mira's place. He should have shown more restraint and awareness of danger. His action was foolish, there's no doubt about it," Rysiek continued, "but it wasn't absolutely reckless. If there was one particular mistake Adek made, it was to become

infatuated with a Russian girl whose mother took in lodgers — this time, unfortunately, two Jewish boys who got themselves arrested.''

"That was an extremely unfortunate coincidence, to say the least: sheer bad luck." Janek's comment was valid.

"It's such a pointless tragedy — for them to have survived the Ghetto, then to lose their lives just when their survival was practically assured. What a bloody waste!''

"You're right, it was a bloody waste!'' Olek echoed my outcry.

I got up from the table with an effort. It was obvious that it would now be too dangerous for us to travel on papers which showed the same employer as Adek's and Felka's. I had to make fresh documents. Rysiek, Janek and I would have to travel together and take the first available train to Shmerinka. I set to work and tried to keep my mind on what I was doing. It was arranged that I should spend the night with Olek, while the other two would be put up by one of Liuba's aunts. Before they left we agreed to meet at nine the following morning in the Wehrmacht canteen at the railway station. We could wait there for the two o'clock train without endangering our friends.

After the other two had gone with Liuba, I had a long talk with Olek.

"I wish you could cut down your activity," I said. "I don't mean completely, just play safe. Look, Olek, you have a lovely wife now, her parents love you dearly, and you have enough money to live comfortably, no matter how long the war lasts.''

He listened politely, not interrupting me, just nodding his head. I don't think he agreed with one word I said; but at least he didn't tell me to mind my own business.

"I think you are a bloody lucky man — just don't overdo it,'' I concluded.

That night I slept badly. I could not stop thinking of the senseless way in which two lives had been lost. We had become too complacent. Our false sense of security was the real reason for the tragedy. We must not make the same mistake again. In future we must confer with one another before any decision was made, however trivial, and abide by that decision absolutely.

With the first rays of the early sun, the nightmare came back the moment I opened my eyes. I got up straight away to check the new documents I had made.

Both Liuba and Olek insisted on accompanying me to the station. Olek promised to make inquiries about Felka and do everything possible to help. Being as vulnerable as we were, it was obvious he had to be extremely careful. The slightest suspicion from any quarter could mean disaster, not only for him, but for the Liskovs.

"Don't forget to write and let us know where you are and how you are managing. One day, when all this is over, I am sure we'll meet in Lvov!" he said.

"I promise," I replied. I thanked them both for all their help and wished them luck for the future. There was deep affection in the way Olek and I shook hands. I knew I was leaving behind a very good friend.

Some months later, in Bucharest, I was told that a young Pole married to a Russian girl in Kiev had been killed by the Gestapo for black marketeering. When the Germans came to arrest him he tried to get to a hideout in his yard, and was shot. From the description I assumed it was Olek. Nobody ever found out he was Jewish.

Another senseless waste of a young life.

17

Wearing my German uniform, I arrived at the station as the big clock on the canteen wall showed nine o'clock. Janek and Rysiek, deep in conversation, were sitting there holding steaming mugs of coffee. We found that the Kharkov to Munich train was due within an hour. A group of German soldiers was already on the platform waiting for it. We collected our food supplies for the journey and joined them. We sat among them as the train sped out of Kiev towards Shmerinka. At the Rumanian border we were able to treat the customs officials with the same lordly contempt as the German soldiers.

We left the train in Shmerinka and went to the flat where Rysiek and I had stayed on our first trip ten days ago, and received a warm welcome from the landlady. But nothing could lift our depression. We lay on our beds through the long afternoon and evening, too miserable for conversation. We could hardly believe that our little group would never be together again. When at last we unpacked our rucksacks we just looked at the bottles of vodka we had brought and put them back again. By the time we undressed and went to bed it was nearly midnight.

The next morning we were a little brighter, if no

happier. We had a long talk with Mrs Morozow. She told us that her husband was in the army and that her twelve-year-old daughter was at school in Vinnitsa, where her own parents lived. She was a strong believer in Communism and hated not only the German government but everything connected with the Nazis; as Pcles we shared her hatred, and she accepted us as friends at once and offered to do whatever she could to help us. We told her we needed to change some money.

"I know somebody on the black market," she said. "Would you like to meet him?"

"Yes, please, the sooner the better."

"And I have a nice surprise for you," she went on. "I have another young Pole staying here." She went to the foot of the stairs. "Mr Krolik!" she called. "Would you like to come down and meet your countrymen?"

We looked at each other in near panic. We were trapped. We would just have to bluff it out.

"Mr Krolik!" She clicked her tongue. "What is he doing?"

The young man who came down the stairs was clearly no more eager to meet us than we were to meet him. Wladek Krolik was about thirty, short, with a weather-beaten face and an anxious but friendly expression. He looked as Aryan as I, but as we shook hands recognition was instant and mutual. Four very relieved Jews waited for Mrs Morozow to leave them alone so that they could talk together.

"Where are you from?" we asked him.

"Lvov."

"So are we! What are you doing here?"

"I'm waiting for a friend. He and another man went back to Lvov five days ago. They're returning with fresh papers, and then we're all going to Odessa. I shall go on to Rumania — I've got relatives in Braila and Bucharest."

231

"What's your friend's name?"

"Salek. Salek Meissner."

It was incredible. None of us could believe our luck. Salek would be here in a day or two! We were so excited we did not even bother to keep our voices down, particularly when we found Wladek could give us recent news of friends we had left behind in Lvov. We all liked him; he had a straightforward sensible manner. "I just wish Salek would get back here, though," he said. "He's been gone too long for comfort."

After he had gone back to his room we looked at each other and knew we were all thinking the same thing. He seemed a decent fellow, and if Salek did not come back soon we would ask him to travel with us. I felt strongly about it; he was Salek's friend and I owed Salek so much, I thought it was the decent thing to do. That evening we told him about our decision.

"But I don't have much money left, and I need the papers Salek is going to bring."

"Never mind about the papers," I said. "We'll get you to Odessa."

The meeting with the black marketeer recommended by Mrs Morozow proved disappointing. The amount of marks and Rumanian leus he had at his disposal was minute. We took all he had and asked him to get in touch with us again as soon as he could arrange to change more.

We all agreed our next stop should be Odessa.

Mrs Morozow proved to be a mine of information. "I was in Odessa not long ago," she told us. "There are foreign ships coming in and out of the port all the time — I don't know what nationality they are though. All I do know is that it's very difficult to get documents to travel west. But if you are going there, try to stay with my

friend Fedor. He's the manager of the Matros Hotel, on the waterfront. The prices are a bit high but the food is superb. Remember me to him and I am sure he'll give you a lovely room with a balcony overlooking the sea.''

What a wonderful woman. I began making documents without delay.

We expected our stay in Odessa to be a prolonged one, and because of this we would report to the German authorities on arrival, spend the first night in the army barracks, then move to a private lodging. During our planning of the trip to Shmerinka, we had devised a clever little trick. If, for instance, we wanted to travel from point B to point C, the document I made would be from Point A, a little village about fifty kilometres before B, to point D — another small village, seventy kilometres past point C, our real destination. The advantages were twofold. Firstly, it made it much more difficult, if not impossible, for the Germans to check with the building company that had issued the document; telephone connection with small villages was non-existent. Much more important, however, was the fact that when the document was presented in point B, it already had official stamps from the transport office in point A, made by me. It would have one stamp reading *"Gepruft"* (checked), and another indicating that we had received food supplies. Any NCO in the Transport Office would automatically accept this kind of document as genuine.

Another version we devised was to make papers entitling us to travel from point D to point A and *back*, so that our documents would show we had already made the first leg of our journey. The stamps used in the offices were of standard Wehrmacht design with only the name of the town changed. The date was inserted by hand by the transport officer. I preferred this version for our trip and made stamps accordingly, with one extra for Wladek. We

decided to wait until Friday for Salek.

Friday arrived. There was still no sign of Salek. We were now very worried; he and Otto were normally so reliable in their arrangements. We now knew we would have to leave at once. Much later, I heard that Salek and Otto had been recognised by a Polish informer in Lvov, who followed them to their hotel and contacted the Gestapo. Both were killed.

Wladek was understandably nervous when we arrived at the station, but the ease with which our papers were stamped and with which we obtained our food supplies helped to settle his nerves a little. The train we had decided to travel on was for "Germans only", which did not make things any easier for him, especially as we were unable to find four seats together. Janek and Rysiek had to go into the next compartment; Wladek and I found ourselves wedged in among German soldiers.

To help him relax, I suggested he tell me about himself and his life. It took a while before he was able to shake off his nervousness, but once he started to talk his story came in a flow. We spoke in German, keeping our voices low, so that the soldiers sitting near us couldn't hear what we were saying and would not be alerted by our less than perfect accents.

Wladek told me that before the war he had been a fitter and turner. He was also a dedicated Communist, and his politics had caused him a great deal of trouble with the Polish police. "Do you know, every year about a week before the May Day celebration, hundreds of active Communists, including myself, were arrested and kept in jail until the fourth of May." This was something I was not aware of, although I knew that the Polish police were quite vicious with local Communists.

"But the Russians were even worse," he continued. "It only took a few months after their arrival for my enthusiasm for Communism to die. They regarded Polish Communists as 'foreign' fellow-travellers, opportunists and trouble-makers. I'd worked my guts out for the Party, I'd been arrested more than once for propagating the ideology, and then I was discarded like a bit of dirt." There was deep and bitter disappointment in his voice.

Our conversation lasted until we reached Kishinev, where we all got out of the train and were served hot soup, bread and coffee by women in the familiar Red Cross uniform.

When we boarded the train once more, the soldiers in our compartment smiled at us as though we were old friends and began to chat. They were going home on leave; after the long winter months in Russia they were longing to see their families and enjoy some home cooking. They were open, intelligent young men, and as we talked with them it was chilling to realise that they, or their brothers and friends, could be the merciless killers of so many Jews. How could the human mind allow itself to be twisted by propaganda into accepting cruelty almost beyond comprehension, as a duty to be carried out in the name of patriotism? We looked into their smiling faces, laughed with them, and told them we were pleased they would be home soon.

We paid many different prices for survival.

When we arrived in Odessa it was completely dark. The usual story about being left behind while getting a cup of coffee came out again and was as successful as ever. We were given a chit for overnight accommodation in a small hotel next to the station. After the hours on the train we were all tired. A long drink of vodka straight from the bottle made a wonderful nightcap and we were all smiling as we turned in. Wladek's weatherbeaten face looked particularly cheerful.

The next morning we took a *droshka* to the Matros Hotel. It was a sunny day; the fresh sea air was bracing and made us feel how good it was to be alive.

Mrs Morozow had been quite right about the hotel. Fedor, the young manager, had an empty right sleeve, which made it obvious why he hadn't been called up; he showed us to a second-floor room with four beds, a huge balcony and a glorious view. Down below we could see a small fishermen's wharf with ancient boats among craft of later design; beyond the wharf, about three kilometres away, was a bay in which merchant ships and German naval vessels rode at anchor.

Fedor gave us useful information about the city. He seemed a knowledgeable young man; later we would find out how much he really knew.

We went to the park, where old men were sitting reading newspapers or else pursuing the national pastime, chess, and housewives on their way home from market were resting and gossiping. We took a stroll around the wharf, where the buildings were either in disrepair after years of buffeting by the salty winds from the Black Sea, or had been damaged during the war.

To our surprise, one of the buildings had a battered old "Restaurant" sign. Peering inside, we saw a room bare of everything but a few wooden benches and a long table. Although it was so tumbledown and neglected there was a curious charm about the place. We went in, sat down, and waited for someone to come to take our order; there were no menu cards on the table. An old woman dressed in black, with a black scarf tied around her head, eventually appeared carrying a basket of black bread and four glasses. She put these in front of us without saying a word, went away, and soon returned with a large wooden bowl full of small marinated fish and a bottle of red wine. No plates, no knives, no forks.

The fish had to be picked up with the fingers and the head tilted back to drop them into the mouth. That was a memorable meal. The combination of fish, black bread and red wine was perfectly balanced, and we enjoyed it so much that we went back there every day during our stay in Odessa.

We still had the bulk of our money in occupational currency, and had no idea how we could change it. We wondered if Fedor could be of any help. It seemed politic to take dinner at his restaurant so that we might get to know him better.

"We'll have to be careful how we talk to Fedor," Rysiek warned us. "We don't really know anything about him. Let's not volunteer any information about ourselves. We should make him talk, answer our questions, rather than the other way round."

After our lunchtime treat the hotel dinner was an anti-climax, but we enjoyed the Rumanian wine served with it. We stayed in the restaurant until the rest of the diners had left, and when the old gramophone that supplied the background music stopped scratching the ancient records, we asked Fedor to have a drink with us. The conversation was lively, but unfortunately Fedor did not have much to tell us that was of use. He either did not know or was not prepared to pass on any information about money changing. I couldn't help noticing his surprised reaction when he saw the size of the bundle of notes I took from my pocket as I paid for more vodka.

"Nice to have some money for a change," I said, smiling. "The job in the Ukraine is finished and we've just been paid off for our three weeks leave."

For all my quick-thinking explanation, I felt it was a mistake to have flashed so much money in front of him. I worried about it long after I went to bed, and it was still on my mind when I woke up in the morning. Halfway

through breakfast, I suddenly stopped eating and a broad grin spread over my face.

"Now what?" Janek asked.

"I've got it!" I said. "I know how we can change the money!"

"Okay, let's hear it." I detected scepticism in Rysiek's voice.

"I think it's one of the best ideas I've ever had," I continued. "And do you know how it originated? The lie I told Fedor last night sparked it off." I was getting more excited by the minute. "Listen, let's presume I really was a German employee who had been paid the normal week's wages plus three weeks holiday pay in occupational currency. Right? You're with me? Then I'm recalled to Germany; which means that somewhere on the way I have to change my money into marks. The logical place is the German Bank. Any questions so far?"

The others were concentrating hard.

"Well then," I went on, "if that doesn't create any problem, what happens if a *number* of employees who have been similarly paid off and recalled to Germany travel together? Obviously they are issued with a group certificate — just as group certificates were issued for ration cards."

"Bloody marvellous!" Janek shouted. "What about a letter from the director requesting the bank to exchange his employees' money?"

"Yes," Rysiek added, "and with a list of the employees' names, and the amount each man requires changing, printed beside his name."

"Are you sure it will work?" asked Wladek. "Shouldn't you give it more thought?"

We did, and the more we thought the better the idea seemed.

"So let's get on with it!" I said.

238

Janek, in his impeccable German, composed a letter to the bank and within minutes was on his way to find an office where he could type it. Rysiek went out to locate the German Bank. While they were gone I studied the map to work out logical points of fictional departures and arrivals, and tried to decide how many names should appear on the group document, and how much money could logically be allocated to each one. We still had nearly all the occupational currency Olek had paid us for the eighty ration cards, as well as other money we had saved. It was a large amount.

When the others returned, we sat down to work out details. Excitement ran high.

"Now, quieten down," I said. "Let's not get emotional about it. You do realise that of all the cheeky and crazy things we have done in the past, this is undoubtedly the most audacious?"

"Yes," Janek echoed my statement. "Impatience can lead to carelessness, and that's the one thing we can't allow to happen. Let's go slowly and carefully, take one point at a time, then I'm sure a foolproof plan will emerge."

We decided that twenty-six men travelling on a group document should be on their way from Zhitomir, at the end of their work contract, to Munich, where the head office of the company which employed them was situated. I would compile a document, showing all the stamps it would have accrued for food and accommodation supplied on the way to Odessa. We made up a list of twenty-six names, typed it, and gave Wladek the job of dividing our occupational currency into twenty-six bundles, each to be wrapped separately with a note of the amount and the name of the man to whom it belonged. We checked the money three times before the bundles were finally tied with a piece of string. We double-checked

the document; we rehearsed Janek in the "off-the-cuff" explanation he would casually give the bank official. When we could find nothing else to check we knew it was time for us to put on our German uniforms and take the trolley-bus to the bank.

As we were ready to leave the hotel room, Rysiek made a very interesting remark. The logic of it further intensified our already inflated confidence.

"Even if the Germans in the bank thought a group certificate unusual, I'm sure they would never suspect such harmless and inexperienced looking youngsters of thinking up such a scheme as this, let alone having the nerve to carry it out."

"You're right — the sheer audacity of the scheme is its main strength," I said.

Wladek was left at the hotel to sweat out the time until Rysiek, Janek and I returned. I was glad not to be him. At least we were actively stimulated by the danger which faced us.

"Good luck!" Wladek called as we set out.

We stepped off the trolley-bus and walked to the bank in silence. A circular drive led to a beautiful mansion set in an exquisite formal garden. We were called to a halt at the ornate wrought-iron gate. I stared at the large sign, *Deutche Reichsbank*, set above the Russian double-headed eagle, and avoided the eyes of the two sentries who seemed to observe us far too carefully as they checked our papers. I felt cold beneath my uniform. Janek merely showed a bored indifference to the scrutiny, and smiled politely as we were given our papers back and waved inside. We found ourselves in a hall, bigger than most theatre foyers, from which two curved staircases rose to join at the top of a wide landing. Tall lamps with crystal shades stood at the base of each staircase and a huge chandelier hung from the ceiling dome. As I walked up the

staircase I noticed the faded patches on the wallpaper, which revealed that large paintings must once have decorated this magnificent entrance. I wondered if the Russians had managed to save them from the Germans, or if they were among the loot which had been shipped to the Fatherland.

Reaching the first floor, our brisk, confident step had slowed down considerably. Until now it had been only a matter of talking about this escapade. Now, as we were faced by a huge ornate double door, I for one began to doubt whether the money justified the risk we were taking. We looked at each other, but our nonchalant expressions did not reflect our feelings. One more deep breath, then Janek gave a quick nod and the thumbs-up sign before he knocked.

The door opened as if by magic. Two German soldiers armed with rifles stood to attention on each side as they let us in, and then the door was gently closed behind us. That sound had all the finality of a trap closing. We had passed the point of no return. We hesitated. The unexpected sight of two heavily armed soldiers had given us a real shock.

We walked in and, as though reacting to a command, the three of us clicked our heels in unison and stretched our right arms high in a "Heil Hitler!" that everyone in the room could hear.

It was a vast room with tall windows and high ceilings; clerks were busy at desks behind a long mahogany counter. Over in the corner, some distance from the others, was a larger desk where a colonel was sitting beneath a large photograph of Hitler, surmounted by draped red flags which showed the black swastika on a white circle.

The soldiers acknowledged our salute, but most of the clerks just lifted their heads in surprise. One of them — he looked rather like a retired army officer — softly

replied, "Heil Hitler", got up from his desk and came to the counter.

Although Janek was only seventeen, he had a calm air of authority that ensured polite attention to his request.

"Would you attend to this, please?" he said, handing over the letter and the list of names.

The clerk inspected it and his eyebrows rose. "This is a lot of money," he said.

"It sure is," Janek said easily. "We've been working for a year. You can't spend much money in a little place like Zhitomir, and we each have three weeks leave-money as well." He indicated his own fictitious name at the top of the list and smiled with satisfaction. "It's good to be going home with money in our pockets!"

The clerk continued to look doubtful. "Just a minute," he said, and went across to the desk where the colonel was sitting.

The colonel looked like everyone's idea of the typical Prussian aristocrat; he had a monocle screwed firmly into place and a long scar, that famous insignia of student days in Leipzig or Heidelberg, running down his cheek. An Iron Cross hung on a ribbon around his neck. His monocle gleamed as he looked up in response to the clerk's respectful request. He took the papers, studied them, looked at us, screwed his monocle in even more firmly, and studied them again. Then he motioned the clerk to bend closer and they began a muttered conversation.

It was the first time that any Germans had ever taken so much trouble to examine documents I had made. Normally, they gave one quick look then stamped them. Now I was afraid that someone with sharper eyesight and a more suspicious mind might detect the small imperfections inevitable in stamps which had been drawn by hand. I was acutely conscious of that locked door behind us as we stood waiting. It was difficult not to sway with relief when

I saw the colonel pick up a pen from a marble penholder and sign the document. Rysiek swallowed loudly.

The clerk came back to the counter and we produced the briefcase which contained our money. As he made out a form, we placed the twenty-six packets on the counter and undid the string of each one ready for him to count the amount and check it against the name. Then we passed them towards him one at a time.

He took an age to count the notes. Every minute we spent there was charged with danger; it was agony to watch the careful, precise way he worked. At last it was completed to his satisfaction.

"You won't want to go through all that again," Janek said, smiling. "If you'll just give us the total amount and the rate of exchange, we'll divide it up between the men for you."

The clerk's relief was obvious. "That *is* a good idea," he said. "Thank you very much."

He took the money and the papers and disappeared behind a double door. We were not out of the woods yet. The five or so minutes we had to wait before he came back were among the most anxious I experienced during the whole of the war. Aware of the two armed soldiers right behind us, we could not even speak amongst ourselves to relieve the tense situation. At last the clerk returned, bearing a large bundle of German notes. He placed this on the counter, carefully checked the amount against the one shown on his form, then pushed it across to Janek, inviting him to check it for himself.

"That won't be necessary," Janek said. He signed the receipt, put the money in the briefcase and we said another "Heil Hitler!" before turning to go.

The soldiers opened the door for us. We had to restrain ourselves from hurrying down the staircase.

When we were well out of earshot, around the corner

from the bank, I turned on Janek and Rysiek. "Good grief! If there ever was a stupid pair! You can't be relied on for anything!"

The smiles left their faces. They looked stunned. "What do you mean? What have we done?"

"It's what you *haven't* done," I said. "How come that two young men who consider themselves to be intelligent can't be relied upon to do a single thing without being told?"

They both stopped and looked at me angrily. "What are you talking about?" Rysiek shouted angrily.

"I'll tell you what I am talking about — why did neither of you have enough sense to bring along some vodka? I'm dying for a drink!"

We all collapsed into hysterical laughter.

18

The satisfaction we derived from this daredevil episode far outweighed the financial gain. The seventeen-year-old boy and the two twenty-year-olds who had pulled it off felt they deserved more than one drink. We bought a supply of vodka and caught a trolley-bus back to the hotel, where Wladek was anxiously waiting.

"I've aged," he said. "Now we can move on!"

Then we remembered the missing members of our group who would not be sharing this wealth with us. Our temporary happiness dissolved into depression. Quiet and gloom descended on us.

"Won't you come to Rumania with me?" Wladek asked hopefully.

But we had our eyes set on further adventure. We were all prepared to smuggle ourselves into Greece or Turkey, where there was no hated Gestapo to avoid. We had plenty of money to offer as a bribe; all we had to do was to find a ship willing to take us.

"You are the innocent-looking one," we told Janek. We felt that with his shabby civilian clothes, tousled hair and youthful appeal, he would have no difficulty in striking a chord of sympathy with a shipmaster and even

getting a better price for the voyage.

We soon found out we had not a hope.

Janek came back from spying out the possibilities in despair.

"The place is thick with the Gestapo. They're inspecting every ship with a fine-tooth comb, looking for German deserters. It seems that after Stalingrad, nobody wants to stay in the Wehrmacht! And the crew of the ships are either Turks or Greeks who only speak their own language. The only fellow I could get through to told me to get lost when I said I had three elder brothers I couldn't leave behind."

The sea-voyage was out.

"So you will come to Rumania with me," Wladek said happily. "We can all stay with my relatives in Braila."

Of course we would go with him; he had proved a good friend and companion. But we wouldn't stay in Braila.

"We want to get to Bucharest as quickly as possible," Janek said.

"I tell you what," said Rysiek, "you two go straight to Bucharest. I'll go to Braila with Wladek and we'll join you later."

It was an arrangement which pleased everybody.

When we sat down to plan how we would make the journey and work out which documents I would have to make, I realised we had hit a snag. We had managed to get round the question of a border pass when we went to Shmerinka, but that had been possible because of its unique geographical location. Now we were faced with a direct journey from one country to another, with all the strict controls that entailed. And there was something else which had to be taken into consideration. Until now, all our travels had been in the Ukraine, where, every day, thousands of German soldiers were travelling to and from the Front. The trains were so busy they did not have the

time to make a thorough check of a document: if it was typed in German and had the correct stamps, that was enough. But on a train crossing one frontier into Rumania and continuing into Hungary, then into southern Germany, we could expect controls to be extremely strict.

Our first crucial decision was to travel not as Poles but as German ethnics — all we had to do was to put the word *Volksdeutche* in front of our names and we were one of them, entitled to a number of privileges and benefits. Moreover, our spoken German did not have to be perfect for us to be able to pass ourselves off successfully.

The next thing was to make four sets of documents. We already had our story. The "our-job-in-Zhitomir-has-ended-and-we-are-on-our-way-to-Munich-for-fresh-deployment-by-our-head-office" routine would be used once again. I drafted the appropriate travelling documents from our fictitious employer, and Rysiek went out to get them typed while I worked on the stamps; but we still had not decided how to handle the border crossing.

Janek was biting his nails while concentrating on finding a solution, his young face creased with worry. I felt sorry for him. So did Wladek. Looking at him, the idea came to us more or less simultaneously.

"We'll have to try to get through on sympathy," I said. "We're young and inexperienced — what do we know about international travel? We just do as we're told."

Janek looked up. "I know," he said with comical resignation. "It's up to me again! Do we start rehearsing now?"

We took a last stroll around the city and went down the famous Potemkin Steps which led down to the water like wide, pale ribbons stretched across the side of the hill. It was time to say farewell to Odessa and Russia.

The following morning we said goodbye to Fedor and took a *droshka* to the railway station. In our roles as *Volksdeutche* the three of us naturally wore our German uniforms. We did not have a uniform for Wladek, however, and as we did not want him to be the odd man out and so more likely to be noticed, we left him outside the transport office and took his document with ours to be stamped.

Except for a sergeant and two soldiers, all at their desks, the office was empty. That would not help. The sergeant, fat and completely bald, had cold blue eyes and a tight mouth. He looked at Janek's papers first, then compared them with ones I gave him for the rest of us. He did not seem suspicious about them but he wanted to know what we were doing in Odessa.

"We're on annual leave, and our manager said we could stop over for a few days if we wanted to see the place. It gave us the chance to change our money before we get back home."

"What money?"

"We've been paid off," Janek said. "If you don't believe us, ring the *Deutche Reichsbank*, they'll soon tell you."

"No," the sergeant said, "that isn't necessary." He sorted through our papers again, and was about to stamp them.

"Where's your border pass?" he asked, shuffling through them again.

"What's a border pass?" asked Janek.

The sergeant looked at him in exasperation.

"All I know," Janek continued, "is that we're on our way to Germany and those are the papers we were given to get there. If we need anything else could you give it to us?"

The sergeant threw up his hands.

"Well," — Janek was getting into his routine — "the office in Zhitomir is closed, our manager will be in Munich by now, so what do we do?" He fixed the sergeant with a pleading, bewildering gaze.

"I can't let you go without the proper papers," the sergeant said emphatically.

"But we can't stay here for ever," Rysiek chimed in. We turned our three worried faces on the sergeant and willed him to use his stamp. He just sucked his teeth and shook his head slowly. "You stay here, I'll have to look into this."

Once more we were standing at a counter waiting, hearts thumping, trying to look as though the thought that we could be arrested at any minute had never entered our minds. The waiting grew so long that I felt my chest muscles beginning to tighten. What was keeping the sergeant so long? Where the hell had he gone? At last the door at the back of the office opened, and he came back.

"This is most irregular," he said again. "I don't know what to do with you." Nothing was solved.

Janek gnawed his fingers, growing more apologetic and desperate by the minute. "We're sorry to be a nuisance," he said, "but if we can't get to Munich I don't know what we'll do."

"I know!" I said suddenly. "Could you let us go to Bucharest, sir? There's another company office there and *they* could worry about getting us a pass to Munich!" I was getting to be as good an actor as Janek.

How could the man resist off-loading his problem on to somebody else? We smiled at him, relieved at being able to make his life easier. His eyebrows shot up and he wagged his head as he thought about it. "I suppose, in the circumstances, that's the best solution," he said at last.

"Thank you for being so helpful, sir," we chorused.

He gave us the necessary clearance to allow us to break

our journey in Bucharest and handed us our stamped papers. His cold blue eyes were not as cold as they had been. "Get your food supplies at the canteen," he said.

Tension did not ease until the train was well within Rumanian territory. Then, in spite of interruptions by military police, who came several times to check our papers, we enjoyed the sweetness of untroubled sleep.

Rysiek and Wladek left the train at Braila, promising to be with us in Bucharest in two days time. Although the separation was to be brief, Janek and I felt quite emotional as we waved them goodbye and the train drew out.

"I've always wanted to go to Bucharest," Janek said.

At last we could laugh again.

As soon as we arrived in Bucharest we reported to the German transport officer, and explained why, though our ultimate destination was Munich, we had been forced to break our journey.

"Would it be possible," Janek asked, "to get some accommodation while we got the matter sorted out?" The officer was taken by surprise. Janek was not prepared to wait for a possible refusal. "We have to go to the office in the morning, and I'm quite sure our director would be most grateful for your help."

The officer hesitated, then, with a voice full of authority, said; "But you can't go to the office tomorrow. Tomorrow is Sunday."

He was right, of course. Now we had to try to get two nights accommodation. We succeeded. The German telephoned a hotel, booked a room for us, gave us a slip of paper with the address and instructions how to get there, and wished us good evening and a pleasant stay.

The hotel, Casa Romanescu, was only minutes away

from the Gara du Nord station, and, to our delight, was one of the most luxurious hotels in Bucharest. For Germans only. There were very definite benefits in the treatment given to the *Volksdeutche*! We were given a beautiful room on the fourth floor, and for the first time in a long while enjoyed the luxury of deep, hot baths. Afterwards we fell between snow-white sheets and were asleep in minutes.

We were awakened the next morning by the music of a military band. We went out onto the balcony and stood in the sun, beating time to the music, and waving to the band down below. It was a wonderful way to start the day. It was a national holiday and the band continued to rehearse as we ate our way slowly through a huge breakfast. We had a free day at our disposal.

We strolled around Bucharest, admiring the wide, tree-lined streets, the theatres, modern hotels and huge government office blocks. Food shops had lavish displays of delicacies, some completely unknown to us. The windows of department stores and fashion shops were Aladdin's caves; we had forgotten there could be such an exquisite variety of chocolates and confectionery. In pure envy, Janek and I pressed our noses agains the plate-glass of a tailor's shop window: ready-made, faultlessly cut suits were on display, and bales of materials in all shades and patterns. Everywhere we looked we saw abundance. There might be a war on, but it certainly was not here in Bucharest. It was a fact which never ceased to amaze us, but which we were very happy to accept.

Wandering down the main street, the Boulevard Bratianu, we admired the well-dressed crowds. Men and women looked as though they had come straight out of a fashion magazine. But what really fascinated us was the gaiety and untroubled vitality of the young people, especially the girls in their brightly coloured summer

251

dresses. The contrast between these girls and those we had known over the last two and a half years was incredible. They breathed an air of confidence in the future; there was only despair where we came from. Bucharest, I decided, was definitely the place to be!

We followed a group of teenagers into a large park where there were a number of small interconnected lakes with rowing-boats. All over the grass, couples were playing with laughing children or setting out picnic lunches. Elderly people sat side by side on benches, benevolently smiling at the peaceful scene around them.

It was too much. We shook our heads in disbelief. With our vivid memories of the Ghetto and of Janowska camp, the comfortable life people were leading here seemed indecent. *No!* The indecency lay in what we had left behind, not in what we saw now. Life, surely, was meant to be enjoyed. I turned to Janek, who was engrossed in his own thoughts.

"My father used to say — 'One day the sun will shine on our side of the street'. It certainly shines on the citizens of Bucharest!" He just looked at me and gave a little smile. His face was quite unlike that of the young, inexperienced boy for which the world so often took him.

Two days later, true to their word, Rysiek and Wladek arrived from Braila. Wladek was bubbling over with new confidence, the result of his family reunion. No sooner had we got them both settled into our hotel than he rushed us off to find his cousin Leon. "You'll like him, I know — and I am sure he'll be able to help us!" he declared.

We arrived at the modern block of flats where Leon lived soon after he had come home from work. The reunion of the cousins was something to be seen. If noise denotes happiness they were both very happy. There were hugs, back-slapping, excited questions, a positive torrent of words. Ula, Leon's wife, watched smiling, and shyly

bade us welcome. She was a small slim girl, so quiet that we almost forgot she was there as Leon turned his attention to us.

He was tall, good-looking, about thirty. His fine reddish moustache suited his jocular manner and tremendous sense of humour; it was easy to imagine what a success he was in his job as a travelling salesman. He wore a big gold signet ring and a gold wristwatch; his nails were beautifully manicured. I could not take my eyes off his clothes. He wore a smart, light-beige suit, the whitest starched shirt I had seen for years, a brown polka-dot silk tie and a jaunty white handkerchief in his top pocket. He was the picture of nonchalant elegance. Wladek, too, was fascinated, and did not mind saying so, whereupon Leon took us to his bedroom and opened one of the wardrobes with a flourish, revealing at least ten suits and rows of shoes. He whipped open the drawers of a huge chest to show shirts in a variety of colours and styles. He could have started a shop with what he had there.

"I'm a travelling salesman for a liquor company," he said, as though that explained everything; then, making sure that Ula was out of earshot, "And do I have a ball!"

We all settled down for the evening and Ula and her mother cooked Polish *pierogi* for us — semi-circles of dough filled with potatoes, onions and bacon. We washed down the delicious meal with a selection of the best Rumanian wines.

While Wladek and Leon caught up on news of relations and mutual friends, I talked to Ula and her mother, and found they, too, came from Lvov. Ula's parents were typical small-town shopkeepers, with limited education but smart enough to have made sufficient money to ensure their daughter's successful marriage. At least that was the impression I got. That they were good generous people there was no doubt. During the evening we learned many things.

Life in Bucharest was in fact as normal as it seemed; there was no slave labour, no persecution of Jews, no armbands. The Jewish community in Bucharest was powerful and influential in government circles. Looking around the flat and seeing the way Leon lived, we could believe it.

"It would be wonderful to live legally for a change," Rysiek said wistfully.

"Why not?" said Leon, on to it in a flash. "There's a Polish refugee organisation here. You are Poles, aren't you? Jews maybe, but Poles as well. We won't talk about the Jewish angle. I'll get on to the organisation; they work through the neutral Swiss government."

Leon was a remarkable fellow. He made a few phone calls, and within minutes we were assured of two rooms and use of the kitchen in a flat nearby, where the landlady was an old friend of his. Wladek had not been wrong when he said he was sure Leon would do all he could to help us.

We moved into our rooms and took Leon's advice to remain inconspicuous until he got our new papers through. We were naturally keyed up and impatient. One afternoon, when the four of us were round in his flat, he told Wladek to stay where he was while he slipped back to the flat with the rest of us. Puzzled, we went back with him and found three young, attractive women waiting for us. There were bottles of wine on the table. With his customary flourish and good humour, Leon introduced us all round, patted us on the back and went to rejoin Wladek.

We didn't waste much time talking; the girls did not speak German anyway. French was their second language and we did not speak that, and if they understood Russian, they were not prepared to admit it. Later that evening, we agreed that Leon was a gentleman and a scholar, with a remarkably deep knowledge and understanding of his fellow men.

There was a sequel. The following day Lisa, the girl
who had been with Rysiek, came to the flat again, and
wanted to talk to me. Communication was something of
a hit-and-miss affair, but she managed to make herself
quite clear. Another girl had stolen her boyfriend and she
would like me to take his place. All I had to do was to
look after her and be nice to her. She would buy me
beautiful clothes and I would not have to work for the rest
of my life. She told me, with pride, how much money she
made. I looked at her, in her pink blouse and tight white
skirt with her blond hair swept high; she could have been
sixteen or twenty-six. Her pleasant face was delicately
made-up, her lipstick matching the soft pink of her
blouse; her movements were relaxed and sensuous. Look-
ing after Lisa would not have been too hard to take. I told
her how flattered I was by her offer, but said very gently
that my plans for the future did not quite coincide with
her need for a new boyfriend. I wished her the very best
of luck.

The story of her generous offer was too good to keep
to myself, and I made a great mistake of telling my friends
about it. I admit I bragged a little. They certainly made
me live to regret it; they didn't let me forget the story for
years. But after all, it isn't every day a young man gets a
proposition like that, and I still feel I was entitled to a
little justified pride!

Our papers finally came through — and we received a
nasty shock. The Rumanian Government insisted that all
Polish refugees should live in country areas under the con-
trol of the YMCA and the Swiss Embassy; there were
camps in a number of small towns, and once you were
assigned to a camp you were supposed to stay within the
confines of the district. Local police kept a close eye on
the restaurants and cinemas in the city, and even closed off
streets in order to check identity cards and impose fines on

people found outside their given radius. They displayed considerable enthusiasm in the performance of their duties; it was well known that many of the fines went straight into the policemen's pockets. Now we found that we were to be split up; Janek and Wladek were advised that they must go to Slatina, while Rysiek and I had to go to Dragasani.

Before we separated, we decided that a new wardrobe would give us all added confidence. With Leon as adviser, we bought a mixed bag of good quality, secondhand suits and some smart shirts, shoes and ties. Four well-dressed Jewish boys discarded their *Volksdeutche* papers and assumed Polish identities a little nearer to their real ones.

It was quite an emotional parting.

Dragasani is a small country town on the slopes of the Carpathian mountains north-west of Bucharest. A pretty place, close to a river, it was then virtually unaffected by the war and its way of life was almost feudal. The locals, mostly small farmers working for a landlord, lived miserably, but like their fathers before them knew no better, and accepted their conditions without complaint. They lived mainly on sweetcorn and wheat; the highlight of the year was the Christmas pig their landlord allowed them to kill. Grapes were grown on the mountain slopes, and their meagre diet was supplemented with a variety of wines and a moonshine spirit called *tsuika*, made from beetroot or sweetcorn. It had the proverbial kick of a mule.

Rysiek and I reported our arrival to the Polish Refugee Committee, which had its headquarters in a timber building known appropriately as "The Polish House". There were about a 120 refugees already in town, most of them former NCOs and low-ranking officers. A few had their wives with them. There were no Jews, at least not officially. Our papers

were issued in our adopted Polish names — it was still too early to revert to our real ones. Most of the Poles knew we were Jewish, but it did not worry us. In any case, we had very little to do with them. Social procedures were conducted formally, with titles and army ranks acknowledged and repeated constantly. First names were never used, it was always "Mr Captain", "Mr Corporal", or "Mr Solicitor". This rigidity of conduct, so typical of pre-war Poland, seemed to be what kept them going; it certainly gave "Mr Captain", who served the food, a clear feeling of superiority over plain Mr Smolinski, when he asked for more mashed potatoes and fried onions with his meat.

It was midsummer when we arrived, and the countryside was at its most beautiful. The weather was perfect, with crisp mornings, hot days and cool evenings; but I soon found out, to my despair, that no matter how pleasing the scenery and climate, it could not compensate for the boredom of life in the village.

The refugees spent their days playing cards or chess, or discussing international politics and holding interminable post-mortems on the debacle of 1939. This period of my life left me with very few memories. It was a complete anti-climax after the excitement of the previous two years.

After three months our boredom became unbearable. Rysiek and I wrote to Janek and Wladek telling them we could not stand the place any longer; we were going to take a chance and go back to live in Bucharest. Janek agreed to join us. Wladek, who had become involved in a small shoe-manufacturing project, decided to stay in Slatina for the time being.

We were delighted to see Janek, and amazed to find how the number of Jewish refugees in Bucharest had increased during our absence. We met many from Lvov, among them schoolfriends and members of *Dror*; Janek even found a cousin. Once again Leon helped us with

257

accommodation and gave us good advice. Our money was rapidly dwindling, and I thought I might try to get a job.

On the face of it, my chances of finding employment seemed unlikely. Every time we went for a meal we had to convey our needs to the waitress by signs and drawings, and every other transaction we made brought home the fact that we were foreigners, cut off from the natives by lack of a common language. But Leon arranged an interview for me with the art director of a publishing company . . . how I got the job as his assistant I'll never know. My artistic experience was limited to two years study at the Art Institute, but he took me on, at a wage far less impressive than the title I was given.

I enjoyed the job tremendously; I was learning Rumanian much faster than I otherwise would have done, and every day taught me something new. I made rough sketches for book and magazine covers, did layouts for the compositors, helped to select typefaces for the text, checked proof and colour separations for illustrations. The discipline of having to get up each morning and go to work did me a lot of good; I was the only one among my friends to be able to find and hold a steady job and I was very pleased with myself.

But good luck always seemed to arrive with a transit visa, and all too soon our easy spell ran out. Coming out of a cinema one night we were picked up in a *razzia*, a police raid organised to round up people who were living in Bucharest illegally. We spent a night in jail and Rysiek and I were sent back to Dragasani the following day. It was sad to have to say goodbye to Janek again, and he was no more eager to go back to Slatina than we were to return to our boring life in Dragasani. It was positively infuriating to find out later that only a small amount of money would have been sufficient bribe for the police to close their eyes to our presence.

It was October now, with the chill of winter beginning to thin the air, and after the comfortable way we had been living in Bucharest I was not pleased with my new home. It was a little shack with one small window, and a door which opened straight on to the backyard of the house where my landlord lived with his family. We all shared the outside water tap and toilet. The furniture was depressingly basic: bed, table, chair, wardrobe and bedside chest. There was no way in which the little room could be heated, and when the snow began to fall and the wind was in the right direction I would wake in the morning to find a soft white carpet stretching halfway across the room, blown in through the five-centimetre gap between the bottom of the door and the floor. As winter deepened the room became an ice-box; to sleep in it took courage and organisation. I would first discard my shoes, leaving my socks on, then take off my overcoat and spread it over the thin eiderdown on the bed. Then I hung my jacket on the back of the chair and climbed into the ice-cold bed wearing shirt, trousers and gloves, with my flannel pyjamas clutched in my arms. As the bedclothes began to lose their chill I would brace myself to start undressing. I did it piece by piece, juggling my way thankfully into the warmed pyjamas. It took quite a while, but I always felt the effort was worth it. I consoled myself with the thought that the place was cheap, it wasn't far from Polish House and it was private. The privacy came in useful when, on New Year's Eve, the Polish Committee organised a big party.

There was a special dinner of pork cutlets with plenty of wine and *tsuika*, an amateur dance-band, and a choice of local girls as partners. I lured one of them to my room for a nightcap. Plying her with the potent *tsuika*, I managed to get her undressed and into my bed. But as soon as she felt the touch of my ice-cold sheets she screamed,

shot out of bed and within minutes was into her clothes and out of the door, stone-cold sober and beyond all temptation.

There was one worthwhile and memorable experience during my sojourn at Dragasani. A short list of three artists who had supplied sketches for frescoes in a newly erected church had been selected by the local parish officials; the three artists were invited to come to Dragasani to make a large panel for the judges to make their final selection. I went to the church to watch them work.

One of the artists was an elderly man with long silver hair; when I spoke to him he answered softly and courteously. We found that we could converse quite easily in a mixture of German, Russian and Rumanian. We talked about pre-war art in Rumania and Poland, and compared the two; we discovered that we shared a mutual admiration for Cezanne and Gauguin; but the old man's love for modern artists such as Klee and Picasso was beyond my understanding. I needed another ten years at least before I could appreciate what they were trying to say through their painting. I knew nothing about the technique of fresco painting; anxious to learn as much as I could, I offered to help him. It seemed I could be very useful. Fresco painting must be one of the most difficult branches of art. Frescoes are intended to last hundreds of years and the preparation on the surface of the wall on which they are to be painted is of the greatest importance. A section of the wall has to be perfectly cement-rendered, and the drawing then traced upon it and painted while the cement is still wet; a damp sheet of hessian can be hung over the work in progress to retain moisture.

For an elderly man, the constant climbing up and down the scaffolding and the mixing and application of the cement were physical strains which depleted the strength needed to do actual painting; he was worried whether he

would have the stamina to complete his work in the week the competitors had been given to paint a panel three metres wide and two metres high. He was so kind to me, and taught me so much, that I was delighted when, due to my help, he was able to finish his panel on time. The scene he had chosen to depict was of the Holy Family entering Bethlehem: it was designed in Byzantine style but at the same time with a sophisticated approach — an unusual combination. The colour harmony and the intricate design created an impressive work of solemnity and reverence.

Since the artist was staying on his own in a hotel, he was glad to have a companion in the evenings, and we exchanged many ideas over a bottle of wine. He was interested in what our life was like in pre-war Poland, and questioned me closely about the day-to-day changes which came with the Russian and the German occupations. The day before the panel was finished was so cold and miserable that we decided to stay inside the church and eat lunch there. We spread out our bread and cheese and salami, opened a bottle of red wine and settled down, our backs against the church wall.

"What was your life like when you were twenty-two?" I asked my friend.

A strong wind was whistling through the high unglassed windows, disturbing the silence of the church. He put his glass down, and his voice seemed quieter than ever. "I will tell you what it was like when I was a teenage boy first," he said. "It will help you to understand."

He came from a strict Catholic family, he told me; one of his uncles was the Bishop of Cluj. He found the strict rules which had to be followed difficult to accept, and rebelled against them. "Why?" he would ask. The stock reply: "Read your Bible, you'll find all the answers you need there," did not satisfy him.

"There was continual conflict between my religion and my art," he said, the sadness of old perplexities still with him. "If I want to talk to God I know I can do it anywhere; He does not require me to stand before an ornate altar or beneath stained-glass windows before He is willing to listen to me. My prayers don't have to be amplified by the splendour of the church. If I have done something wrong, I know it, my conscience tells me so. My wrongdoing does not become less because I talk about it to a priest. I don't need a priest as mediator, still less as a judge. My conscience is God-given. I cannot escape it. It is with me wherever I go. These were the things I was thinking when I was young."

I waited for him to go on.

"I think them now — and yet," he said, pointing to the colour sketch of his work which was lying on the floor beside the scaffolding, "I have made many of these paintings to please people who need to pray in an atmosphere of splendour. There is still conflict between my religion and my art."

The feeling in his words made me admire him even more; to me he was a good man in every sense of the word and his painting was full of living religion. When his work was finished and he left Dragasani, he told me that if the judges chose him, he would like me to work with him as his assistant. But I never saw him again. I have no idea whether he got the job. A few weeks after he left, life became so unbearable that I went back to Bucharest. Janek, once again impatient with life in his village, was already living there with some friends. Wladek, too, was back under Leon's wing. Rysiek, who had found himself a girl, was content to stay in Dragasani.

My money was now completely gone. I failed to get my

job with the publishing company back again and I became wholly dependent on a weekly allowance from the Jewish Welfare Organisation, which Janek had discovered. Time and again we wondered if it would not be wiser to go back to the country, where the Polish House and the YMCA would still look after us. Was it better to continue to pretend to be Poles? Was it now safe to admit to being Jewish? However, we stayed on in Bucharest and accepted this help. The Jewish Organisation was permitted to operate without restriction. We were looked after by a wonderful woman, our landlady, Madame Esther.

Madame Esther was a one-woman charitable institution who began her working life as a call-girl. She was never a prostitute, she insisted, for she never walked the streets or worked in a brothel. She freelanced. Freedom was necessary for her fiery temperament. Early photographs showed a stunning redhead with a statuesque figure and lovely eyes and mouth. She had a clientele of regulars, some of whom took her away to France and Italy. Life in those days, said Madame Esther, was full of fun. But she never forgot that she was Jewish. She went to pray in the synagogue several times a year and put her shopping change into her "Blue Box" when the Jewish National Fund, *Keren Kayemeth*, was set up.

During the First World War she fell in love with Laslo, a Hungarian hussar stationed in Bucharest. They married in 1918, when she was twenty-five. She had every intention of being a good mother, and her two daughters were born within the first three years of her marriage. But Laslo, so debonair and virile-looking in his silver-buttoned parade uniform, loose cape and tall cylindrical hat with splendid feather, was much less attractive in civilian clothes, with a job as a travelling salesman. Esther knew that she could reduce her shortage of money and frustration simply by lifting the phone; during Laslo's absences she began to lift

the phone more and more often. However, a life of deception was foreign to her nature, and when Laslo returned home from one of his trips she met him at the door with all his things packed in two suitcases. When he subsequently wrote that he would like to say goodbye to his daughters before emigrating to America, she invited him to dinner. Eight years later, at his request, they were divorced. Esther went on to build up one of the most exclusive establishments in Bucharest; she herself stopped working in 1931.

In 1938, when the Germans entered Austria, Laslo, showing admirable foresight, sent immigration papers so that his daughters could join him in America. The girls, now seventeen and nineteen, who had both been taught English at his request, were thrilled by the idea. Though the thought of parting with them tore Esther apart, she knew it was in their best interests to go. She made them promise they would come back the moment they felt unhappy, and one grey November day, ten months before the outbreak of war in Europe, she waved them a sad goodbye.

When the Germans came to Bucharest, Esther made a fictitious sale of the business and continued to run it as manageress, but when high-ranking officers and the SS and SD became regulars, she thought the time had come to retire. She was not going to cater for the needs of those who were murdering her people in Poland and Germany. She handed over the business to two of her favourite girls, and in return received a weekly retainer for the rest of her life. She now had several investments, among them four small houses built around a courtyard and garden. She lived in one of these and housed Jewish refugees in the other three, regardless of where they came from and whether or not they could pay rent. She fed us on hot soups and brought us baskets of fruit and vegetables; she

nursed us when we were sick and looked after babies so that harassed young parents could relax for a while.

Janek had found space for me in the room he was sharing with two other Polish Jews — Edek, a short young man with thick glasses and a brilliant mind, and Jozek, who unfortunately had a rather aggressive personality. When Bronek came to join us there were problems; five people into two beds would not go. We solved the problem by working out a roster which gave each of us a regular turn at sleeping three in a bed; there were not enough blankets to enable the odd man out to sleep on the floor.

Poor Bronek had had a bad time. He had been working as a welder in Dnepropetrowsk, and, to escape the constant threats of denouncement to the Gestapo made by his Polish co-workers, had put his hand into the flame of an acetylene torch so that he could be taken to hospital. He escaped from the hospital that same night and in terrible pain began the long, terrifying journey to Bucharest.

Although we were relatively safe we were worried about Wladek. He had been talked into going back to Lvov to fetch some people out and had been caught by the Gestapo and accused of being a Russian spy. He could not make them believe he was only a Jewish refugee trying to save his own life. When they found stamps on his documents allowing him to get German food supplies, they were convinced he was part of a plot to supply hundreds, maybe thousands, with German food. They brought him back to Bucharest to try to make him identify other members of the suspected organisation, but by now he knew local conditions better than they did and was able to escape. The grapevine said that he was safely in hiding, but knowing that he was a marked man made us feel very uneasy for him.

We found out later that shortly after the Russians entered Bucharest in 1944, he went back to Lvov, which was already in Russian hands.

Part Four

Bucharest . . .
Budapest . . . Palestine

19

The long-awaited spring of 1944 brought a gradual worsening of life in Bucharest. Allied bombing increased and we spent many hours huddled in air-raid shelters. The Germans had suffered a second disastrous winter in Russia and were retreating along the full length of the front line from the Baltic to the Black Sea. We saw trucks and train-loads of troops on the move and there were streams of poorly dressed and desperate refugees on the roads. Some were Hungarian Jews who had managed to escape to Rumania. We learned that the Germans had taken over the running of Hungary and that vicious anti-Jewish measures were being enforced. Thousands of Jews had been arrested; most were sent to concentration camps in Poland and Germany. A Jewish area in Budapest had been declared a ghetto and there were plans to centralise all remaining Jews inside and seal it off. How the Rumanian President Antonescu stopped the Germans from behaving in the same way in Rumania I do not know. It must have cost international Jewry a tremendous amount of money.

Life was not easy for Janek and me. We were in Bucharest illegally and we could not earn any money. We

depended on the Jewish Welfare Organisation. We were given a very small weekly allowance, a daily lunch of hot soup with a slice of bread, and clothing when our need became desperate.

One day we came back to our room and were told that a distinguished-looking man had left a message inviting us to go to his home at eight-thirty that evening to discuss an urgent personal matter. His card read *Dr Edmund Sobel, Dental Surgeon*. We had never heard of him. What could he want with us?

At exactly eight-thirty we were at the address shown on his card, an expensive-looking block of flats. Doctor Sobel was waiting for us outside. He was plump, in his fifties, with a ready smile and an assured manner. His immaculate suit and pearl pin showed that he was a man of substance. From the moment we met until the moment we said goodbye, he was never without a cigarette in his hand.

He showed us into a large flat on the ground floor, seated us comfortably, then went away to prepare drinks. While he was gone we had a careful look around. The room was tastefully decorated. The antique furniture, Persian rugs, excellent paintings and a lovely collection of porcelain and bronzes had obviously been selected with care and taste. In the corner was a baby grand piano and a bronze bust of Beethoven.

When Dr Sobel came back with the drinks his wife came with him and it was immediately obvious who was responsible for the grace we saw around us. Madame Sobel was considerably younger than her husband, and had a high degree of sophistication. She looked very smart in her navy pleated skirt and white silk blouse.

We suffered the usual formal pleasantries and then she came straight to the point. "We have a married daughter who has been living in Budapest for the last two years.

Her husband has just been deported to a concentration camp in Poland, and we are terrified . . ."

Once she began to speak she seemed unable to stop, and I became all too aware of the white lace handkerchief she was holding in her restless fingers. She twisted it, stretched it, let it lie on her lap. As much as the words she chose, her hands spoke for her. We listened in silence to the story of the persecution of the Jews in Hungary, a story so well known to us.

"A friend told us that you might be able to go in and bring our daughter back to Bucharest before the ghetto is closed. Money is no object," Dr Sobel said. Distress made him almost as voluble as his wife.

Janek and I looked at each other. We knew what our answer was going to be.

"No," we said simultaneously. "No, thank you."

We needed no time to make the decision. We had been conditioned since Kiev, since Adek and Felka were caught. We knew the danger of over-confidence and its dreadful consequences. We discussed the subject many times, when the lack of excitement in our present life created temptation to do something. We knew that we could travel, make money by smuggling goods or people, but what was the point in taking risks now? The Allies had landed in Sicily months ago, there were only a few pockets of Germans left on Russian soil . . . the end of the war was just around the corner. Nothing was more important to us than staying alive to greet the peace.

"Thank you for your confidence in us. We hope you will find somebody else to help you," we said, rising to our feet to leave.

"I have coffee for you now — and sweets," said Madame Sobel.

We sat down again. We knew that for these tormented parents we were their last hope of seeing their daughter

again. In great misery of spirit, we told them once more how sorry we were that we could not help.

"From people arriving every day from Budapest we have heard how dangerous travelling has become," I said, trying to make them understand the reasoning behind our refusal. "There are thousands of German deserters trying to get back to Germany. Can you imagine how strictly all the trains are being checked, how great the risk would be?"

They nodded their heads, but their eyes still carried the look of hope that we might change our minds.

"At last we are reasonably safe here," Janek continued. "We are practically certain now of seeing the end of the war, and we'd be fools to gamble our chances away. Surely that is obvious? We are truly sorry."

When we shook hands to say goodbye Dr Sobel's palm was wet with perspiration.

As we tramped home Janek tried to bring the subject up again.

"Forget it," I snapped. "Only a crazy fool would consider such a hazardous trip."

"I know," he said, "but what fun if we could bring it off!"

He was still looking at the war, and risk to his life, as an adventure, a game. I did not answer. I was too afraid that the excitement of the challenge might override my commonsense.

"And the money would come in handy," he added softly.

By the time we arrived home we had come to an agreement. The proposition was tempting. The proposition had to be refused. We would put it out of mind.

The next day Dr Sobel was waiting for us in our room. "She is my only child," he said. *"Please!"*

It was dreadful to stand and watch him walking slowly away.

Two days later, at seven o'clock in the morning, we were awakened by a loud knocking at our door. Madame Sobel, her eyes red with weeping, held out a letter to us. Her daughter had had no word of her husband and was desperate. She had to move to the ghetto the following week. Was there no way, she pleaded, that she could be got out of Budapest?

Madame Sobel also held a photograph. "This is Helen," she said. "Can you do nothing to save her life?"

We looked at the photograph of the pretty girl with bright, smiling eyes and long blond hair, and I knew that for Janek, as for me, Helen Sobel was no longer an abstract "somebody's daughter". She had a face, she had become a person. What had happened to that carefree smile? Would she ever smile again, or see her husband and her parents? Janek and I looked at each other. Can we do it? we asked silently, and if with our experience and confidence we think we can, do we have the right to refuse to try to save her?

We had another closer look at the photograph and agreed that there was nothing Jewish in Helen's looks. Madame Sobel assured us that Helen was able to hold an intelligent conversation in German. She was no longer weeping. She had sensed our new uncertainty and was not prepared to give us time to think, or dismiss her arguments. She no longer pleaded, she *demanded* our help. She was fighting for the life of her daughter, and I feel sure that at that moment she would have been capable of doing absolutely anything she thought necessary to save her child. The effort drained the blood from her face; exhausted, she stopped talking and began to shiver, leaning against the wall for support. Her tired eyes gazed not so much at us, as into us. It was more than we could stand. Afterwards, Janek and I agreed that in Madame Sobel we each saw our own mother pleading for us.

"Go home now," I told her gently. "Let us talk about it. We'll call on you this evening with our final answer."

When she left we both knew that we were committed; to go back now would break her heart. The decision had been made not by us, but by deep parental love.

I shall never forget the gratitude in the Sobels' faces when we told them we would go to Budapest and try to bring Helen home. We asked them to tell us everything they could about her and they promised to have three passport-size copies of her photograph made as soon as possible. We were working against time. If we were to arrive in Budapest before the ghetto was closed we would have to leave in four days, preferably earlier.

When we told our friends what we planned to do, Bronek exploded. "You stupid bloody fools!" he exclaimed.

Jozek asked to come with us.

"How much are you being paid?" Edek asked. It was only then we realised that money had never been discussed.

There were many decisions to be made. Should we try to get German uniforms from the Bucharest markets, or travel as civilians? Should we go as Poles or *Volksdeutche*, as on our last trip? What reason did we have for the journey, and why would three of us be returning when only two set out? Why would a young woman be travelling with two young men? Would it be better to let her travel alone, with us nearby in case she was asked awkward questions? What papers were necessary for the journey to Budapest and back? Should I prepare Helen's travel documents here, or wait until we were in Budapest? Each decision had to be the right one. We had only one chance to succeed.

I did not feel too happy about the position we were in. On previous occasions I had plenty of time to study the

situation and make detailed plans before committing myself. The decision to go to Budapest and bring Helen home had been made under the stress of emotion, without any consideration given to ways and means of going about it, or to assessment of the dangers. Now we needed clear heads to make all our plans before I could even start to think about the documents I would have to make.

We finally decided on a plan and worked on the mass of details which had to fit together like pieces of a jigsaw puzzle. We would all pass ourselves off as workers for the Viennese construction company Otto Stingl, which was involved in repairing and rebuilding bridges in occupied Russia. I would have to make documents showing our photographs and bearing the company's round stamp to establish our professions and identities. Janek became a storeman, I was a draughtsman, and Helen's paper showed that she was a typist and general office worker. We knew we had no hope of getting the border pass needed to cross from Rumania to Hungary, so after checking the newspaper reports from Russia, and consulting the map, we decided our papers would prove that we worked for the Archev branch of the company and were travelling from there. Archev was a small town near Vosnensk on the River Bug, close to where the fighting was going on. We hoped to achieve our objective by saying that the Archev office had run out of border passes, or that in the general haste the clerk had forgotten to give them to us, or that nobody there seemed to think a border pass was necessary. An added advantage was that the railway line from Archev to Bucharest ran through towns and countries we knew well.

Our story was that with the front line so close, our work in Russia had ended and we were being transferred back to headquarters in Vienna before being deployed elsewhere. The train from Bucharest to Vienna passed

through Budapest. We needed a valid reason for breaking our journey there, so we decided to say that our director was in Budapest for a meeting with the Wehrmacht, and that he wanted to see us in case he might have fresh instructions for us before we went to Vienna. Helen, according to her papers, would be his private secretary.

Following our story one step further, we decided that the *Herr Director* did indeed have other directives for us. After discussing the situation with the army staff, they agreed that the work in Archev would have to be abandoned and all three of us had to return there immediately. Janek and I were to check and supervise the loading of materials and equipment, while Helen would be needed to make an itemised list of goods involved. To make it look even more authentic we decided that instead of issuing us with new travel papers from Budapest, our fictitious director should write a short instruction by hand on our existing documents: *"Sent back to Archev to supervise the shipment of materials and equipment"*, dated in Budapest and signed *"Dr Heinrich von Cramm, Managing Director"*. There would be no stamps, just the simple directive.

On arrival in Budapest, I would copy all the stamps we collected on this trip on to Helen's paper, to make all three documents identical. We went through each stage of the plan over and over again, modifying it, changing details, and working out the answers we would give to all the questions we thought we might be asked. Then I made our three sets of documents. Supposedly issued in Archev, they had the rubber stamps of the different checkpoints through which we passed. There were three *Gepruft* (Checked) stamps, with the name of the place and the date; three stamps showing that we had received our travel food supplies on the way (*Reiseverpflegung*); and two stamps (*Wehrmacht Ubernachtungsheim*) which showed

that we had stayed overnight at army barracks while waiting for a train connection. With such an impressive array of stamps, surely no German would dare to query documents which had been scrutinised and passed so often before.

It all seemed feasible, possible and logical, yet I knew that our journey through Central Europe would be nothing like travelling in occupied Russia. There, tens of thousands of military and civilian personnel were on the move constantly; reinforcements going east and retreating armies going west. In addition, there must have been thousands of deserters, not only German and Austrian, but also Rumanian and Hungarian, who, after the debacle in Stalingrad, were prepared to risk their lives in order to join their families.

Janek and I talked about it.

"How could we find out anything about travelling to Vienna or Munich?" I asked Janek.

His face was blank. "All the refugees come from the east, and the few Hungarians who manage to get to Bucharest escape through the forests or cross rivers at night."

"With so many unknown details and procedures, there'll be a hell of a lot of ad-libbing to do," I said. Janek grinned. "Tell me honestly," I asked, "after all the discussions we've had, are you still as keen to go as you were two days ago?"

Janek looked at me, and instead of answering my question he asked in return, "Aren't you?"

I did not know. One moment I had very strong doubts about the wisdom of risking our lives in such a hazardous adventure; the next, I was full of enthusiasm, looking forward to beating the Nazis at their own game. I looked upon it as a personal contest. Then I would wake up at two in the morning in a cold sweat. What on earth had

made me commit myself to this crazy escapade? What had happened to my determination to survive? If Janek and I were caught before we reached Budapest, that would not help Helen at all, and if all three of us were arrested, we would all die. So what was the point of going? Was it to prove to ourselves, or to show others, that we could still do it? I never had any desire to become a hero — that honourable title is usually reserved for courageous men who are dead. That was not my ambition. The point was, I decided, that Janek and I would travel to Budapest, bring Helen back with us, and in the process we were going to enjoy it. That sounded much more exciting!

Helen's parents gave us her address and phone number, and another address to which she might have moved in case of trouble, also a letter introducing us to her. Dr Sobel offered us money in advance; we accepted enough to buy a few clothes and to cover incidental expenses.

We had decided to travel as *Volksdeutche* and after long deliberation had chosen to wear high jackboots, brown shirts with black ties, identical to the official uniform of the Nazi party, windjackets, and black berets with swastika badges. We looked as though we belonged to a semi-official organisation, though no one could be sure which one; by throwing away the ties and berets we could look like ordinary civilians.

On the third day, our plans and documents complete, we were ready to go.

I would not have undertaken the mission to Budapest with anyone but Janek. From the day he walked into the flat in Kiev I had liked him for his commonsense and positive attitude to life. As our friendship deepened I grew to rely on his unquestionable dependability and the way he thought and acted always as a member of a team. He made intelligent and positive comments during discussions and decision-making and was never afraid to speak

against anything he did not agree with. Though he was mature beyond his years he could still act like the boy he was; sometimes his bravado had to be tempered by my greater caution. This he readily accepted. We each knew how the other's mind worked and could anticipate reactions with certainty; often a quick exchange of glances would tell us all we wanted to know. And, of course, I relied on his superior knowledge of German. All in all, I felt that our specific strengths and weaknesses made us an ideal team for the coming ordeal.

We arrived at the railway station full of high spirits and confidence. We received a rude shock. Procedures had been changed. Now a steel-helmeted military policeman, his metal symbol of office hanging from a chain around the neck, was checking documents at the door of each carriage. We braced ourselves and after short deliberation came to the conclusion that it might be wiser to find out all the details about the strict security from the MP rather than the transport officer. That would give us the advantage of knowing beforehand what it was all about. If necessary, it would also give us time to work out how we could solve whatever resulting problem might arise. We walked up to the nearest carriage and showed our papers to the MP at the door. Our usual confidence was missing.

"Where's your *Sitzplatz* (reservation)?"

"Do we need one?"

"This is a 'Germans only' train. If you are eligible to travel on it you can get a reservation from the transport officer." The suspicious look he gave us was like a warning light of what might lie ahead. It is amazing how quickly self-assurance can change into self-doubt.

The transport office was filled with noise and cigarette smoke. We joined a queue of about thirty soldiers, a few railway men and one or two civilians moving slowly past a sergeant's desk where documents were being checked

and stamped. Standing in a queue gave us a welcome break. These twenty minutes or so allowed us to regain our composure. When there were only eight men in front of us, the sergeant called out: "That's it! All places filled! The rest of you will have to travel tomorrow."

Pandemonium broke out. The sergeant, a big, red-faced man in his late forties, had obviously been through it all before. Without expression he motioned the queue to keep moving. Grumbling and swearing, the men in front of us edged forward. When our turn came, Janek placed both our papers in front of the sergeant with an easy smile. The German's watery-blue eyes studied the two strangely dressed young men and their documents and seemed for a moment unable to see the connection between them. However, the proliferation of stamps on our papers cleared his mind; then, just as he was about to bring down his rubber stamp, his arm stopped in mid-air.

"Where is your border pass?" he asked.

"What border pass?" asked Janek.

The question did not come as a surprise. We had rehearsed this scene many times, and the experience we had gained in Odessa was invaluable. Nobody could look more innocent or surprised than Janek.

"You need a pass to travel from one country to another — a special permit," the sergeant said with careful patience. "It's something like a visa — do you know what a visa is?"

Janket ignored the question. "Rumania, Hungary, Poland — what's the difference? Aren't they all part of *our* Third Reich?" Then, taking advantage of the sergeant's obvious tired pity for such ignorance, Janek became even more argumentative. "If it's such an important document why didn't they give it to us in Archev?"

"I can't do anything to help you unless you produce the pass," the German said.

"But our managing director is expecting us in Budapest! We can't go back a thousand kilometres to get a missing paper and still meet him on time!" Janek's voice was lifting.

"You can't travel without the pass!"

"Doctor von Cramm will not be pleased! We'll have to ask you to write on our documents that you wouldn't let us go to Budapest because we didn't have the right documents. Will you please sign your name and give your serial number?" Janek was in his element now. All nervousness had disappeared.

His request naturally nettled the sergeant. "Certainly not!"

"Then please sign our papers. We have to clear ourselves with Doctor von Cramm."

It was a calculated gamble; either give us our *Sitzplatz* or be identified as the man who refused it. How was the sergeant to know how important the Doctor was or who he might know? In refusing to give a couple of youngsters clearance, would he be risking the loss of a safe job in one of the most beautiful cities in the world, a long, long way from the Russian front? As we watched him wrestle with the problem, the men behind us became even more angry and vociferous.

"I'd like to see your CO." Janek's voice was polite, yet it carried a lot of self-confidence.

The sergeant gave him a look of stunned disbelief, then got to his feet and lumbered over to the officer sitting at the other desk. We watched him pointing at us and showing our papers to his superior, who studied them through horn-rimmed glasses, then turned his quizzical look towards us. Although we seemed out of danger for the moment, I was uncomfortably aware that the more people looked at our papers, the greater was the danger that one of them would ask one question too many or look a little

too closely at the stamp. I could tell that for Janek, as for me, confidence was diminishing again. I began to wonder whether we had not bitten off more than we could chew.

The officer seemed to be amused. Whatever he said to the sergeant made them both laugh. He gave the papers back and was about to get on with his own work when a preposterous thought struck him. "They surely couldn't have made them themselves!" he called to the sergeant as he made his way back to us. He was still grinning as he stamped our papers and pushed them across the table, complete with reservation stickers showing our seat numbers for tomorrow's train.

"Thank you," I said, picking them up. "We'll tell Doctor von Cramm how helpful you were."

Without daring to look at each other, Janek and I walked away. We were over the first hurdle, but came straight up against a second one. It was like running into a brick wall!

The all-important seat reservation stickers were like large postage stamps, printed with an all-over design in many colours which left two white panels for the written insertion of date and seat number. They had been printed on a sophisticated machine and there was no way I could hope to duplicate one for Helen. What a way to start the trip! How many more shocks were there in store for us? At least we had time to think about our problems; we had twenty-four hours to spend before catching the next train, and even then Budapest lay a long way ahead.

Since the Germans were responsible for our delay, we felt they should provide us with comfortable hotel accommodation as compensation. We went back to the transport office. We certainly were not going back to our own room to be faced by questions from our friends. The corporal behind the accommodation counter checked our papers and sent us to a Wehrmacht hotel in the centre of

the city. There in our room we put all the papers on the
table and had another look at them.

"I don't want to worry you, Janek, but we have a prob-
lem on our hands." I pointed to the colourful addition to
our *Marschbefehl.*

"This *Sitzplatz* sticker, you mean?"

"Yes, there's no way in the world I could produce one.
We'll just have to work out another way to bring Helen
back. And, we'll have to do it fast, in case we have to type
another document for her and make all the necessary
stamps. I wouldn't like to have to do it in Budapest."

The hot sun was streaming into the room through the
open windows. Janek sat down and spent a few minutes
studying the sheets of paper lying on the table, then he got
up. "Let's get out of here and go to Floreasca Park. I find
it easier to think in the open air." I felt the same way.

Once on the street, we crossed the road to walk in the
shade of tall buildings, protected from the hot June sun.

"What worries me," I said, "is that Helen's papers are
only good as far as Kazatin. They are stamped to show
they were checked and that she collected food supplies.
But there's nothing to prove how she got to Bucharest."

We walked along the tree-lined avenues of the park to
where we could see the sun shining on the waters of a lake.
The peaceful air was gentle with birdsong and the
fragrance of flowers. It was the perfect place in which to
think clearly.

"Don't forget her story has to tie up with ours. We
broke our journey in Budapest, so did she. Not having the
registration sticker on her document, it's clear she didn't
come by train. What other means of transport did she
have at her disposal?" I asked.

"The only alternative would be an army transport, but
it's doubtful whether a woman on her own would be
allowed to travel like that," Janek said, and immediately

added: "Wait! If her last stopover was in Hungary, she could have come on a local train; that wouldn't require any reservation."

That sounded likely. It would do, for the time being at least. Now we had to give her a good reason for stopping in Budapest.

As we walked and talked, a picture began to build up. We could see how it *could* be done; now we had to decide on the final details.

"I think better over a glass of wine," Janek said, leading the way to the park restaurant.

He was right. After two glasses of wine we had our solution. Helen, who according to her document was a typist and Dr von Cramm's private secretary, suddenly became his interpreter as well, speaking fluent Rumanian and Hungarian as well as German. They travelled together in his car from Bucharest, and Janek and I strongly suspected she was also his mistress. We were convinced that Madame Sobel would not have approved of this scenario, but she did not have to know what her daughter was doing!

The clock on the restaurant wall showed ten past five as we pushed our chairs back and walked out into the bright sunlight. We were pleased with ourselves. There were two more days to perfect our story; in any case, as we knew from past experience, there would probably be some verbal explanation to be worked out, and mental preparation for some nerveracking confrontations with authorities, but this was only possible when the "bones" of the situation were clearly established in our minds.

"Let's go to the pictures," I said, "then we can have dinner and get to bed early."

Full of confidence again, we chose a French thriller starring Jean Gabin and enjoyed watching him struggling against, and always beating, odds much greater than ours.

Back in the hotel room, we took full advantage of the facilities lavished on us by the German army. Eyes closed, elbows floating loose, I soaked in the large tub, only my mouth and nose out of the steaming water. What luxury! Snuggled comfortably between pristine sheets, I said drowsily: "Madame Esther's place was never like this."

"And we don't have to go to the backyard to go to the toilet," Janek murmured, on the verge of sleep.

The following day we took our seats on the train. The military policeman took one quick look at our documents and showed us to a compartment where two young airmen were sitting smoking. We said "*Heil Hitler*", put our little suitcase, which contained a few items of clothing, my stamp-making equipment and a stuffing of old newspapers, on the rack, then went to the canteen for lunch and to collect our food supplies. Though we pretended to be nonchalant, we were not. Our minds had been working constantly, trying to anticipate any new hitches that could arise.

Lunch did not taste as good as it should have. After collecting our *Reiseferpflegung*, we returned to our compartment. Outside the train a number of soldiers and airmen were arguing with the military policeman who would not let them board. Without the *Sitzplatz* they found themselves in the same situation we had experienced the day before. Smiling smugly, we waved our documents at the policeman and entered the train.

Janek took the window seat and I sat next to him, our backs to the engine. We lit cigarettes, and gazed out on the milling crowd of Germans on the platform, most of whom were on their way home on leave from the Russian front. Our feelings were beyond description. Here we were, two Jewish youngsters, sitting in comfort, smoking

German cigarettes, with suitcases now bulging with German food, on a German train which would take us to Budapest to smuggle a Jewish woman out of the ghetto — while members of the "Master Race" could not even get a seat. At that moment the exhilaration we felt had nothing to do with the war, Jews, Germans or Helen Sobel . . . it had everything to do with facing a challenge we were determined to win. This exercise was our personal contest, with the most exciting part still to come.

For Russian counter-offensive 1943–45, see map 6, p. 342.

20

A few minutes before the train was due to leave, two SS sergeants, an army corporal and a private with his arm in a sling got into the compartment. We gathered that they had travelled together from Zhitomir and were anxious to resume their interrupted game of cards. They ignored the rest of us.

Janek and I read our German magazines. We were pretending to be ethnic Germans living in Poland; my father was a nasty Pole who would not let my mother teach me her mother-tongue, hence my less than perfect command of German. Janek's parents were both German, so naturally his knowledge of the language was excellent.

During the first half-hour of travelling, five different pairs of military policemen came in at various times to inspect our papers. It was difficult to relax, especially as the two young airmen sitting opposite were so full of questions. Our "uniform" intrigued them.

"We've finished our job in Russia and we're on our way to Vienna," Janek told them. "We thought we might join the SS there."

We flicked a glance at the card-playing sergeants, but the men were too engrossed in their game to have heard.

The airmen became silent and the hours passed. When we went to the corridor to stretch our legs and have a private talk, two more MP's asked to check our papers.

"Why this constant inspection?" Janek asked irritably.

"This train is going home," one of them said. "There are many soldiers without correct papers who would like to be on board." He was actually saying that thousands of deserters from the Russian front, desperate for home, were willing to take any risk to get there.

Janek shrugged. It was no concern of his. "What time do we get to Budapest?" he asked casually. We needed to know but had been unable to find anybody who could tell us.

"Who knows?" said the policeman. "It depends on how long it takes in Szolnock."

"What happens at Szolnock?"

"What do you think? The train is full of soldiers coming back from the front. Some of them have been in Russia for months."

"But we are not soldiers!"

"That doesn't matter. You and the train and everything on it will have to be fumigated, and then all men will go through a medical examination. This train goes to Vienna, then to Munich. You surely don't think any lice or disease could be permitted to enter our homeland!"

"Where's Szolnock?" I found voice enough to ask.

"About two hours the other side of the Hungarian border," he replied as he pushed past us.

My eyes followed him as he entered the next compartment, then turned to Janek. We did not need words. The expressions on our faces said it all. We were really frightened.

"We have some hard thinking to do, don't we? You know what it could mean if we have to go through the quarantine procedure."

"Nothing short of suicide." Janek's voice was full of distress.

There were over a thousand men on the train. At Szolnock, most probably we would all be stripped of our clothing. Circumcised men would be immediately identifiable. The pure German, if he so wished, could be circumcised without fear, but we could never pass as pure Germans. We feared not so much the Germans as the Poles, Ukrainians and other nationalities who had enlisted in the German army and were rabid to identify Jews for their masters. We would have to face both doctors and nurses. In three hours the train would reach Hungarian soil.

"What shall we do?" Janek asked.

"One thing we are *not* going to do. We can't go to Szolnock."

The simplest way out was to get off the train at the nearest station and take a Rumanian train back. Once in Bucharest, we would apologise to the Sobels: "Sorry, we just couldn't do it." We didn't enjoy thinking about that.

"Wait a minute!" Janek exclaimed. "If we could get off the train while it's still in Rumania and return by a local train to Bucharest, why couldn't we get off the train *after* it's crossed the border and continue by a local line to Budapest?"

"Backwards, forwards — what difference does it make?" I said. The positive thought was always so much more appealing than the one that spelled defeat. The choice simmered in our minds. "We could always say, as we've done before, that we got off the train to have a drink and that it went on without us; we could throw out our berets and black ties, change our shirts and pass for civilians . . . couldn't we? Of course we can! We'll be on Hungarian soil and won't need a border pass any more," I concluded.

After reaching the decision to continue, we felt exhausted. We knew we must go back to the compartment and get some sleep. As we slid the door open we were confronted by one of the two airmen who had been sitting opposite us.

"I'd be grateful," he said, "if you would come back into the corridor with me. There is something I wish to discuss with you."

We backed away. Janek looked as worried as I felt. What was it this time? The young man ushered us, step by step, to the end of the corridor, where conversation could not be overheard. His young face was very earnest.

"While you were out of the compartment my friend and I had a long talk about you two. We had to take care our travelling companions didn't hear what we were saying."

We did not dare to inquire what that might have been.

"We think," said the young airman in a low voice, "that if you pursue your plans, you will be making a grave mistake."

We both stared at him, hypnotised. The clack of the train wheels over the rails seemed unnaturally loud. How had we betrayed ourselves? What could he possibly know? My mind worked furiously.

I saw Janek take a quick look at the train door. We were travelling fast now; this was no time to attempt to leap from it. "Plans?" he asked carefully.

"Listen," the young airman said, leaning towards us, his voice almost a whisper, "for two intelligent young men like you it would be throwing your lives away . . ."

We shook our heads at him, uncomprehending and wary.

"We don't understand," I said.

It was his turn to shake his head. His expression changed to one of pained admonition. "Did you really mean what you said about wanting to join the SS?" he

asked, and silenced Janek's sudden snort of relief. "Don't you realise that Himmler and the SS *Commandatur* pick their men from the gutter? They are vulgar savages. Their work is not for men like you. Don't do it," he said. "Why not join the Luftwaffe instead?" His young face was open and pleading.

"Could we?" I asked. "The Luftwaffe?"

For nearly an hour we faced his blue-eyed belief and were subjected to the most convincing Nazi propaganda we had ever heard. His enthusiasm for the glorious future of a victorious Germany showed his complete ignorance of the situation the Third Reich was facing. How could he not know that von Paulus and his army had long been Russian prisoners in Stalingrad; that the last pocket of German troops in Africa had surrendered more than a year ago; that the German army had retreated almost to the Polish border? He must surely know all this, even though none of us were yet aware that yesterday Rome had fallen into Allied hands.

We listened to him gravely. We showed fascinated interest.

"Do you think it would be easier to become a navigator than a pilot?" Janek asked earnestly.

"I've done six years in mechanics at high school," I said. "Do you think that after the war I could train as an aero engine designer?"

The more we asked the more enthusiastic the young airman became. His eyes shone as he talked about the creation of an immense network of civilian airlines which would one day service Britain and Europe and offer a glorious future for all former Luftwaffe personnel. He was anxious that we should be part of that tomorrow instead of sacrificing ourselves on what he clearly thought was the altar of the anti-Christ. It was impossible not to feel sorry for this likeable young man who was trying so hard to

salvage our future. But it was time to stop egging him on.

I held out my hand. "We can't thank you enough for taking the trouble to guide us in the right direction."

We shook hands. Janek followed my example, and with deep sincerity, we both solemnly promised that we would not join the SS.

Back in the compartment we shook the hand of the other airman, gave him a wink and nodded our thanks. For the rest of the journey we found it hard not to burst out laughing when we thought of that incredible conversation.

Suddenly we became aware that all the station signs along the route were in Hungarian; we must have crossed the border without even knowing it! So much for all the fuss about getting a border pass. The time was coming near for us to leave the train.

When the police came to make yet another check of our papers, Janek asked what time we would reach Szolnock.

"We are not going there," we were told. "The RAF bombed it last night, the barracks and hospital have been completely destroyed and about two thousand men were killed."

It was only later that day that we realised that if we had been able to take the previous day's train from Bucharest, we would have been in Szolnock among those dead.

The countryside was changing now. We had seen small farms, white-washed cottages with thatched roofs and garden wells, and now we were travelling through fields of golden corn and sunflowers. The hills and the Transylvanian Alps in the background were rounding into gentle slopes and rolling plains. The sun flashed on small canals and streams. The women we saw at the local stops wore

embroidered skirts and colourful shawls and the men wide white linen trousers and black knee-high boots.

We slid into Budapest, with a screech of brakes, at one o'clock in the afternoon. We wandered around the station until the train had continued its journey and only then did we go to the transport office to report our arrival. Clicking our heels we announced our presence. The sergeant behind the desk was not pleased to find we had broken our journey, and told us so in no uncertain manner.

"You can't just get off the train whenever you please."

"I wish you would tell our director that," Janek said. "It wasn't our idea to stop here. But he wants to see us, so here we are. We would much rather be with our friends in Vienna. But, employees don't argue with their director, especially not with Doctor von Cramm, they do what he tells them or else!"

"When he tells us to jump, we jump!" I sounded bitter and even more angry than Janek. The German was easily persuaded.

"Quieten down," he said, stamping our papers and giving us a twenty-four hour pass. He also gave us the address of an army barracks where we could get food, supplies and a bed for the night.

"We'll report back as soon as we have things sorted out with our director," I told him, and we walked out into the city.

It was a wonderful feeling. The Hungarian police had no jurisdiction over us and the German authorities had given us the freedom of the city until midnight tomorrow. For nearly two whole days at least we were untouchable, and here we were, on this sunny afternoon in June, in one of the most beautiful cities in Europe.

We found our barracks, where we left our suitcases and changed some money into Hungarian poengo. We bought an ice-cream to celebrate. Wandering around the city, we

entered a small park, found a telephone box and tried to ring Helen.

We had to ring her number three times before we made contact. We explained to her slowly, in Rumanian, that we had a letter from her parents and would like her to meet us, at once, near the entrance to a small park on a certain street. We told her to bring a spare jacket without the Star of David, and to change into it once she was in the park. We said that we would recognise her from her photograph.

"I'll be there in twenty minutes," she said without hesitation. "Watch out for a tram number forty-four. There's a stop near the main entrance."

We found the entrance and the tram stop. I recognised Helen at once. She was taller than I had expected. We motioned her to follow us, and led her to a secluded bench where we gave her the letter from her parents.

When she had read it she looked at us in disbelief. "You have come to take me *home*?" she asked incredulously.

Carefully, point by point, we outlined our plan.

"It's quite simple," Janek told her. "All you have to do is board the train with us, act naturally and enjoy the trip."

"When we get to Bucharest, we'll take a taxi or a tram to your home," I added.

To a girl scarcely out of her teens who had always lived within the law, it seemed far from simple. She sat stunned, mouth open, eyes staring. Waiting for her to regain her composure, I studied her face as if about to paint her. Her light hair, parted on the side, was kept in place by a pink ribbon, creating a soft contrast. The dark eyebrows were high and formed almost a half-circle above bluish-grey eyes sharply outlined by long eyelashes. Her mouth was small and slightly asymmetrical; the higher left corner created the illusion of a permanent smile. Although she

was not a classical beauty, she had inherited her mother's sophistication and something of her almost regal posture.

Slowly she looked from me to Janek, searching our faces. The rigidity of shock began to ease. "I am sorry!" she said. "I am so sorry. Could you tell it all to me again?"

Carefully and slowly we went over our plans, giving her time to assimilate each point. I have never known anyone listen so intently. As we talked she began to nod at intervals. Her searching eyes never left our faces. At last she spoke. "I've tried to find a guide willing to take me across the border, but everyone is too afraid of the Hungarian border police and the *Csendors* (the Hungarian country police). They gloat over the number of Jews they catch."

"You'll be safe with us."

"You mean that we will travel on a *German army train*?" she said incredulously.

"In comfort," we assured her, "using the same sort of documents which got us safely here. All you have to do is to come to the transport office with us to get your travelling papers stamped."

"Please," she said quickly, "don't ask me to do that. I couldn't, I wouldn't dare. Please."

Her nerves, stretched thin by the disappearance of her husband and the constant threat of the ghetto or a concentration gamp, were now under further strain from our unexpected appearance, and what she clearly thought was our bizarre scheme. It could be dangerous to persuade her to go to the transport office against her will. We saw that at once.

"Don't worry, we'll think of something."

"But on a *German train*," she repeated. And we could tell that she was daring to take heart.

"Can you be ready to catch the ten past five train tomorrow afternoon?" I asked as casually as though we were suggesting an outing to the country.

She caught her breath and hesitated for a few seconds. "Yes," she said shakily.

We impressed upon her how important it was not to arouse curiosity, even in her friends, and to avoid talking on the phone.

"We'll meet you at four o'clock in the café opposite the station. Come by taxi and take off your Yellow Star before you get out of the cab. We will get the papers stamped in the morning and collect our food supplies. If anything goes wrong we'll ring you before ten o'clock."

"Yes," she said again. The colour had come back into her face and the tired and frightened girl was beginning to look more like the image of the one in the photograph. "I can't disappoint my parents, can I?"

For the first time we all exchanged smiles. We took her back to her tram stop.

"Would you like to come to my place for a meal?" she said. "I haven't much but I could easily . . ."

"No, thanks all the same. You go home and pack. Have a good rest," Janek told her. He had obviously made the right answer, for her and for us: we were dying to take a look around Budapest, and it was clear she did not really want us to accept the invitation. We saw immediately how relieved she was when we declined.

We saw her off and then made for the city. The old buildings were as beautiful as we had imagined they would be. We walked and looked, drinking it all in. Tired, we flopped on a bench by the river and watched the long barges and small boats making their slow way up and down the dirty brown water which divides Buda from Pest.

"The romantic Blue Danube?" Janek said in disbelief, and we could not stop laughing.

But there were serious matters still to be considered. We went over our plan yet again.

"She came with the director by car; they stopped off at a few places on the way, where the company was building bridges. Now I'll have to make two stamps showing she's picked up food supplies, and one to show where she stayed overnight."

"Right."

"Where *did* she stay overnight?" I asked.

"In Szolnock," Janek replied without hesitation, and we were laughing again.

We had to get Helen's papers ready by nine next morning. But where could I make them? The crowded barracks where we were staying overnight had four beds to a room and soldiers were always in and out. I would have enjoyed doing it there in front of their noses, but that was too dangerous even for us. Cafés were always full and ill-lit. I needed seclusion and clear light for the fine work. I felt frustrated. Even a simple procedure like making stamps, something that had never created a problem in the past, had become a stumbling-block.

"Where can I make them?" I asked Janek.

We listed the places we knew in Budapest. These were very few and quite unsuitable. Helen's flat in the Jewish sector was out of the question.

"The park?" Janek asked, and while I was considering this suggestion he had it all worked out. "You can do it in the morning — in the park! We can buy some thick magazines to use as a table and I can hold the ink-bottle for you." Crazy as it sounded, in fact it made sense.

"And now that's settled," Janek said, "for heaven's sake let's eat."

It was still an adventure; we were two high-spirited young men out to enjoy ourselves despite the dangers. Used to the thin soup of the Jewish Welfare Centre, we were eager to enjoy fine food and wine. We knew that Dr Sobel would not begrudge our spending some of his

money this way. We found a nearby restaurant, where the stuffed peppers were drowned in hot gravy to conceal the lack of meat, but the red wine was superb. We would have loved a second bottle, but resisted the temptation; we would need clear heads in the morning. With an unaccustomed feeling of opulence, we flagged down a taxi to take us to the barracks. The driver was a World War I veteran who spoke good German and liked to use it.

"What are you doing in Budapest?" he asked.

"We only came this morning from Russia," I said, "and tomorrow we'll be on our way back there. Blast it! And blast the whole bloody war!"

"Then you must make a sightseeing tour of our city! You mustn't miss such an opportunity. Hire me to take you around and I'll show you a Budapest you will never forget!"

He was a likeable and lively fellow and the price he quoted for the service he offered seemed reasonable. By ten next morning we should have concluded our transactions and the time we had agreed to phone Helen if necessary would be past. We would have six hours to hang about in a foreign city where we did not speak the language before meeting her at four in the afternoon. What safer and more enjoyable way to pass the time than in the company of this obliging man?

"Meet us outside the station at noon," I said. "But we have to be back there by three o'clock, you understand?"

That night we slept well; red wine, exhaustion and the relaxed feeling that all would go smoothly put us out the moment our heads touched the pillows.

We never doubted for a minute that Helen would meet us as arranged. We had seen the way she had coped with shock. She would do it, if not for herself, for her parents. The Sobels were a devoted family.

Next morning we breakfasted early. On the way to the

park we bought two Hungarian magazines. We could not stop laughing. We loved to be able to make gestures like this. On a solitary bench under a tree, away from the main footpath, with the magazines as support and Janek holding the bottle, it took only about twenty minutes to complete the stamps from the tracings I had made of the genuine ones. I wrote identical orders of return to Archev on our three documents. I signed them *"Dr H. von Cramm"*, checked everything carefully, folded the documents, took a deep breath and nodded to Janek. It was time to make our way to the transport office.

The sergeant we had seen the day before remembered us.

"Can you believe it," Janek said, pushing the three sets of papers towards him, "we are ordered back to Russia, practically to the front line, but our bloody director is going home!"

The sergeant checked the papers. "There are three lots of documents here," he said.

"Don't we know it! We've got to take his personal secretary with us."

"Secretary!" I chipped in. "More like his mistress . . . and a right bitch! She's probably still in bed with him!" I took Helen's certificate, with her photograph stamped with the firm's imprimatur, from my pocket. "You wouldn't think it to look at her, would you?"

The German scrutinised it. "She'll have to collect her papers herself," he said with a sly grin.

Janek immediately went into top gear. "Don't make things worse than they are!" he almost shouted. "Dr von Cramm will be bringing her down here minutes before the train is due to leave and there'll be hell to pay if her papers aren't ready!"

Just at that moment two agitated soldiers rushed into the office and whispered something to a captain sitting

behind a huge desk on the other side of the room. The captain's jaw dropped and he reached for the phone. Soldiers and NCO's appeared from nowhere; the next moment the place turned into a wild confusion of shouting voices, ringing phones, chairs overturning. The sergeant got up, our papers in his hand, and joined the gesticulating throng of military men. After a minute he came back to us; he was breathing heavily.

"*Was ist loss*?" (What is happening?) Janek asked.

The sergeant brought his rubber stamp down, once, twice, three times. "The bastards, the English and Americans landed in Normandy this morning," he said savagely. He did not seem to see us. Quickly we picked up our stamped documents and left.

It was D-day, 6 June 1944. Millions of people will never forget that day, least of all Janek and I.

From noon until three o'clock we cruised the twin cities of Buda and Pest in a state of euphoria. Our cabby was a wonderful guide. He showed us buildings, monuments, bridges, hills and a beer garden where the local beer and frankfurts with sauerkraut made a meal to dream of. I still remember the taste of the caraway seeds in the sauerkraut. At three o'clock he took us to the barracks to collect our suitcases. At four we were waiting for Helen in the café opposite the station.

She arrived on time. She stepped out of the taxi looking very smart and quite unlike the bitch I had told the sergeant she was. She wore a light-brown skirt and a yellow blouse, her blond hair was neatly tied back and her young face showed only the suggestion of make-up. She carried just a small leather case, a handbag and a cardigan. As she walked across the road to join us, few people would have noticed the nervousness in her smile.

We bought her coffee and told her the good news about her documents. She accepted it quite casually. "But I *knew* you would do it," she said limpidly, smoothing down our incipient indignation. Such immediate and peaceful trust did a great deal for us all.

"It will all be over soon," we assured each other.

We told her the Allies had landed in Normandy. We calmed our feelings, rehearsed our cover story, checked that Helen remembered all we had told her, then faced up to the fact that it was time to go.

She and Janek walked across to the station while I paid our bill and bought some sweets for the journey. When I joined them on the station platform I was astonished to find Janek red-faced and more angry than I had ever seen him. Helen, looking sheepish, was clutching her bag nervously.

"What happened?" I asked urgently.

"You'll never believe it," Janek said through his teeth. "We'd barely left the café when this elderly man with the Star of David on his jacket rushes up, grabs me by the arm, and starts to babble about how grateful he is that I am taking Helen to Bucharest! I had to shut him up and shove him off — God knows who heard him!"

"I'm sorry," said Helen, near to tears. "He was my father-in-law. Poor man, he's been through so much . . ."

Janek made a brusque motion and Helen fell silent. It was enough that nobody seemed to have noticed. We never mentioned the incident again. Fortunately there had been few people around, and now, on the platform, there were only about a dozen officers and soldiers, and fewer civilians waiting for the train. When it came it was nothing like the Pullman in which we had travelled to Budapest. It had no individual compartments, just benches with a passageway at the side of the car. There were quite a number of empty seats. We bundled Helen into a window seat,

put her luggage on the rack and tried to ignore the approving reaction of the soldiers already on the train towards this young, attractive woman. The train pulled out of the station. The suburbs of Budapest were slowly left behind, and we journeyed on into the depths of the countryside. It was then we realised that these young soldiers, their hilarity induced by wine and spirits, were going back to the Russian front after home leave. They had nothing to celebrate!

One of the young corporals tried to engage Helen in conversation. Still under great tension, she could do no more than be awkwardly polite and the boy was soon put off. We gave her a drink of vodka and encouraged her to sleep.

We passed the once-dreaded Szolnock in the darkness of the night, with a full moon and bright stars outlining the reflection of the city in the river Tisha. By the time Helen woke, we had been on Rumanian soil for more than an hour. I will never forget the satisfaction with which Janek told her that she was on home ground.

Helen's mother had been quite right; her daughter spoke good German. As the day and journey lengthened and the young soldiers, irresistibly drawn towards a pretty girl, came up to talk and joke with her, we realised that it was quite safe to leave her alone with them. Janek and I moved towards the window in the passageway to have a talk, something we had been unable to do in comfort since we boarded the train.

We were now high in the mountains, in magnificent country crisscrossed by rivers and streams, with tall pines and flower-carpeted rocks. Slowly, the train began to reduce speed and slowed down to a halt. What now? We found there had been a derailment a few kilometres ahead, and that our train might be immobilised for some hours. Our annoyance was immense. This meant we

would arrive in Bucharest late that evening. It would be difficult to find a taxi, and there would be no time to get a tram home before the curfew! How quickly the human spirit makes its adjustments.

Helen chatted with her soldiers, the train eventually began to drag its way forward, and sure enough, we arrived in Bucharest late in the evening. There were no taxis. We took a tram. Then we walked. Minutes past curfew time we arrived at the block of flats where Helen's parents lived, to find the main entrance door locked. Janek climbed on my shoulders and knocked on one of the windows shrouded by heavy curtains, behind which we could tell a light was burning.

"Who's there?" said a voice.

"Helen," Janek replied.

There was a scream of excitement, then a quick exchange of words; we hardly had time to walk to the front door when it opened and we hurried inside. We went in with Helen but we did not stay. No matter how much we had risked, we were still outsiders and we knew it. We went quietly, unnoticed, leaving the three of them in privacy for their moments of almost intolerable emotion. Such joy and relief is beyond the range of usual experience.

Silently we crossed the deserted streets, knowing we were out beyond the curfew but unable to worry about it. Suddenly, there in the middle of the road, we both stopped walking, looked at one another for a few seconds, then spontaneously threw our arms around each other, while our tears began to fall. How long we stood there, hugging each other and sobbing, I do not know. It could have been two minutes or fifteen, there was so much tension and so much bottled-up emotion to be shed.

"We made it! We made it!" we told each other over and over again. Exhausted but happy, we sat on the kerb

and talked; we felt too elated to go home and were reluctant to lose this feeling of euphoria. Back in our room we would once again be faced by monotonous reality; after the heady excitement of the last four days that was the last thing we wanted. We felt marvellously alive and very hungry. Taking bread, cheese and salami out of our cases we ate ravenously, stuffing the bread into our mouths without bothering to cut it. I remember those moments as one of the highlights of my life.

"I told you it would be as easy as eating a piece of cake" — Janek, his mouth full of food, was justifiably proud of the confidence he had displayed all along.

"I can't help wondering whether we would have been so successful with the British or French," I said, and without giving Janek a chance to reply I added: "I certainly wouldn't have liked to try my luck with the Russians. They're such a suspicious lot, they don't trust anyone."

The experience meant a great deal to us; there was pride and satisfaction in a job well done. Thanks to our good planning and anticipation, we were confident and in control, and at no time in danger of our lives. Understanding the mentality of the Germans made our job so much easier; without imagination, or the capacity for initiative, blindly obedient to orders from superiors and always impressed by an official stamp, they were relatively easy to manipulate.

For four days we had been behaving like experienced underground agents, proud of the surgical precision of our planning; now we were just two weeping boys; Janek had just turned nineteen, while I was not yet twenty-two.

Glad though we were to have been able to see Helen safely with her parents, we could not help thinking of our families and the dear friends we could not save. My thoughts turned inevitably to Giza, so close in age to Helen Sobel. And to Felka.

304

Once again life had shown how little control we have over our own destiny and that of the ones we love, and suddenly an immense sorrow overcame my elation at the success of our mission.

21

We got home very early in the morning after dodging the Rumanian police patrols. We woke our friends.

"It all went well, Helen is safe with her parents, and we are dead tired. All your questions will be answered tomorrow." We fell into bed and were asleep within minutes.

The next morning we could not bring ourselves to get up; it was marvellous to lie there and relax. But Helen's father, still wildly excited, was around to see us before we were dressed. He couldn't stop thanking us or praising us enough for what we had done.

"The money I advanced is just a bonus, I'll leave you this envelope." At the door he turned around with tears in his eyes. "My wife and I will never forget last night, neither will Helen. Goodbye."

After he had left Janek looked at me and added: "Neither will we."

Anxiously I opened the envelope. There was a small bundle of notes. I took one out, gave it a quick look and passed it to Janek.

"American dollars!" he shouted. "One hundred American dollars!" He passed the note round to our

friends, who were no less excited. While the note was being scrutinised, I fanned the bundle and started to count the rest slowly, laying them on the table. "One, two, three, four . . . " There were forty of them.

"Four thousand American dollars!" I just could not believe it. "Imagine what that's worth on the black market!"

Later in the day, when we found out, we were amazed. The amount was staggering — far more than anything we could have hoped for.

Naturally the first thing we did was to provide a splash-up dinner for our room mates. We took them to a night-club and before the dinner was over handed two hundred-dollar notes to each of them. It was the least we could do. Over the last months they had shared food, clothing and beds with us.

Then Janek and I moved out. Our new room in Piata Rosetti was part of a flat which came with a middle-aged landlady. It was neatly furnished and only ten minutes walk from the commercial centre of Bucharest, with its shops, restaurants and nightclubs.

The real fun began when Janek and I started our shopping spree. We let ourselves be talked into buying a quantity of eighteen-carat gold scraps so that we could have two signet rings made. I designed one for each of us and we stood over the goldsmith as he cast them with our gold. We had to be sure that the rings we received contained the metal we supplied. My designs were impressive and the rings looked lovely but I had no experience in the manufacture of gold jewellery. When we put them on the weight of the gold made it hard for us to lift our hands. However, we got used to that and enjoyed the comments they created wherever we went. Next we ordered two pairs of riding-boots; not that we intended to ride, but they were high fashion at the time. They were handmade from

the finest and softest leather, and to go with them we bought gabardine breeches and suede leather jackets. A Pelikan 51 pen in the pocket and a Tissot watch with a black face and a long second hand were musts, and so was a Tyrolean Borsalino hat with a jaunty feather. Any small and exquisite item in a shop window was ours within minutes.

Word about us got around!

Because we had proved we could bring people from Budapest we were inundated with requests to go back and bring out other Jews. The money we were offered was beyond belief, but it was ludicrous to think that there was enough money in the world to induce us to try to bring out a rabbi, complete with beard, ringlets, black caftan and wide-brimmed hat; or, more outlandish still, a rabbi with his wife and daughters. "Name your price," we were often told, and just as often we said "No."

Somehow people also learned of our recently acquired "fortune" and had all sorts of fabulous business offers. I wish I could remember the propositions made to us; some of them kept us laughing for weeks. Our own objective was clear. The war was winding down; all we wanted was to be alive at the end of it. We looked forward to enjoying ourselves while waiting for the peace to come, in the sure knowledge that when it did, there would be plenty of time and opportunity for us to make new fortunes in the years ahead.

There was one offer, however, which quite took our fancy, although we did not like the woman who made it. A friend arranged a meeting with her. She was about forty, tall and slim, with a long thin nose, eyes that were too close together and a loud, unpleasant and aggressive voice.

"I have buried about fifty kilos of gold and jewellery outside Budapest, and if you could bring it back, I would share it with you," she told us.

Naturally we liked the idea of the gold, but it was really the excitement which appealed to us; it was something that we could do ourselves with no one else involved.

"Let's meet tomorrow at the same time and we'll give you our answer," I said. I knew the answer already, but did not like to appear too anxious. When we met her again, Janek and I knew how we could bring the gold. We planned to pack the gold and jewellery in two expensive-looking suitcases labelled "General Graf von Binder" or some such high-sounding name. We would board the train early, put the suitcases on the rack in a first-class compartment reserved for high-ranking officers and dignitaries, then settle down ourselves in a second-class compartment. With a name like that on the labels, no one would dare to touch the cases. When we arrived in Bucharest we would wait for the officers travelling in the compartment to leave, and then go in, replace the labels with ones bearing our own names and just walk out of the station with them.

Sad to relate, the lady did not trust us. "Could I come with you?" she asked, obviously to make sure that if we did get the gold we would not go off with it.

"Yes, certainly," Janek said without even looking at me. "But there's just one thing. Do you know that we travel on German army trains?"

"Is that how you brought Helen to Bucharest?"

"That's right," I said, rapidly losing interest in this adventure. She looked at us for a few seconds and finally decided against the whole offer. I am sure even the possibility that we might murder her to get all the loot for ourselves occurred to her. Although we had no regrets, I suppose Janek and I will always wonder if we could have got away with it; the gold may still lie buried, for all we know.

After that we put all ideas of another trip out of our

minds. We simply concentrated on our spending spree, loving every minute of it. The girls in Bucharest were known for their insatiable thirst for life and their generosity. With a nice place to live and a willingness to spread money around, Janek and I unashamedly made the most of this fortunate situation. How we enjoyed ourselves!

The Allied bombing, initially centred around the oilfields, was spreading towards Bucharest; thousands of RAF Lancasters and American Liberators were in the skies over Rumania. We lost a lot of sleep. One night, after three hours in the shelter, the sirens wailed the all-clear and we stumbled out from our below-ground refuge to find the houses all around us on fire. Ours was miraculously untouched. We fell into bed exhausted, but the light from the flames penetrated our heavy blackout curtains and the red glow was visible even behind closed eyelids. But if we could not sleep at least we could lie there knowing the Russians were closing in.

The Germans held on to the airport until they had only one Stuka left.

"The tales they tell!" said Janek, coming back from the city where he had tried to ascertain how much longer we had to wait before Rumania was purged of the Nazis. "They say that the last pilot out, after running out of bombs, threw down stones, and when those were gone, spat on the people below. How would they know? The way people talk! And what they believe! It's incredible."

But what we could all believe was the announcement that young King Michael had ordered the arrest of Marshal Antonescu. This was on 23 August 1944. On 30 September the Russian army, under General Malinowski, entered Bucharest. I shall never forget the night when,

310

together with more than half the population of Bucharest, Janek and I stood in front of the palace, where a young man declared his country once again a sovereign nation. As far as the eye could see candles lit the darkness. We felt that a whole nation was there, young and old, rich and poor. And when the crowd lifted its voice in the majestic, measured beat of the Rumanian national anthem, I am not ashamed to say that we were both near to tears.

That September was a long month for us. Young and cocky we might be, but our nerves were fine-drawn. Behind us lay nothing but danger, disaster and the need for vigilance. Dare we relax now?

Though the fighting had ended in our part of the world, we, as Jews, had found no real peace. There was no place in the world we could call home. "Where do we belong?" we asked ourselves. No matter how emotionally inspired we might be, one question was constantly on our minds. "The war is almost over, but what are we going to do now? Where can we go?" The idea of settling down in Rumania did not appeal to either of us.

"Certainly not Poland!" Janek was thinking aloud. "The memories are too fresh and painful . . ."

"Besides, Lvov, together with eastern Poland, will become part of Russia, I feel sure," I added.

As the country settled down to normality, the incidence of *razzias* increased. Time and again Janek and I, along with other friends, were caught by local police and only escaped being sent back to Slatina or Dragasani by handing over bribes. Since Janek and I were the only ones with any money, and since we could hardly leave the others in the lurch, we paid up. Our lovely money was now almost gone; we anticipated that before long we would have to sell some of our treasures in order to eat. The good times were almost over.

Our thinking began to change. Janek had become

involved with a Zionist organisation, *Gordonia*, and since Western Europe was still involved in heavy fighting, an idealistic viewpoint was being mentioned more frequently.

"Palestine," said Janek. "Europe is tearing itself apart. Our place is in Palestine."

But how to get there? *Gordonia* had some answers. Through them we, and many others, applied for a permit of entry to Palestine, and were informed that there would be a waiting period while the International Joint Organisation — "Joint" we called it for short — processed our applications and passed them on to the British Embassy in Switzerland. Palestine, as we were never allowed to forget, was under British mandate.

Eventually, certificates enabling Jews to sail on the *Mercury*, *Bulbul* or *Maritsa* from Constanta, a Rumania port on the Black Sea, came through. We were annoyed to find that our names were not among the first batch.

"We'll be going anyway, so why wait here?" I asked. The place to be was Constanta. We would surely be smart enough to smuggle ourselves aboard some vessel that was leaving, and our friends would look after us during the voyage.

It was a long, long train ride to Constanta. We found our way down to the harbour. The *Mercury*, *Bulbul* and *Maritsa* were all in dock; the environs were aswarm with agitated people waiting to board the three ships. Officials were calling out the names of passengers so that identity papers could be checked before they were allowed through the gate and on to the wharf.

"You won't get through the gates unless you have the proper papers," we were told. We did not have them, but we still had a little money. Shoved, buffeted, we struggled our way forward. We recognised friendly faces among the crowd and pushed our way towards them. They were heading for the *Mercury* and we fell in close behind them.

We could see they were holding up identification papers.

"Get the money ready," hissed Janek.

The custom officials seemed as happy to accept the folded wad of notes as they were to accept an official document. We were through and on the quay without any trouble.

"Take a look at *that*!" Janek said, pointing at the *Mercury*.

The *Mercury* was an old fishing boat. It was already crammed with people on deck and more were still crowding the gangplank. It seemed remarkably low in the water. Janek and I, still holding our suitcases, stood and looked at the ship and at our friends who were beckoning to us from the deck, then we looked at each other and, as we had done so many times before, shared the same thought at the same time.

"Move on!" somebody shouted from behind.

We let the press of bodies push us to one side. It would be standing-room only on board. I caught Janek's eye and he gave a comical thumbs-down. This was no way to travel. Not for us! For some time now, on German papers, we had moved around in comfort. Why should we now travel in such obvious discomfort? We did not want to get to Palestine desperately enough to stow away on an old fishing boat overcrowded with people. We could wait until our own papers came through, and gamble on the chance that the authorities would provide us with better shipping. Our friends had reached the deck and were waving and urging us to get aboard. Without a word we waved them goodbye, then turned and walked away.

"We did right," Janek said on the miserable and expensive train ride back to Bucharest.

It soon became apparent how prophetic the decision had been. The *Mercury* was torpedoed by a German patrol boat in the Black Sea; there were only 2 survivors

out of 360 people. Everybody we knew on board was drowned.

Apparently the patrol boat had repeatedly signalled to the ship, requesting her to identify herself, but the Turkish crew members were too drunk to take notice of the request and repeated warnings. Failing to receive any response, the Germans fired on the ship and sank it.

"We were at the foot of the gangplank," I said to Janek. "Only a few more steps . . ."

We were sobered by our thoughts and our grief for the many friends we had lost. Most of them had survived the terror of Holocaust, only to finish at the bottom of the Black Sea.

Action, however dangerous, can be exhilarating. Waiting is always frustrating and irritating, particularly for the young and impatient. It seemed forever before the news came through that the Jewish Organisation, with the approval of the Russians, had worked out a route which would take Jews to Palestine — by train.

"It means puffing our way through Bulgaria, Turkey, Syria and Lebanon!" Janek exclaimed.

I was enraged to find that permits were allocated according to age, and that Janek, Rutka and Lesia, two girls with whom we were involved, all under twenty, were listed on the first train to leave and I was not. At twenty-two I had to wait for the next transport.

Going back alone to the room I had shared with Janek really upset me. For the last eighteen months we had lived and travelled together and shared more experiences than most people go through in a lifetime. I missed him badly. I willed myself to concentrate on what lay ahead. I might have to wait a little, but we were bound for a new life, among people who spoke the same language — the language of the survivors of the Holocaust. I was part of a mass determination to live. I could ignore any temporary hold-ups.

I received my permit to travel sooner than I had expected. On 10 November 1944, I joined six hundred other people to make what could be the most fateful journey of my lifetime. At the station the confusion was frightful. Nobody knew where to find their allotted seats and we all struggled through innumerable compartments, dragging our luggage. Men and women carrying small children crying with fright fought their way in and out of cars; the children they held by the hand were often carried away in the crush, and the air was filled with panic-stricken cries. One voice lifted higher than the rest: "Benny! Where are you, Benny?"

By the time I found my seat it was almost dark, and the other seven occupants of the compartment were already in possession of theirs. Trying to ignore the disappointment of finding that my friends were scattered throughout the train, I put my suitcase on the rack and squeezed down into my seat. The attractive girl next to me eased up to give me room with a friendly smile. She was a pleasant surprise. I introduced myself. She replied: "Magda, Boros Magda." The people sitting opposite muttered their names. I gave a big sigh of relief on seeing that there were no small children in the compartment, and tried to make myself comfortable.

Magda said something I could not understand. It sounded to me like Hungarian. I shook my head. "You don't speak Rumanian?" I asked. It was her turn to shake the head. We exchanged looks filled with frustration.

"*Sprechen sie Deutsch*?" (Do you speak German?) I asked, holding my breath and hoping for a positive answer.

"Yes, I do. And English also." Her smile grew wider and more friendly. Thank God we had a common language to communicate in.

Relieved, I looked at the other people in the compartment. There was an elderly couple with an equally elderly

female friend or relative. Next to them was a sickly-looking man with thick glasses. On my right was another woman and a younger man; the way they spoke, I gathered they were mother and son. The language they spoke was Czech.

"At least we're on the train," I said to Magda. "Let's hope it won't be too long before it starts moving."

"Sitting here won't get us anywhere," she answered and smiled again.

We sat there until eight o'clock at night. By that time Magda and I had become friends. She told me she was Hungarian and was travelling alone. My usual luck had held; allocated a seat at random, I had found a friend. I had a feeling that Magda was just as pleased as I to have somebody young to talk to. The November night was cold and we snuggled together under my heavy overcoat. By ten o'clock we were crossing the Danube at the border town Giurgiu. We were in Bulgaria. The light in the compartment was switched off, and with the warm girl very close to me, I fell into a fitful sleep.

Long before dawn we were all awakened by the sudden switching on of the overhead light and the loud call: "Papers! Papers!" Two Russian officers with powerful torches in their hands, and a man from Joint stood over us, as we struggled to produce them from inside our heavy clothing. The Russians carefully checked each face against the photograph on the passport shown, then handed the precious document to the man from Joint, who checked it against a typed list. All eight of us in the carriage passed the check. The compartment door closed behind the men and we were left in peace. But it was impossible to sleep again. We could hear doors opening and shutting as they worked their way down the train, which I now realised had stopped. I pulled down the window and, in the half-light, managed to decipher a station sign.

"Stara Zagora."

"Where's that?"

None of us knew. After about one hour the train shuddered and began to move. We felt relieved, but it did not gather speed. With a sinking heart I realised it was being shunted into a siding and the engine disconnected. Now what?

It was a long time until daylight. Breakfast provided in the station building was welcome, but did little to allay our fears. During breakfast I had the opportunity to take a good look at Magda. She was quite tall and her figure was rather plump. Her light-brown hair, with a reddish tint picked up by the light, was parted on one side; her dark eyebrows were carefully plucked into perfect arches. She wore a beige woollen skirt which fitted tightly over rounded hips and a tan jacket buttoned up the front, showing the high collar of a red blouse. Though she did not look more than twenty-four, she displayed an enormous amount of self-confidence and lust for life.

The officials would not tell us why we were being held up. Rumours, as usual, flew.

The truth was that the Russians suspected a number of deserters from their own army had joined the last transport; they had accused the Jewish Organisation of smuggling Russian-Jewish officers and men to Palestine. They expected more to be found on our transport, and were refusing to let the train leave Stara Zagora until all their deserters were handed over. We were trapped in this bleak place while discussions were conducted on a high level in Switzerland.

"What do you think about this predicament?" Magda asked.

"I hate to even consider what the Russians will do if they can prove there are deserters on this train. It's a very ticklish situation. On the other hand, could anybody

blame Jewish soldiers and officers for trying to get to Palestine? But being gloomy won't help. Come on, let's have another cup of coffee." Over coffee I started telling her about Janek and my other friends in Palestine.

Stara Zagora was the third largest town in Bulgaria, situated on a high plateau at the foot of higher mountains, where it attracted cold winds and heavy rain. The local population consisted of small farmers, artisans and shop-keepers who had very little to sell. The area around was mainly agricultural; like most of the rest of Bulgaria, how-ever, it had a meagre food supply. We were not pleased to find that we were likely to have to stay here for some time.

A day dragged by, then another, and another. It was impossible to find a warm comfortable place. We walked the streets in groups, occasionally buying roasted corn-on-the-cob from a street vendor, or a cupful of hot peanuts. The peanuts proved good hand-warmers when you put them in the pockets of your overcoat. We would come back to the train for a rest, then go out again with another group of people so that we could have a change of com-pany and different topics of conversation. Magda and I usually joined other people, but quite often we would walk together.

These long walks on a crunchy powder-snow, gave us a chance to learn more about each other.

"I finished high school the year before the outbreak of the war," Magda told me. "Instead of going to the Uni-versity, as my parents would have liked, I concentrated on dancing. I've been learning to dance since I was six years old."

"What kind of dancing?" I asked.

"Classical ballet. But I grew too tall and so I decided to become a teacher instead. I also taught ice-skating. It's a lot of fun!"

"That's interesting. I've been skating for years myself. I also played ice-hockey."

Magda told me about her father, who lived in London and her aunt, who worked for Barclay's Bank in Jerusalem.

"When my mother was arrested in May, I escaped to Rumania, and here I am now on the way to Palestine!"

"I am very glad that you are," I said, and she smiled again.

Things improved a bit when the school holidays began. Women, children and elderly men were allowed to sleep on the floors and tables of the schoolrooms. Best of all, we were able to use the school's kitchen facilities. A canteen was set up, serving a hot meal once a day and plenty of black coffee made from vegetable beans.

After suffering a particularly cold night on the train, Magda and I tried out the schoolroom floor, but it was just as hard as the bench of our compartment, so it was back to the compartment — at least we had some privacy there.

We were always cold, our hunger was never quite satisfied, we were never able to wash properly, but our greatest hardship was the uncertainty and boredom. The Russians wouldn't let us through, the Rumanians didn't want us back. We were marooned in no-man's land.

With so much time to spare and so little to do with it, there were plenty of conversations, and sometimes quite heated arguments broke out. We exchanged confidences about our pre-war lives and war experiences; all of us were guilty of forgetting what we had told to whom; quite often our stories came back to us in different versions. The most fascinating topic of conversation, though, was the future. For us the war was over. Although the Allies were still fighting the Germans, they were now on German soil, and Hitler's suicidal defence could not last much longer. We

allowed ourselves cautious optimism about what lay ahead; but those like me who had escaped from the ghetto and spent the last few years wandering around and living on their wits could not dismiss a feeling of apprehension.

We were on our way to start a normal life. We would have to change our way of thinking and learn how to plan, not for just "now" and "today", but for the next five, ten, twenty years. We would have to get up early and go to work every day, five or perhaps six days a week; maybe sit at a desk for eight or nine hours a day, taking orders from a boss. How would we, who had been so independent, adjust to the discipline of an ordered life in which tomorrow was the same as yesterday and today? And how would we accept the laws we would be expected to obey without automatically looking for some easy way to bypass or defy them?

These problems were common to most of us, but I had an additional and personal one. Would I be able to control the natural ability I had discovered, which had saved my life so often in the past, but which might now threaten my future? Did I have the willpower to reject the temptations that would come my way because of my talent as a forger of stamps and documents? In the small country to which we were going many people would be aware of my talents. How long would it be before one of them came up against a problem it would only take ten minutes of my time to solve? How much money would be offered, and how badly would I need it before I gave in? Well, it was no use alarming myself by such questions; only the future would be able to answer them.

Christmas came and went. The train, after standing for almost seven weeks on the siding, was getting into a shocking condition. Broken windows had been replaced by sheets of plywood or cardboard; graffiti disfigured the walls both inside and out, and children's drawings were

320

scrawled everywhere. Nothing changed except the rumours.

"A friend of a friend apparently overhead a telephone conversation between . . . and found out . . ." "A man talked to a Russian officer, who told him . . ." "A woman from the next compartment said she had seen a telegram from Joint in Switzerland definitely promising . . ."

The officials on the train tried their best to inject optimism into the atmosphere of gloom and depression. No one believed anything any more.

At last, on 29 December, after forty-eight days and amid scenes of wild jubilation, the train was shunted back onto the track and coupled up to an engine, and Stara Zagora was thankfully left behind to the snow and cold. The celebration hardly had a chance to subside when we arrived at the tiny border town of Svillingrad, high in the mountains which separate Bulgaria and Turkey.

We got out of the train to admire the beautiful snow-covered landscape, the tall pine forests and mountain peaks which towered above us, their heads hidden in clouds. After two hours our capacity for admiration was exhausted. Why were we being held up yet again? Surely this could not be another Stara Zagora? It was clear this was not just a routine stop: there must be another legal complication. What was it this time? We soon found out.

If it hadn't been so serious, the situation would have made a great slapstick comedy. To explain our situation we have to go back to the year 1917, when Lord Balfour, on behalf of the British Government, prepared a document — "The Balfour Declaration" — which pledged support for the establishment of a Jewish state in Palestine. In 1922 the League of Nations gave the British a mandate over Palestine, and they allowed a steady stream of Jewish immigrants, mainly from Russia and Poland, to enter the country. But the Arabs living in the

area became antagonistic to the new arrivals and there were frequent skirmishes between the two sides.

During World War II the oil-producing Arab countries exerted pressure on the British to halt the immigration; not for the first time, and certainly not for the last, commercial advantage outweighed moral obligation and the British succumbed. However, as a sop to conscience, they did allow a small annual quota of entry permits. Our "Certificates", as the permits were called, were issued to each of us by the British Government for the year 1944, and could be used during that year only. The fact that millions of our people had been killed and hundreds of thousands made homeless did not seem to matter. We were trapped in the cobweb of democracy, the proverbial meat in the sandwich.

Due to the delay at Stara Zagora we arrived at the Bulgarian border with Turkey on 29 December. This meant that the earliest date we could hope to reach the Lebanon-Palestine border would be 4 January 1945, by which time our entry permits would have expired. The Lebanese authorities had been quick to pick up this point. They notified the Syrians that unless they had assurances from the British Government that we would be accepted into Palestine, they were not prepared to let us into their territory. The Syrians then notified the Turks that they could not let us through, unless *they* had similar assurances from the British. This message was relayed in turn to the Bulgarians. So there we were in Svillingrad, once again stuck in the train in a siding, refugees whom nobody wanted.

When it became obvious that this was going to be another long delay, the women and children were moved to a local school, where at least they could keep warm. The men slept in the train, and we greeted 1945 by climbing out of the train window to shove away the snow so

that we could open the doors. Everybody grumbled. What a New Year celebration! Fortunately there was plenty of wood about and we kept some burning in an old iron bucket in our compartment. In such freezing weather, sweet plump Magda was the ideal person with whom to snuggle under an overcoat during the daytime.

After three days, when food and cigarettes were almost gone and personal hygiene was becoming a problem, we were all becoming irritable and intolerant. When the news came through that, due to international pressure, the British Government had decided to honour our expired certificates, our jubilation was more subdued than when we left Stara Zagora. Then it was announced that volunteers were needed to move snow from the track and put fires on the steel lines to defrost the wheels. Though every able-bodied person on that train set to work with a will, it was more than three hours before we were able to begin the careful descent towards Istanbul.

By now we were prepared for any sort of surprise, but when the train stopped in the middle of the night on the banks of the Bosphorus and all six hundred of us were unloaded and bundled into a small, very old, very dirty ship which was then taken out into the middle of the harbour, we were really baffled. The area below decks was dark, sanitary facilities were minimal, the crew spoke Turkish and could not tell us why they were running up the yellow flag which indicated sickness aboard — or, in our case, quarantine. It was more than forty-eight hours before we were taken off the ship and allowed on to special carriages attached to the "Taurus Express", which ran to Aleppo in Syria. By that time we must have been greater health hazards than before we boarded their wretched little vessel.

Aleppo was over a thousand kilometres away; the route took us right across the desolate and deserted Asian part

of Turkey. The high rocky country, with no sign of life, was completely dried out, and the drifting red dust was so thick we had to close the windows against it. It looked a hostile place; we all kept our fingers crossed as the train covered mile after mile of wilderness bleaker than anything I, for one, had ever imagined. If the train were to stop and we were left at the mercy of this barren wasteland ... the thought was horrifying. But our crossed fingers must have had good effect. We reached Aleppo without mishap.

Again we disembarked and the long straggle of men, women and children, clutching their belongings, made their way to a goods train that awaited us. The floors in the vans were covered with straw, and there were two armed black guards in British uniform to each wagon. They were taking no chances that any of us might attempt to stay in Syria or Lebanon rather than go on to Palestine.

Long before we got to the Palestine border we slid the large van door wide open and anxiously scanned the passing landscape. I was surprised by the height of the Lebanese mountains and the extent of the area covered by snow. We travelled along for about a hundred kilometres with glimpses of the sun-drenched Mediterranean on our right and snow-covered mountains on our left.

Beirut was only a "whistle stop". We knew that now we were nearly in Palestine. Emotions could no longer be concealed. Conversation died and everybody concentrated on the passing scene, waiting for the moment when we would reach the Promised Land.

Another stop. I watched the Lebanese border guard walk past the train and give the all-clear signal. It seemed strange to cross a border without having to present a pass.

A few minutes after we had got under way again, a murmur ran the whole length of the train as we passed a

large sign which said simply: PALESTINE.

People kissed each other, women wept, and as I took a sobbing Magda in my arms I felt my own eyes fill with tears. All the tension and apprehension from which we had been suffering disappeared. Softly at first, then swelling in volume, voices lifted in joy and gratitude in the *"Hatikvah"*, the Jewish national anthem.

As we passed through Nahariya, the first Jewish town across the border, we waved to the people working in the fields and called "Shalom", longing to be able to meet them and shake their hands.

It was an hour before the train reached a small station where some British officers and army personnel were waiting for us. We were asked to stay on the train until told to alight, but several older people could not contain their impatience. They pushed past the guards and fell on their knees to kiss the soil of the Holy Land and to pray. As I watched everyone finally disembarking from the train, carrying their belongings towards the army trucks which were to take us to our camp, I was reminded of all the other people of our race who had set out in a similar way, carrying their pitiful luggage. I had seen them being escorted away by Russians, by Germans . . . I had been one of them myself. But now, the faces around me were quite unlike those of my companions on the way to Janowska camp. These faces were alight with joy. Everywhere I saw hope and eagerness, without fear of the future.

On 8 January 1945, after a journey which had taken eight weeks, we arrived at the quarantine camp of Atlith, a few kilometres from Haifa. We were in the middle of nowhere. A few palm trees threw short shadows on the rows of large tents; there was nothing else to see but sand and more sand. It didn't matter. The exodus was over. We were safe in Palestine. We were *home*.

Safety began with a thorough medical examination, a number of inoculations and a surprisingly intense period of questioning by both British and Jewish Intelligence.

Two days after my interview, lying on my bed daydreaming and nursing a swollen arm, the result of a smallpox vaccination, I heard a loud announcement over the PA which brought me back to reality: "Mister Marian Pretzel, please report to the Administration Office." It was repeated twice, in both Polish and German. Although I had nearly two years of a relatively peaceful life behind me, hearing my name echoing all over the camp startled me. Once out of the tent I regained my composure. Surely there was nothing to worry about. Not in Palestine!

The weather outside was depressing. The fine shower that had been falling since early morning had increased to a heavy rain. I ran to the office, jumping over puddles and mud patches.

A corporal escorted me to a small room where I faced a young captain, sitting behind the desk. It was not the same man who had interviewed me before.

"Please sit down, Mr Pretzel." He came straight to the point. "It has been brought to my attention that you had some remarkable experiences during the war. Would you like to tell me about them?" He spoke Polish but it was obvious that he had learned the language abroad, most probably from his parents. Although his accent was strong, his vocabulary was good.

"Oh, that was a long time ago," I said without interest. "I am only concerned with my future, not my past." I didn't feel like disclosing all my escapades and my ability to forge stamps. If he wanted to know anything he would have to ask me. He did. He wanted to know everything and made it obvious I must cooperate.

"Start at the beginning." He lifted his head and looked at me squarely. "Tell me about your family, what life was

like under the Russians, in the ghetto, in the concentration camp. And tell me," he said, leaning forward, "how you got away with forging stamps and documents."

I told him everything. I had no option, it seemed to me that he already knew quite a lot about my immediate past.

He was particularly interested in my forging ability. "Do you think you would have got away with it if you had been dealing with the British or the Americans instead of the Germans?" he said, repeating a question I had once asked myself.

"It would probably have been easier," I replied. He looked at me sharply. "People in the Western world are basically honest," I explained, "and they expect other people to be honest too. Shopkeepers don't bite on coins to see if they are genuine; they don't check every bank-note, and the tram and train conductors don't go over every ticket with a magnifying glass. Apart from anything else, they don't have the time. The Germans had neither the time nor the men to make every check a detailed one. And I'll bet that if anybody wearing a British or GI uniform had shown one of your soldiers an official-looking document and said he was travelling on army business, your men would have let him through. Thousands of soldiers and civilians were travelling about — what chance did the occupation authorities have to detect every forged document? If a document looked right it was accepted on sight. You were no better off for time and personnel: why should you have been any different?"

It was not quite the answer he had expected.

The questions then began to centre on the time I spent studying at the Art Institute in Lvov after the Russians had taken over the country. I realised that in a round-about sort of way he was trying to pump me about my attitude to the Russians.

"It's a love-hate relationship," I told him. "I love the

people, hate the system. Whoever said that Russians make the best friends and the worst enemies knew what he was talking about. I wouldn't be alive today but for the help of some wonderful Russians. But, as an artist, I couldn't possibly live in an environment where my work and all my thoughts had to be in accordance with the Party line.''

He thought about that for a moment, then said: ''How did you feel when you were travelling on those false papers? Do you think you'd ever have the nerve to do it again?''

''I was three years younger then, and though what I did was primarily to save my own life, I was kid enough to enjoy the adventure — and, of course, the success. But I'd only do it again if it were a case of life or death.''

''Weren't you afraid when you travelled on forged papers, wore German uniform and did all the things you claim to have done?''

My reply then was the one I was always to give. ''If I had been caught, the first bullet going through my brain would have been because I was a Jew; the ones after that would have been for the forged papers and all the other things, and they couldn't have hurt me any more.''

He smiled. He got up, shook my hand and said, ''Thank you, Mr Pretzel.

After eight days of rest and decent food we were released from quarantine. It was hard to part with Magda. She was going to Jerusalem where her aunt lived. My sights were set on Haifa. Janek was there.

We entered Haifa and travelled along busy Kingsway Road; the deep water harbour was on our right and the tall white buildings of the commercial area to our left. The streets leading up from sea level were steep and narrow; the houses, tiny, whitewashed and very old, had openings in which shop goods were on display and the people crowding the cramped pavements wore clothes hardly

changed from those worn in Biblical times.

As we came into the residential suburb of Hadar Hacarmel, the streets gradually became wider and the houses larger. There were modern blocks of flats with large windows and plant-filled balconies, surrounded by beautifully kept gardens. Although it was January, and there were no flowers in bloom, I could imagine what the rainbow of colour would be in summer.

Looking at the strange surroundings, I could not help thinking back over the two and a half years which had passed since the day I came back to Lvov from the camp in Wilniczka and found my parents had been taken from me. I realised how fortunate I had been and how blessed I was now. I not only survived the Holocaust, but, unlike the great majority of survivors, I lived through those terrible times without once being physically hurt. Though there were occasions when I would have liked more to eat, I was never without food; I was never without warm clothes and I was never sick.

I grieved so much for my parents, who never had a chance of survival. There was not a single thing I could have done for them. I grieved for Giza, who unknowingly sacrificed her own life for Karol, without being able to do anything for him. Her action, as noble as it was, lacked all recognition of the reality of the times. I grieved for so many close friends; given the chance, they could not, or were afraid to take it; and I grieved for Adek and Felka, who threw their chances away.

The chance I would not take in all that time was to pray for help; I was afraid of possible disappointment or disillusion. I always did my job and was willing to try to help myself. I suppose I was rewarded by the way I always seemed to be in the right place at the right time and was able to do things "by my own authority". Although I did not say "please" I was always happy to say "thank you".

Another of my father's favourite sayings was: "You can't make a fist without fingers". I was blessed by being given "fingers" that made a good fist. I was young and strong, I did not look Jewish, I had natural ability and training that enabled me to forge stamps and documents which the Germans did not question. Being a sportsman, I was conditioned to be a fighter. Although I was only twenty when the tragedy struck, I was able to recognise all the advantages I had. But the most important part of my "fist" was undoubtedly my good luck: fortunate coincidences, half-miracles, even absolute miracles — all matters for astonishment and gratitude. There were times during this period of my life when things worked for me to such a degree that I felt I could virtually walk on water. I cannot recall how often I raised my eyes towards the sky and whispered "Thank You" to the Power that protected and guided me.

As the bus drew into the city, emotion almost choked me. This is where my future lies, I thought. No more forged papers. No more running away. I am Marian Pretzel again. The nightmare which began on 25 August 1942 was over.

A large group of people waited to greet relatives and friends. Janek was one of the first people I saw.

I looked up into the fair and cloudless sky and whispered the most heartfelt "thank you" of all.

Epilogue

Australia

After living in Palestine for almost two years, I returned to Europe — this time to Vienna, where I resumed my studies in art and worked in my chosen profession of graphic design.

This lasted for about three years, then once again I began to feel restless. And so, in 1949, I decided to migrate to Australia. Life in my new country started in the Queensland bush. However, within six months I was living in Sydney, and although I had to borrow money to get there, I was full of confidence for my future in Australia. Now, after living here for more than thirty-six years, my feelings are as strong as ever.

Early in 1955 I met Yvonne, the Australian girl who was to become my wife. Now the wheel had come full circle. The terrible loneliness that began on 25 August 1942 was over, and thirteen years in a wilderness were at an end when, on 23 October 1955, Yvonne and I were married.

The regret of my life is that neither of my parents ever saw Yvonne or our two children, Stephen and Shari. How happy and proud they would both have been!

Exactly forty years after Janek and I had travelled to Budapest to bring Helen back, we made another decision.

This time we planned a "sentimental journey" to Bucharest and Budapest.

We met in Vienna on 4 May 1984. At Janek's suggestion we were to spend a weekend in Budapest, then fly to Bucharest for five days.

Before leaving for Budapest, I had one important task to perform. I wanted to meet Simon Wiesenthal once again. On my previous visits to Vienna I had missed him. This time I wrote to advise him of my arrival, and I sent him a manuscript of this book.

We called at his office. The last time I had seen him was in Linz in 1946, but he did not seem to have changed. Nobody would have believed that the previous New Year's Eve he had celebrated his seventy-fifth birthday. We talked for well over an hour and I reminded him of the part he played in my escape from Janowska Camp.

Janek and I went by bus to Budapest. The Hungarian government had severed diplomatic ties with Israel, which meant that Janek could not obtain a Hungarian visa. However, this did not prevent the authorities from issuing Israeli citizens with special weekend permits. It seemed the hard currency the tourists brought with them was of greater importance to the Hungarians than political principles.

We hired a taxi and went straight to the railway station, so vividly engraved on our memories. It was an exciting and poignant moment for us. Then a tram went by — number forty-four, the same one that brought Helen Sobel to our first meeting, and we were overcome with emotion. Our next stop was outside the park where I had forged our papers for the return to Bucharest. Then we went to the Balasc Utza 9, to have a look at the house where Helen had lived. (Janek's memory is incredible!) On Sunday the bus took us on a sightseeing tour, with lunch in Buda accompanied by gypsy music. Then we returned to Vienna.

The following Tuesday, an Austrian plane brought us to Bucharest. Janek's acquaintances met us and drove us to the hotel. Although both Hungary and Rumania are members of the Communist Bloc, the similarity ends there. While Hungary had seemed reasonably prosperous, with shops filled with goods and foodstuffs, in Rumania the picture was completely different. Driving from the airport, we could not help noticing the long queues outside the shops; we were told this was an everyday occurrence. People were queuing for cucumbers, onions, bread, even for newspapers. When we arrived at our hotel we were advised to be very careful what we said, not only in our room, which was most probably bugged, but also in private cars and certainly in taxis.

Janek's Rumanian friends were invaluable. They took us in their car to Slatina and Dragasani, where, after a long search, we found the church in which I helped the artist with his mural. I was most disappointed that we were unable to enter the church. The priest was away, and he held the only keys. The mystery of whether "my artist" got the job therefore remains unsolved.

Back in Bucharest, we hired a taxi for a day and visited all the places we could think of . . . the Cismigiu park with its rowing-boats, Kiselef Strand swimming pool, Floriasca Lake, the Gara du Nord and Banyasa railway station. Finally we stopped at Piata Rosetti, where we used to live. We recognised the house and were able to see our flat.

Exciting as it was to revisit the scenes of our past, we felt sad and depressed. In 1943 and '44 this city had been extremely happy and prosperous. In 1984, thirty-nine years after the war had ended, it was shabby, neglected and poverty-stricken. What had happened to the happy, carefree young girls we had known? Where had all the glamorous and beautiful girls disappeared to? There was no fun, no laughter any more. I walked into a large

department store. It used to be the Galleries Lafayette, my favourite shopping ground. I left it in less than thirty seconds. I could not bear to look at the transformation that had taken place.

On the streets, every few yards, foreign tourists were accosted by the locals, who offered to change money, sometimes at up to six times the official rate. No matter how tempting, these offers were much too dangerous even to be considered. Making inquiries about Helen's whereabouts, or her parents', was in the same category. We were told that asking questions was not a recommended pastime for the tourist. Regretfully, we had to follow this friendly advice.

When the time came to board the plane back to Vienna, we were more than happy to leave this unfortunate country behind. We felt sorry for the people, especially those of our generation who could remember the sophisticated life of the 1930s as well as the war years in Bucharest. At the same time, we felt deeply thankful that we each lived in a democratic society.

The ten days with Janek were coming to an end. For ten days we had been able to turn the clock back forty years. Once again we had behaved like the youngsters of the past. The same silly pranks we used to play on one another, the same practical jokes. We were together for twenty-four hours each day, with never a dull moment, and never a suggestion of disagreement. Just like the old times!

Sunday morning found us quiet and subdued. We packed in silence, frequently exchanging sad glances. We both knew it would not be long before we would meet again, yet we tried to delay the moment when we would have to shake hands and go our separate ways. With our arms around each other and tears in our eyes we said farewell, grateful for those ten days together. We shared something that could never be repeated and would never be forgotten.

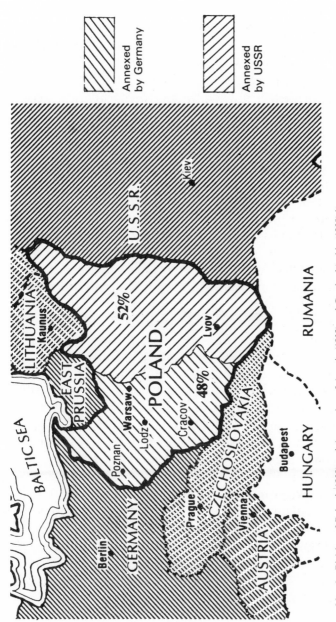

Map 1 Division of Poland (1939) and Annexation of Austria (1938) and Czechoslovakia (1939) by Germany, and Baltic States (1939) by USSR

Annexed by Germany

Annexed by USSR

BALTIC SEA

LITHUANIA
Kaunus

EAST PRUSSIA

GERMANY

Berlin

Poznan

Warsaw
Lodz

POLAND

52%

48%

Cracov

Lvov

U.S.S.R.

Kiev

Prague

CZECHOSLOVAKIA

Vienna

AUSTRIA

Budapest

HUNGARY

RUMANIA

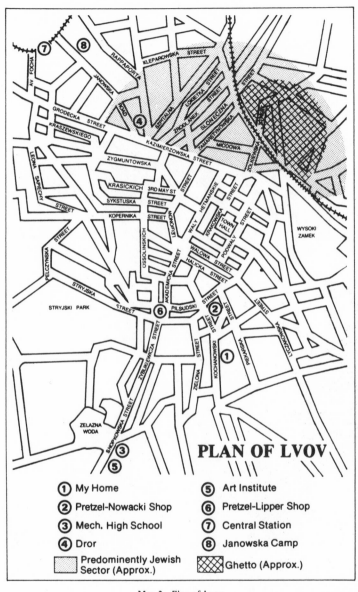

PLAN OF LVOV

① My Home	⑤ Art Institute
② Pretzel-Nowacki Shop	⑥ Pretzel-Lipper Shop
③ Mech. High School	⑦ Central Station
④ Dror	⑧ Janowska Camp
▢ Predominently Jewish Sector (Approx.)	▨ Ghetto (Approx.)

Map 2 Plan of Lvov

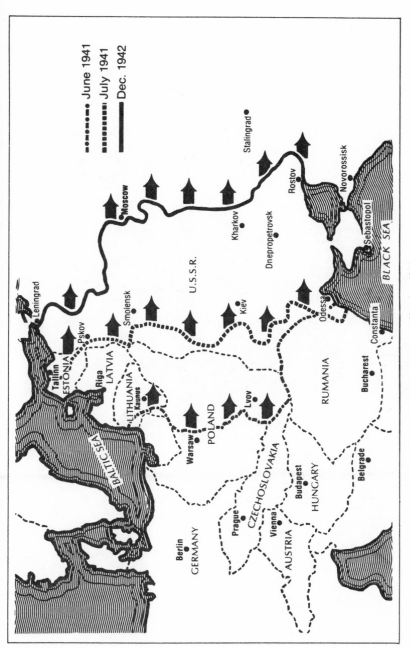

Map 3 German offensive 1941

Map 4 German-Italian occupation of Europe, 1942

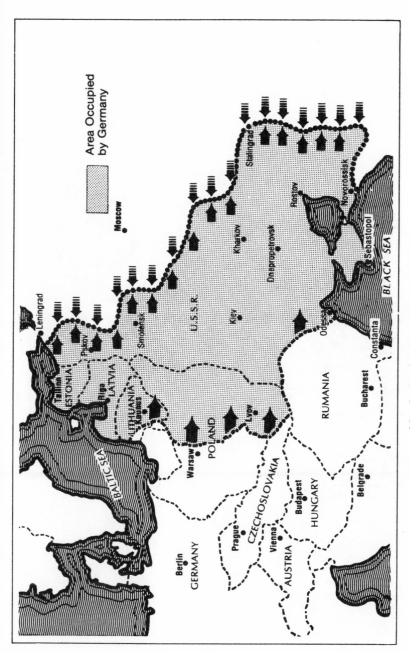

Map 5 Russian front at the end of 1942

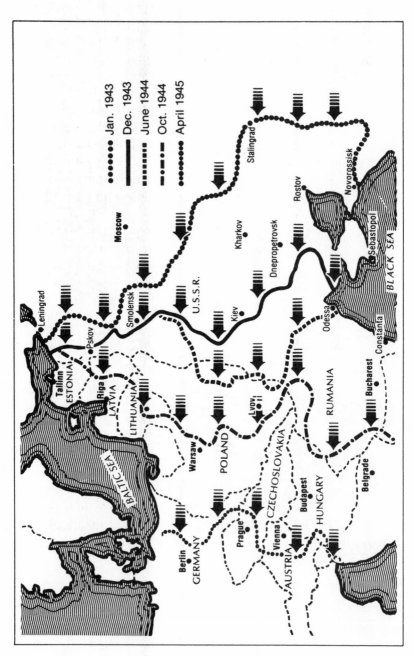

Map 6 Russian counter-offensive 1943–45

Jan. 1943
Dec. 1943
June 1944
Oct. 1944
April 1945

Leningrad
Tallinn
ESTONIA
Riga
LATVIA
LITHUANIA
Pskov
Moscow
Smolensk
U.S.S.R.
Kharkov
Dnepropetrovsk
Kiev
Stalingrad
Rostov
Novorossisk
Sebastopol
BLACK SEA
Odessa
Constanta
RUMANIA
Bucharest
Warsaw
POLAND
Lvov
CZECHOSLOVAKIA
Budapest
HUNGARY
Belgrade
Berlin
GERMANY
Prague
Vienna
AUSTRIA
BALTIC SEA

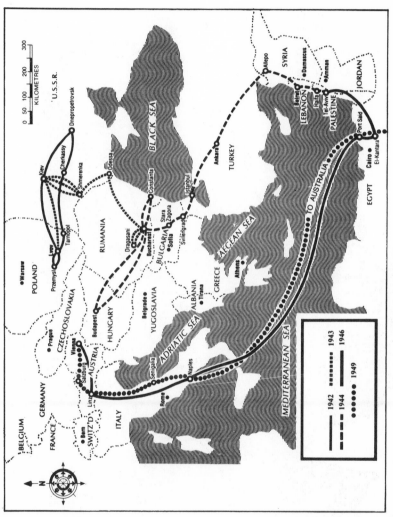

Map 7 My travels 1942–49

About the Author

Born in Lvov, Poland, Marian Pretzel migrated to Australia in 1949. He completed the manuscript of this book forty-two years after the end of World War II. Besides pursuing a successful career as a graphic designer, he had held exhibitions of his paintings. He has continued to pursue his love of sport and has won many golf trophies. He is a past vice-president of the Australian Jewish Holocaust Survivors' Association and is Chairman of the Holocaust Museum Committee. He is married, has two grown children, and lives with his wife Yvonne in Sydney.